# The Rise of the Sixties

# The Rise of the Sixties

## American and European Art
## in the Era of Dissent

Thomas Crow

Laurence King Publishing

# Acknowledgments

For their immensely helpful advice and readings of the manuscript, I want to thank Tim Barringer, Hal Foster, Robert Haywood, David Mellor, Catherine Phillips, and William Wood. Many galleries, museums, and individual collectors were responsive and generous in providing photographs. Robert Frank and Robyn Denny offered exceptional assistance with the illustration of their work. Throughout the production of this book, Jacky Colliss Harvey and Susan Bolsom-Morris have been tireless, perceptive, and sympathetic editors.

**Frontispiece** ROBERT RYMAN *Untitled,* page 116 (detail)

First published in Great Britain in 1996 by
George Weidenfeld and Nicolson Ltd
Reprinted edition published 2004 by
Laurence King Publishing Ltd
71 Great Russell Street
London WC1B 3BP
Tel: + 44 20 7430 8850
Fax: + 44 20 7430 8880

A catalogue record for this book is available from
the British Library

ISBN 1 85669 426 7

*Series Consultant* Tim Barringer
*Designer* Sara Robin
*Picture Editor* Susan Bolsom-Morris
Printed and bound in China

# Contents

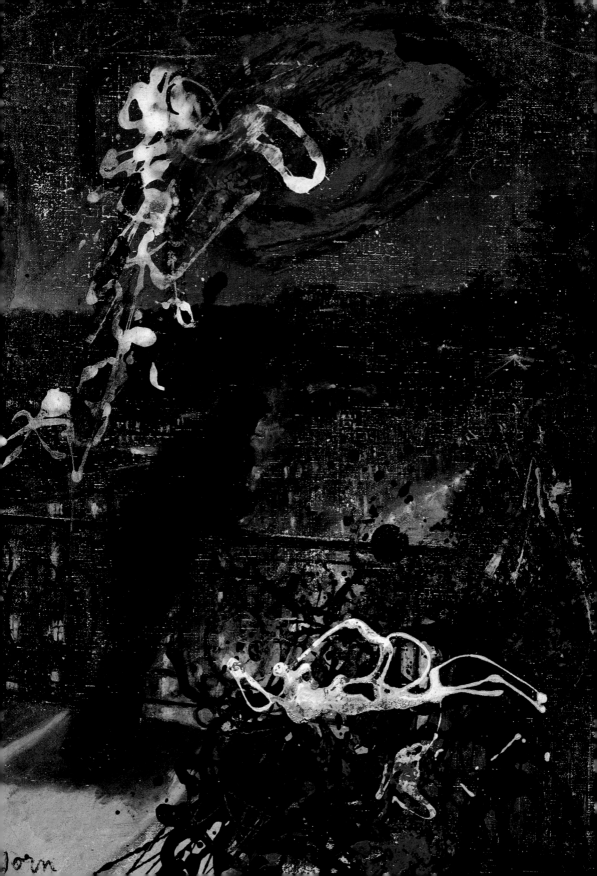

# Introduction

"Contemporary Art and the Plight of its Public": so ran the title of a widely read essay published in 1962, at the heart of the period covered by this book. The lament contained in that phrase remains current. Ordinary viewers of today, hoping for coherence and beauty in their imaginative experiences, confront instead works of art declared to exist in arrangements of bare texts and unremarkable photographs, in industrial fabrications revealing no evidence of the artist's hand, in mundane commercial products merely transferred from shopping mall to gallery, or in ephemeral and confrontational performances in which mainstream moral values are deliberately travestied.

The sum of such activities offers continual ammunition to contemptuous critics of the Right, who claim to speak in the name of an outraged common viewer. Their attacks upon these provocations invariably entail a further, retrospective denunciation of the adversarial culture of the fabled 1960s, which they see as the wellspring of all contemporary scandals.

There is considerable truth in this claim, as every one of the artistic tactics listed above can indeed be traced directly to innovations from the period between 1955 and 1969. But an accurate perception of historical genealogy may not necessarily accompany a reliable account of public perceptions and desires in the present. In any large European or American city, intrigued audiences in the tens of thousands find themselves drawn to exhibitions of this same difficult art in both its past and present incarnations. If much of the work on show nevertheless remains puzzling and remote to those without a secure initiation in the ways of the art world, it is because that wider audience lacks a useful explanatory narrative. And its search for a framework of under-

1. ASGER JORN
*Paris by Night*, 1959.
Oil on re-used canvas,
20³/₄ x 14¹/₂" (53 x 37 cm).
Collection Pierre
Alechinsky, Bougival.

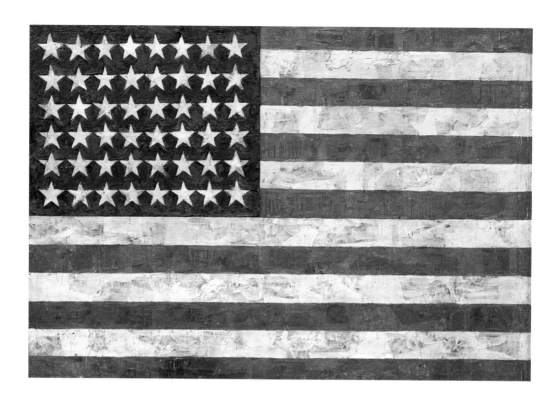

2. JASPER JOHNS
*Flag*, 1954-55. Encaustic,
oil and collage on fabric
mounted on plywood,
3′6¹/₄″ x 5′ (107 x 154 cm).
Museum of Modern Art,
New York.

standing has been particularly frustrated by the inheritance of the 1960s having come under such an onslaught of abuse and misrepresentation.

It could be said that the difficulty is one that the passage of time will solve. Experimental art of the earlier twentieth century, once equally embattled, has attained a comfortable acceptance among a broad constituency: delighted audiences circulate around Picasso retrospectives, sympathetically responsive to his ever-changing play with the means of visual representation. But this fact only underscores the problem of available narratives. Sceptical historians have pointed out that popular fascination with Picasso has been largely induced by the larger-than-life biographical mythology that surrounds the artist. Heroic biography addresses the spectator's legitimate need to place an artist's decisions and aesthetic risk-taking within the continuum of the life that made them necessary. And that task was made comparatively easy by the penchant of artists from Picasso to Jackson Pollock, along with their eager admirers, to couch their ambitions in highly individualistic terms, to speak largely of interior motivations behind their work. The art that emerged in the wake of Pollock's sensational, near-suicidal death in 1956 made similar stories difficult to tell. Even before that event, artists of the next genera-

tion were withdrawing from the heroic model of artistic selfhood. In 1955, Jasper Johns, then a young and little-known artist, began a series of paintings based on a diagrammatic rendering of the American flag (FIG. 2). Viewers accustomed to the startling gestural improvisations of the Abstract Expressionist painters (FIG. 3), found instead a ubiquitous insignia, exalted or compromised (depending on one's point of view) by the Cold War patriotism then dominant in the United States. Johns's choice of motif provided minimal nourishment to the expectation that artists owed their audience some form of spectacular self-revelation.

Nor was he alone in this. From the other end of the American continent, San Francisco artist Burgess Collins (who signed himself "Jess") was composing paintings by overlaying a few gestural improvisations onto canvases with stereotyped images in outmoded styles that he gleaned from junkstores; toward the end of the decade, the Danish painter Asger Jorn had independently arrived at the same procedure (see FIG. 1, page 7). Both artists set about bracketting the marks of their privileged, metropolitan individuality within the anonymity of bypassed, provincial forms of expression.

It would be an understatement to say that Johns has been reticent in explaining the motives behind *Flag*, but Jess and Jorn have been open in announcing critical intentions behind this and other of their disparate artistic directions. Both saw the familiar role of the visionary artist as one more support for a complacent, self-congratulatory high culture and, by extension, stultifying social conformity sweetened by consumer dreams:

3. HANS NAMUTH
Photograph of Jackson Pollock painting in his Long Island studio, New York, 1950.

Namuth made an extensive series of photographs in Pollock's studio. These have subsequently created as vivid a public image of the artist's "pour" technique as have the paintings themselves. Namuth emphasized those moments in which Pollock seemed most physically spontaneous and dance-like in his movements. That image, now mythic in resonance, belies the high degree of control and premedidation evident in close examination of the canvases.

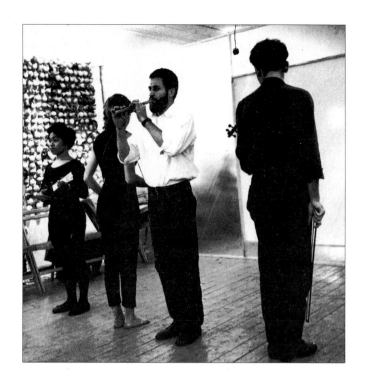

**Right and below**
4. ALLAN KAPROW
*18 Happenings in 6 Parts,*1959.

The illustration below shows the rectilinear partitions in light wood and plastic with which the experimental Reuben Gallery in New York was prepared for Kaprow's event, including, on the temporary walls, results of painting exercises that formed part of the ritualized, absurdist scenario. The artist stands in the center of the illustration to right.

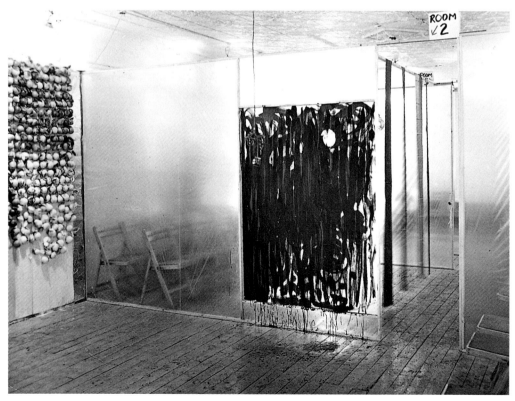

Jess inwardly raged against a militarized Californian suburbia, in which both his gay sexuality and bohemian aesthetic inclinations marked him for persecution; Jorn had joined forces with a trans-European political avant-garde, the self-proclaimed Situationist International, which sought to turn a future revolutionary politics toward contesting the ways in which potentially active citizens are reduced to the status of passive onlookers.

Jorn's subordination of the art of the studio to a collective project of cultural agitation had immediate echoes on the other side of the Atlantic. Allan Kaprow and Claes Oldenburg were only the most prominent in a contingent of New York artists, writers, dancers, and musicians who poured their energies into hybrid events, dubbed Happenings, where the play of chance and group improvisation took over from the authority of any single artistic intention (FIG. 4). Begun for the sake of an aesthetic liberation, that activity too found its way to an overt connection with politics. The first key to this engagement was the national crisis provoked by the struggle against racial segregation in the South, a movement sustained in countless displays of extraordinary and anonymous courage on the part of black protesters with their handful of white allies (FIG. 5). Buoyed by the rhetorical gifts of Martin Luther King, the civil rights movement translated to an American context the politics of conscience pioneered by Mahatma Gandhi in his non-violent resistance to European colonialism in India. It moved social radicalism away from the terrain of industry and mass parties toward the realm of conscience, symbolic expression, and spontaneous organization from below. The dissenting experiments of artists thus found an energizing congruence with the most exciting and successful forms of dissenting politics.

That initial discovery was then redoubled in the European and American student movements of the 1960s (FIG. 6) and in the broadly based protests against the war in Southeast Asia. In that context, every decision that an artist might make was henceforth open to question on principles that might as readily be ethical, political, or bearing on fundamental questions of honesty and falsehood in representation; every serious artistic initiative became a charged proposition about the nature and limits of art itself. The means employed in those arguments were the antithesis of dry verbal debate: artists condensed concepts into dense visual icons, non-linear arrays of objects in space, unrepeatable events, and activist interventions within the museums and galleries now seen as outposts of established power. But arguments they remained, and to grasp the history of art from the mid-

1950s onwards is to learn to follow an intense, multi-part dialogue.

It follows that a conventional narrative, founded on the assumption that art arises as assertion or confession from the artist's sovereign self, will not capture the work that really mattered in this epoch. Leading individuals, as always, remain crucial for understanding artistic change, but it becomes impossible to maintain even a working fiction that a single artist, whatever his or her gifts may be, can synthesize more than a fraction of the dialogue. The narrative that follows does not leave behind the need for a grounding in biography; it preserves more individual life-stories than present-day critical fashion may find comfortable. Its effort will be to complicate biography – the lived experiences and conscious decisions of individuals – with other biographies, so that some equivalent to the questioning and contestation that marked that time in history can come to life in its pages.

At the same time, another narrative inescapably presents itself, one in which the lives of artists gives way to the careers of dealers and the faceless workings of markets and institutions. The eclipse of the old heroic model did not bring about a decline in the importance and appeal of art. On the contrary, the proliferation of dissent and the fragmentation of voices propelled advanced art to new levels of desirability for wealthy individuals, corporations, and great civic museums. It will emerge that the story of art within the new politics of the 1960s is one of considerable ambivalence, as artists attempted to reconcile their stance of opposition with increasing support for their activities in a new and aggressive global marketplace. That exponential growth in the

5. Bus boycott in Montgomery, Alabama, following Rosa Parks's refusal to move from a whites-only seat on a city bus, 1956.

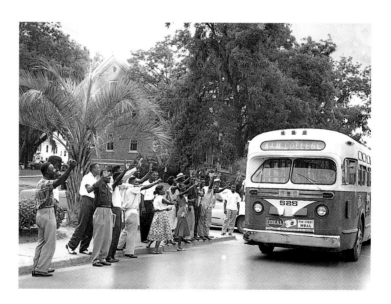

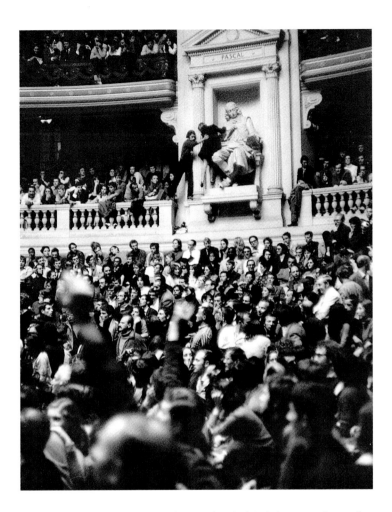

6. Student uprising of the Sorbonne, Paris, May 1968.

measurable resources devoted to art lies behind the attendance fig-
ures for current exhibitions and the ambivalent fascination felt by
audiences for the work of dissident artists. They cannot miss
the aggression in the work, yet its setting speaks in a contrary voice
of acceptance and reassurance. The sharpening of that paradox
is a product of the period from 1955 to 1969, part and parcel of
its art, and finally the central subject of this book.

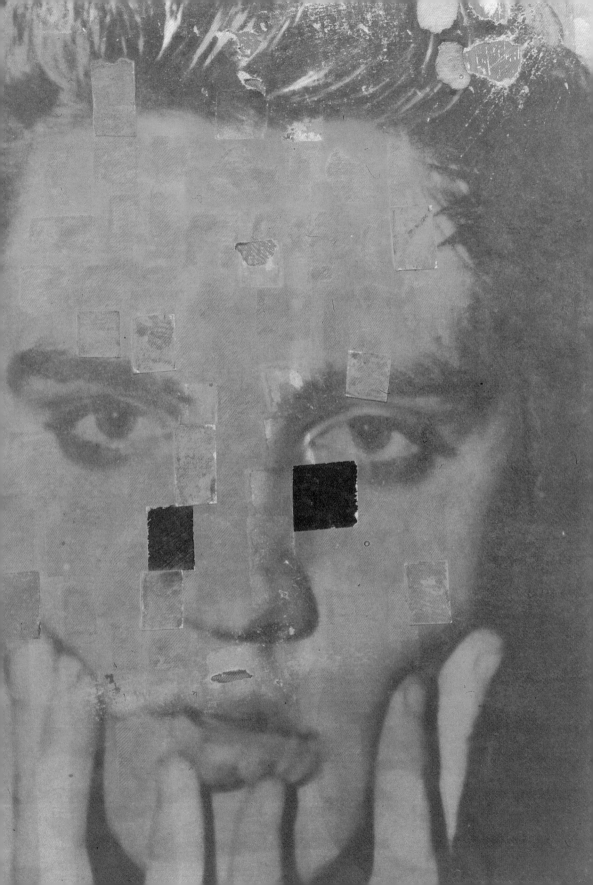

# ONE

# *Independence Days*

To explain the origins of *Flag* in 1954-55 (see FIG. 2) Jasper Johns (b. 1930) came to rely upon an occult scenario: the idea came, he said, from a dream in which he was painting a large flag; his friends, among them his close companion Robert Rauschenberg (b. 1925), encouraged him to realize that involuntary vision. The first public result was a small panel representing the flat pattern of the American flag, which Rauschenberg inserted into a large assemblage of his own for a group exhibition in 1955. That hybrid work, entitled *Short Circuit* (FIG. 8), also contained a painting by Rauschenberg's wife and collaborator Susan Weil (b. 1930) and a collage by Ray Johnson (1927-95), contemporaries whom he also considered the victims of unjust neglect. Pasted alongside were a program from a concert by the composer John Cage and the signature of the actress and singer Judy Garland.

Whether or not its message was received, *Short Circuit* presented a coded defiance of the values that then dominated advanced art in New York. Among Johnson's works at the time were small constructions based on newspaper photographs of such populist icons as Elvis Presley (see FIG. 7, left), who was then a barely mentionable barbarism to sophisticated New Yorkers. John Cage (b. 1912) was the bearer of the anti-expressive, Dada legacy of Marcel Duchamp (1887-1968), who was living in New York but at a distinct remove from an art world fixated on revelatory self-

7. RAY JOHNSON
*Elvis Presley #2*, 1956-57. Ink, collage and paper on cardboard, 10³/4 x 7¹/2" (27.3 x 19 cm). Collection William S. Wilson.

discovery in paint. The composer also represented, through the strength of his combined personal and professional relationship with the dancer Merce Cunningham (b. 1919), an example to other gay artists seeking to find a place among older painters – like the universally admired Willem de Kooning (b. 1904), who went out of his way to project an exuberant heterosexual appetite in his art. The inscription of the pop diva Judy Garland's autograph tied the ambitions of high art to the rituals of gay fandom and camp. The presence of the small *Flag* enacted a cherishing, fostering gesture toward Rauschenberg's own lover and closest collaborator. In a later assemblage work entitled *Canyon* (FIG. 9), Rauschenberg similarly melded patriotic and homoerotic emblems, exploiting the possibilities of immediate visual transcription offered by photographic silkscreen printing.

8. ROBERT RAUSCHENBERG
*Short Circuit.* Mixed media,
4′1″ x 3′10½″ x 5″ (126.4 x 118 x 12.7 cm).
Collection of the artist.

Dream it may have been, but Johns's *Flag* immediately found itself framed by and invested with a network of extra-personal meanings. It rested in precarious suspension between his own, predominantly gay circle of younger artists and the provincial America from which he came. At the same time, Johns was equally beholden to precedents laid down by the older painters of the New York School: there was virtually no way in which a new artist could handle pigment that did not invite comparison (usually negative) with some prior gesture by de Kooning (FIG. 10), Pollock, Franz Kline, Clyfford Still, or Philip Guston; they had mapped, it seemed, the entire available field of the expressive touch.

While more imitative artists faced this dilemma directly when they stood in front of their large canvases, loaded brush in hand, Johns came to invite these comparisons through a working procedure that was a world away from theirs. In fashioning, from oil and encaustic on fabric, the independent panel that became *Flag*, larger than the version inserted in Rauschenberg's *Short Circuit*, he retained his companion's commitment to collage arrangements from found materials while simultaneously reviving one of the oldest media available to the painter: encaustic, a technique of blending pigment into hot wax. It is in fact difficult to say exactly where collage ended and the act of painting began: each stripe, each star, and the blue field were individually cre-

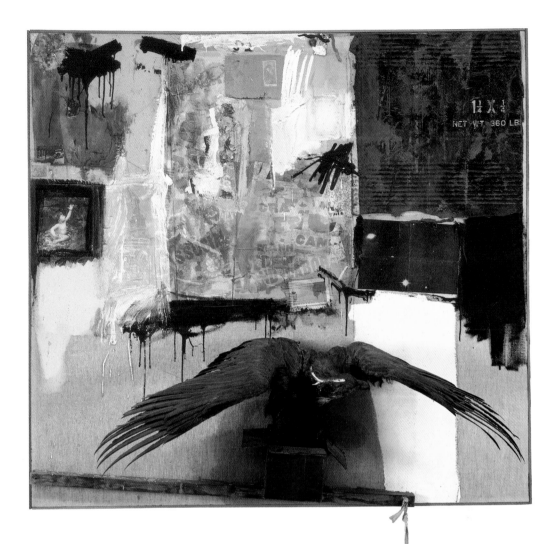

9. ROBERT RAUSCHENBERG
*Canyon*, 1959. Mixed media on canvas with assemblage,
7'4¹/₂" x 5'10¹/₂" x 23" (2.2 m x 1.8 m x 58 cm).
Sonnabend Collection, New York.

A stuffed eagle serving both as national symbol and as the
desiring god Zeus poised to abduct a boy, the cup-bearer
Ganymede (embodied in a collaged photograph of the
artist's infant son from his dissolved marriage).

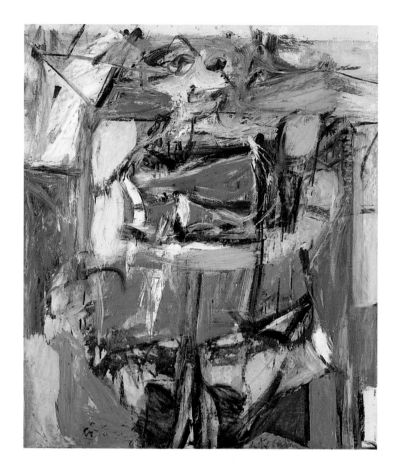

10. WILLEM DE KOONING
*Woman VI*, from the
*Woman* series, 1953. Oil
on canvas, 5'8¹/₂" x 4'10¹/₂"
(1.7 x 1.5 m). Carnegie
Museum of Art, Pittsburgh.

De Kooning worked on the
first of the *Woman* series
for nearly two years before
declaring it finished in
1952 (*Woman I*, now in the
Museum of Modern Art,
New York). This and the
canvases that followed
marked a disputed return
to undisguised figuration
within the Abstract
Expressionist circle (Jackson
Pollock had taken a similar
course in 1951). They
reveal De Kooning's
persistent attachment to
traditional studio
conventions, in this case
those of portraiture and the
female nude.

ated by assembling small pieces of newspaper dipped into wax of the appropriate hue and sealed in place on the underlying ground of thin fabric. The work was painstaking and repetitive; it was the making of a flag (normally stitched together from pieces of cloth of different colors) more than it was the representation of one, while the scraps of newsprint, visible through the surface of translucent wax, amounted to a grid of random paste-ups. But none of that literalness could prevent the drips, beads, and ripples of Johns's archaic medium from evoking – and neutralizing – the analogous effects seen so often in the impulsive painterly rhetoric of Abstract Expressionism.

Johns's modestly scaled pictures – his small range of motifs included targets, alphabets, and later numerals and maps (FIG. 11) – were not publicly exhibited in any numbers until 1958 with his first one-man show at the Leo Castelli Gallery; but when their moment arrived, the emotionally loaded gestures of his predecessors suddenly began to look grandiose and hollow to increasing numbers of viewers (three years before, Rauschen-

berg had created a ghostly work on paper by laboriously erasing a drawing by de Kooning). Johns's way with paint carried a visual seductiveness comparable to the richest surface of a contemporary de Kooning canvas, yet in *Flag* the frozen quality of the forms assumed by the cooling wax worked as a barrier rather than an invitation to emotional empathy. The promise of expressive revelation instead led the attentive viewer back to things known and seen on occasions beyond counting: in one direction to the small ads and trivia of newspaper back pages (there were no dramatic headlines in evidence) and in the other to the impassive completeness and self-sufficiency of a ubiquitous design from the world beyond fine art.

## Heartland

The board of New York's Museum of Modern Art at first rejected a public purchase of *Flag*, fearing that zealous American patriots might protest. The middle years of the 1950s indeed represented something of a peak in veneration of the American flag as a totem of nativist conformity, but Johns's version, for all of its eccentricity, offered little to any radicals hoping for open defiance by artists: overt disfiguration of the national symbol leaves its object as charged as any patriot might desire; Johns neutralized both the negative and positive authority of his motif as thoroughly as he stilled and contained the emotional dramatics of Abstract Expressionist technique.

The flag itself, however, could never be entirely neutralized, and the politics of the Cold War did not exhaust the contexts within which Johns's gesture might be meaningful. According to legend, the Stars and Stripes had begun life as an improvised

11. JASPER JOHNS
*Map*, 1962. Encaustic and collage on canvas, 6'6" x 10'3½" (1.9 x 3.1 m).
Mr and Mrs Frederick Wiseman Collection, Beverley Hills.

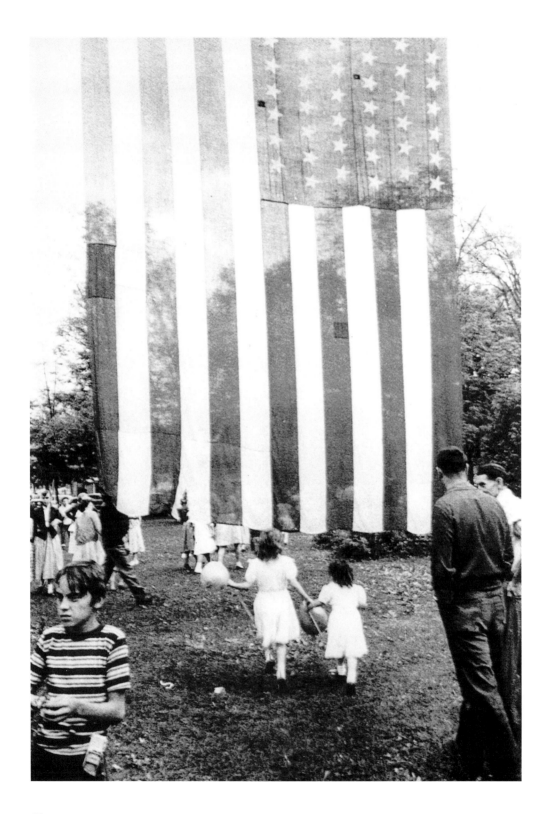

piece of handicraft by the Philadelphia seamstress Betsy Ross. The modest scale of Johns's work and his patient, unassuming methods lent to his objects the homely exoticism of folk art. In a rarefied metropolitan context long fixated on relations with Europe, the flag signaled the little-known expanse of the American continent. At the same moment, a number of New York writers and artists were seeing the path of discovery leading away from the psyche out toward an American hinterland.

Among visual artists, a genuine foreigner led the way in mapping that landscape. Robert Frank (b. 1924) had turned his back on his native Switzerland at the age of twenty-three to take up a commercial career in New York. From 1955 to 1956, with a Guggenheim fellowship to assist him financially, Frank set out on a tour of the United States, following no apparent plan, to compile a photographic record of his travels. Published in the United States in 1959 as *The Americans*, Frank's album of images (FIG. 12) offered a silent documentary that struck most viewers as a despondently nihilistic vision of the country, rendered with a technique indifferent to standards both of professional competence and aesthetic coherence.

In hindsight, there was little that was revolutionary about Frank's off-center compositions or carelessness with focus; both had been anticipated as calculated expressive devices in the work of earlier European photographers (the work was first published in Paris in 1958 as *Les Américains*). What made his collection a milestone was the application of these devices to a physical and social landscape that revealed itself as still raw, unfinished, and incoherent. The European observances of orthodox immigrant Jews (Frank's coreligionists) had to be seen in the company of an astonishing African-American ritual of dawn prayer, glimpsed near Baton Rouge, Louisiana, on the banks of the broad Mississippi. He allowed no single image to stand for its subject in a summary way; the rhythm and movement between the photographs carry less a mordant exposé than a recognition that a new symbolic vocabulary, embedded somewhere in the cheap, cast-off furniture of ordinary lives, had to be grasped on the run or not at all.

Frank's restless action aesthetic is stabilized by the repetition of a few strong motifs. One is the jukebox, which helps make the silence of photography feel like a sudden loss of hearing, a loading of all sensation into sight; its rows and columns of song choices – divided into elective categories of Pop, Jazz, Rhythm and Blues, Country and Western – render the panoply of popular culture into a stabilizing grid. Another motif is the grid-like pattern of the flag, which is never allowed to appear as

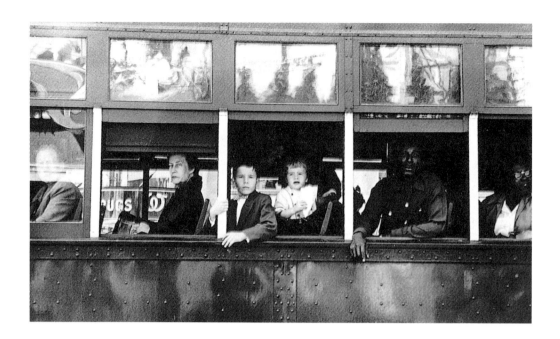

13. ROBERT FRANK
*Trolley - New Orleans,* from
*The Americans,* 1955-56.

such, but always assumes some functional identity, a thing among other things: as sheltering as a roof, as thin as the air . But the most emphatic grid stops the movement dead with the force of social revelation: in sequence, immediately after the gauzy flag of (white) Independence Day, comes the ordered symmetry of windows in a New Orleans streetcar (FIG. 13), the newly contested enormity of racial segregation in the South rendered as a tragic portrait gallery.

## West Coast Tincan Evening Sundown Vision

The convergence between approach and subject matter in Frank's *The Americans* underscored the irony of a self-consciously American avant-gardism restricted to the outlook of a narrow metropolitan community of artists clinging to the northeastern seaboard. When the book was accepted for American publication, Frank wanted an introduction from a native point of view; at a party in New York he found his writer in Jack Kerouac (1922-69), who had just published a record of his parallel cross-country journeys in *On the Road* (1957). That chronicle had been a decade in the making, a thinly veiled fiction laid over the restless wanderings of the author and his companions, who included the poet Allen Ginsberg (b. 1926) and an anarchic thrillseeker from Colorado named Neal Cassady (1926-68). Another New York friend, the Times Square hustler and sometime writer Herbert Huncke

(b. 1915), had taken to using the term "beat" to describe his generally beleaguered condition; for the others it served to describe their disaffection with the oppressively philistine cultural values prevailing in America and, paradoxically, a rebellious state of desire for new sources of excitement in both art and life, a secular beatitude. Kerouac and Frank went on to collaborate in making the consummate Beat Generation film, *Pull My Daisy* (1959), with the American painter Alfred Leslie (b. 1927), but this was not the writer's first encounter with a visual arts milieu, nor was New York the place where the vital cross-fertilization between artists and Beat writers began.

Painters and sculptors coming of age in California shared all of the marginalization experienced by Johns and Rauschenberg in New York, but they lacked any stable structure of galleries, patrons, and audiences that might have given them realistic hopes for worldly success. The small audience they did possess, particularly in San Francisco, tended to overlap with the one for experimental poetry, and in both the majority was made up of fellow practitioners. One couple, composed of a poet, Robert Duncan (1919-88), and the artist Jess (b. 1923), provided a focus for this interaction from the early 1950s. Duncan had distinguished himself in 1944 by publishing an article in the New York journal *Politics* entitled "The Homosexual in Society," in which he argued that gay writers owed it to themselves and their art to be open about their sexuality. For his courage, at a time when a fierce regime of discretion was enforced even in sophisticated circles, Duncan found himself barred from the *Kenyon Review*, the leading poetry magazine in the United States. He returned to his native California and did much to catalyze an underground creative community unconstrained by common prejudices, and not only in sexual matters.

14. JESS (BURGESS COLLINS) *The Mouse's Tale*, 1951-54. Collage and gouache on paper, 47 x 32" (119 x 81.2 cm). San Francisco Museum of Modern Art.

Jess, who had abandoned his family name as a gesture of liberation from a conservative suburban background, began as a student of Clyfford Still (1904-80), the heroically minded abstract painter, at art college in San Francisco. Alongside his own attempts in gestural, nonfigurative painting, Jess began in the early 1950s to work toward forbidden areas of reference, in collages drawn

from everyday vernacular sources. One of the earliest, *The Mouse's Tale* of 1951-54 (FIG. 14), conjures a Salvador Daliesque nude giant from several dozen male pin-ups. In a series of handmade books begun around the same time (FIG. 15), he rearranged into elliptical nonsequiturs one of the most widely read comic strips of the period, Chester Gould's *Dick Tracy*. That strip, though started in the 1930s in a crusading spirit against police corruption, had become an unwitting parody of the aggressively masculine, conformist, and technology-obsessed Americanism of the Cold War era; Jess's *Tricky Cad* (itself an anagram) rearranged the pieces of Gould's pulp fantasies to make that absurdism palpable.

California possessed one of the world's most extraordinary monuments to an assemblage aesthetic. The Watts Towers in south central Los Angeles (FIG. 16) were a fantastic, openwork palace constructed over three decades by the immigrant laborer Simon

15. JESS (BURGESS COLLINS) *Tricky Cad, Case I*, 1954. Notebook of 12 collages with handwritten title page and blank end pages, each collage 9½ x 7½" (24 x 19 cm). Odyssia Gallery, New York.

Rodia (1879-1965) from broken plates and bottles, shells and tiles, pressed into an armature of angle iron and concrete, extending more than ninety feet (30 m) high. Rodia's daring self-reliance and democratic aspiration helped a generation of professional artists see their mission differently from their East Coast counterparts. California artists, largely excluded from participation in any real art economy, were regularly drawn to the cheap disposability of collage and assemblage (much work in the period was never meant to be permanent). On a cognitive level, they exploited these means in order to make sense of their own marginality, recycling the discards of postwar affluence into defiantly deviant reconfigurations.

In the realm of sculpture, the assemblage mode rewarded the opportunistic skills of the wartime scrounger and handyman, who had transferred his talents into the California hot-rod

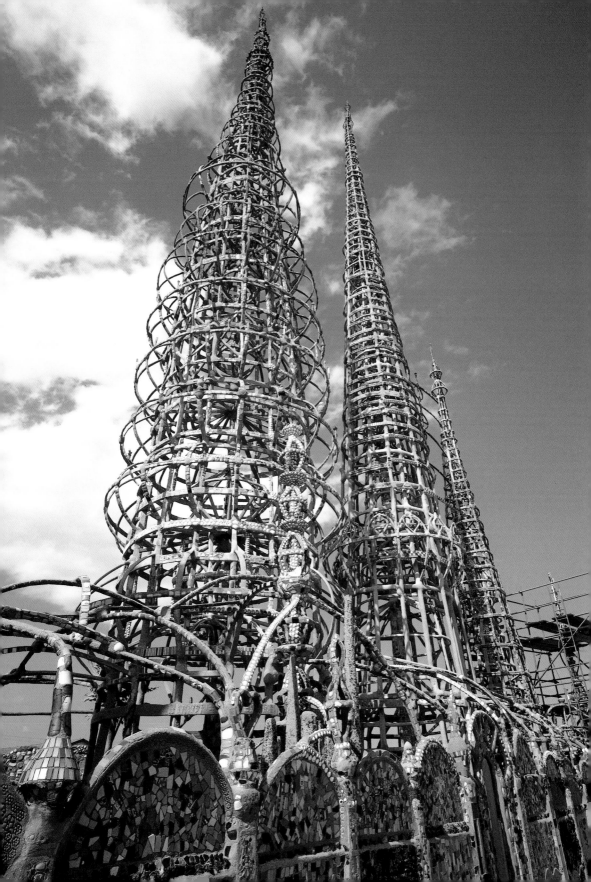

and motorcycle culture. The southern Californian Wally Hedrick (b. 1928) came directly out of the military and car culture, first glimpsing the liberating promise of San Francisco bohemia in the late 1940s, then moving to the city permanently after seeing combat in the Korean War (1950-53). He brought with him some earlier training in modernist graphic design and a commitment to the remnants of the left-wing populism once championed in California by the novelist Upton Sinclair. In 1953, one of the earliest paintings of his career as an artist (now lost) presented a crumpled American flag defaced with the heretical word peace: in contrast to Johns's anonymous stenciling, Hedrick mimicked the flamboyant calligraphy found in the decoration of hot-rod cars (pre-eminently in the freehand painting of cult pinstriper Von "Dutch" Holland); in contrast to Johns's reticence, he was aiming a deliberate protest at the waste of lives in Korea and at Cold War adventurism in general. And in 1959, again recalling his Asian military experience, he painted *Anger* (FIG. 17), a work that must count as the first artistic denunciation of American policy in Vietnam.

The pathos of Hedrick's situation was that few not already converted were ever likely to witness such gestures. The absence of a wider art culture alert to experimental new work invariably choked off promising developments or forced artists to rely on their inner resources alone. Over time, Jess gained a

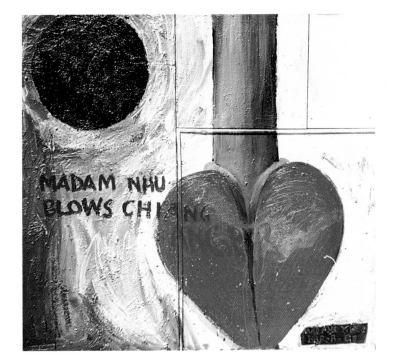

17. WALLY HEDRICK
*Anger* or *Madame Nhu's Bar-B-Q*, 1959. Oil on canvas, 5'5¾" x 5'5½" (1.6 x 1.6 m). Private collection.

At a time when there was little public awareness of American support for the corrupt regime in Saigon, Hedrick directs all his venom against Madame Nhu, notorious power-broker and sister-in-law to President Diem.

18. JAY DeFEO
*The Rose*, 1958-64. Oil on
canvas, 10'9" x 7'8" x 8"
(3.3 m x 2.3 m x 20 cm).
Collection of the estate of
Jay DeFeo.

When *The Rose* came to be
moved for exhibition in
1964, a window had to be
removed from the wall of
the studio so that the work
could be lowered by crane
to the street. Bruce Conner
made a film of the event
entitled *The White Rose,* to
which he added the subti-
tle, "Jay DeFeo's painting
removed by Angelic Hosts."

reputation as a virtual recluse. Jay DeFeo (1929-89), Hedrick's wife
during these years and an active painter and collagist, retreated for
six years into making a single work, a painting-turned-relief enti-
tled *The Rose* (or *Deathrose*; FIG. 18), which grew Rodia-like
into a behemoth weighing just under a ton (1000 kg), incorpo-
rating wood scraps, stones, beads, pearls, and wire suspended in
layers of housepaint.

Hedrick and DeFeo did not go entirely unrecognized out-
side of their immediate circle. In December 1959 both saw their
work included in a group showing, *Sixteen Americans* (includ-
ing Johns and Rauschenberg) at the Museum of Modern Art in
New York. Such token exceptions aside, however, their lives as
artists had of necessity revolved around what exhibiting oppor-
tunities they could create for themselves in San Francisco. In 1954

they had joined in opening the Six Gallery in a former car repair shop, a successor to the shortlived King Ubu Gallery begun by Duncan and Jess two years before and named for the absurd hero of Alfred Jarry's proto-Surrealist drama. Both spaces also served as scenes for poets' readings and performances, which attracted ample audiences. In 1955, Hedrick enlisted the young poet Michael McClure (b. 1932) to arrange a group reading to accompany a show of sculptures by Fred Martin (b. 1927); McClure in turn passed the job on to Allen Ginsberg, newly arrived from New York in the company of Jack Kerouac.

Five poets performed in the midst of Martin's throwaway works, described by McClure as "pieces of orange crates that had been swathed in muslin and dipped in plaster of Paris to make splintered, sweeping shapes like pieces of surrealist furniture." The reading of a single poet, however, overwhelmed all other recollections of the evening: the audience found itself experiencing the first public manifestation of Ginsberg's Beat epic *Howl*. One onlooker put the best description of the event in a letter:

> Hemmed in by a lot of insulting black blotches that kept getting torn off the walls, there was a fine big crowd, wine punch...a kind of Greek chorus by the name of Carrowac (sp?)...kept a kind of chanted, revival-meeting rhythm going. Ginsberg's main number was a long descriptive roster of our group, pessimistic dionysian young bohemians and their peculiar and horrible feats, leading up to a thrilling jeremiad at the end...people gasped and laughed and swayed, they were psychologically had...

The artists in attendance would have seen much of their own experiences affirmed in the poet's gospel of disaffection; Ginsberg's declared aim was to align poetic structure with the rhythms and diction of vernacular speech; the incantatory rhythm and intensity of his performance, borrowed from the call-and-response dialogues of jazz and the black church, responded to the range of their sympathies; even Ginsberg's endless clusters of substantives ("golden hairy naked accomplishment-bodies growing into mad black formal sunflowers in the sunset, spied on by our own eyes under the shadow of the mad locomotive riverbank sunset Frisco hilly tincan evening sundown vision") offered a direct analogue to the accumulations of objects and found materials in assemblage art. When *Howl* was brought out by a small San Francisco press, state authorities indicted the publisher for obscenity, which confirmed the Six Gallery artists in their righteous apartness from a repressive mainstream.

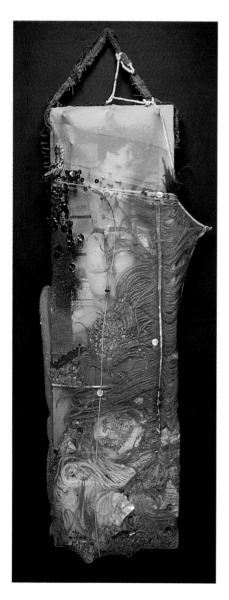

19. BRUCE CONNER
*Black Dahlia*, 1960. Mixed
media assemblage, 26³/₄ x
10³/₄ x 2³/₄″ (67.9 x 27.3 x
7 cm). Collection Walter
Hopps, Houston.

The prosecution was in the end unsuccessful, pointing up how difficult it would be to suppress dissenting literature in the light of American constitutional protections, and also demonstrating the relative advantage of words over unique visual objects. Both Ginsberg and Kerouac were soon to gain a considerable audience and see their art function in a wide variety of contexts. Only one San Francisco assemblage artist, Bruce Conner (b. 1933), managed to achieve even the tenuous link to the East Coast through consistent gallery representation in New York. He had been living there at the time of his first show in 1956, but the presence of McClure, with whom Conner had shared a small-town boyhood in the plains of Kansas, helped draw him to San Francisco the following year. The art he produced in the next few years underscores how decorous and discreet New York art remained in confronting the forbidden aspects of sexuality – it may have been the relative permissiveness of Californian bohemia that made Conner decide to move west. His heterosexuality gave him less reason to avoid self-disclosure than was then the case for many gay artists, but he did not for that reason shrink from exposing fascinations of his own, scandalous in the 1950s, for fetishism, pornography, and sexual violence. Conner's frank confessionalism recalls the self-lacerating autobiography of the eighteenth-century philosopher Jean-Jacques Rousseau and was likewise defended by a stated conviction that human beings were intrinsically good and that the varieties of debasement on constant view in the city were the result of a corrupting social regime. As Rousseau had done, he examined his own imagination to prove the case: *Black Dahlia* of 1960 (FIG. 19) was one in a group of constructions he called "rat bastards," the scabrous associations of the term borne out in both his choice of materials and the nauseated fury that radiates from them. Like the other works in the series, he used women's nylon stockings as his basic matrix and did everything possible to amplify their fetishistic and voyeuristic associations. His title evokes the horrifying and notoriously unsolved murder in 1947 of the would-be Hollywood actress Elisabeth Short (whom the press nicknamed the Black Dahlia for her very dark hair and habitually black clothes). The paraphernalia

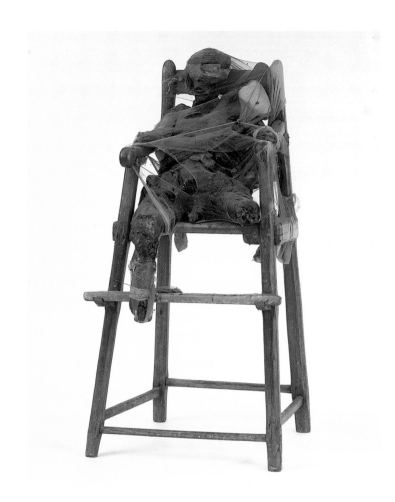

20. BRUCE CONNER
*The Child*, 1959-60.
Assemblage: was figure
with nylon, cloth, metal,
and twine in a high chair,
$34^{1}/_{2}$ x 17 x $16^{1}/_{2}$" (87.7 x
43.1 x 41.7 cm). Museum
of Modern Art, New York.

of enticement – peacock feathers, scraps of lace, sequins, a pattern for a death's-head tattoo, along with the miscellaneous flotsam of a crime scene – appear to settle downwards from the encased nude torso, simultaneously the instruments of its degradation in life and the gruesome products of its post-mortem decay.

The persuasiveness of the piece depends upon the viewer believing that the victimization of women, rather than the woman herself, is the object of Conner's assault. The year before, however, Conner had used similar means to raise a protest of unambiguous principle against a more public horror which might then have been averted. For more than ten years, Caryl Chessman, imprisoned at San Quentin on San Francisco Bay, had been fighting a sentence of death. Intelligent and articulate in his defense against a questionable conviction for sex crimes, Chessman's cause had galvanized an international campaign against the death penalty. Using a cast-off high chair as a support, Conner began sculpting

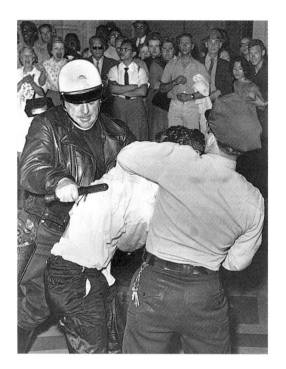

21. Demonstrations against the House Un-American Activities Committee, San Francisco, 1960.

an agonized stand-in for Chessman out of black wax, a figure that transformed itself as he worked into a mutilated child, gagged and bound with torn nylon (FIG. 20). For once, such a gesture had an immediate public impact, sending visitors away horrified from the 1959 annual exhibition of the San Francisco Art Association.

Conner's impulses as an artist converged with a political climate that distinguished his chosen community from the rest of the country. In May 1960, Chessman was finally executed after a signal failure of courage on the part of California's liberal governor Edmund Brown senior; thousands of students joined the mass protest at the prison; two months later many of the same students were among the 2,000 demonstrating against hearings in San Francisco by the Un-American Activities Committee of the United States Congress, which had for more than a decade relentlessly used its powers of subpoena to hound deviants from antisocialist orthodoxy, ruining careers, and jailing some witnesses on contrived charges of perjury and contempt of Congress. In a confrontation that turned the event into "Black Friday," 200 were beaten by police on the steps of the City Hall (FIG. 21); the next day 5000 demonstrators assembled . The libertarian values fostered through the 1950s within the small, beleaguered community of California bohemians had found a far larger constituency in the incipient New Left based in the universities, with exponential repercussions to come across the rest of the country and the world.

## New York Happenings

On the eastern seaboard, the political temperature of the art scene remained distinctly lower. The nearer horizons of the art world itself were so much in evidence that artistic ambitions did not so easily pass to the farther shores of social dissent. This applied as much to those younger artists active in the alternative scene as to those already incorporated into the established gallery network.

The cooperative Hansa Gallery began life in 1952, the same year that Jess and Robert Duncan had opened the King Ubu Gallery in San Francisco. In 1958, the dominant emerging per-

sonality of the Hansa group, Allan Kaprow (b. 1927), organized an environmental installation that he hoped would point the way to a new form of "total art." The commonness and informality of his materials resembled the scavenged detritus of Conner, while the ephemerality of their arrangement and the participatory aesthetic recalled the Beat cult of spontaneity (in that same year Robert Frank had taken a group portrait of the Hansa artists). Kaprow fashioned the interior into a sensory obstacle course – rattan nets, lights from hanging cords, mirror fragments and foil, taped sounds of sirens and doorbells, pungent chemical odor – intended to draw the visitor into completing the work through an unpredictable series of encounters over time. But he was at the same time careful, in a way that marks the distance between the two coasts, to ground his experiment in the most secure artistic precedent available to him.

Shortly before fashioning the Hansa installation, Kaprow published an essay in the journal *Artnews*, then the bible of the Abstract Expressionist sensibility, entitled "The Legacy of Jackson Pollock." Concluding a series of acute and timely observations, he laid claim to that legacy by declaring that Pollock's unorthodox materials and expansive movement over his horizontal canvases forced his successors to leave the boundaries of painting altogether:

> We must become preoccupied with and even dazzled by the space and objects of our everyday life, either our bodies, clothes, rooms, or, if need by, the vastness of Forty-Second Street…entirely unheard of happenings and events, found in garbage cans, police files, hotel lobbies; seen in store windows and on the streets, and sensed in dreams and horrible accidents.

In this spirit, he spoke admiringly of Pollock's crudeness, "unsullied by training, trade secrets, finesse." That judgment was in fact manifestly untrue, an expedient repetition of the simplest media myths of the artist. And Kaprow was careful not to forswear the benefits of his own extensive education, insider status, and refined sensibility. In 1959, he staged his next orchestrated event, entitled *18 Happenings in 6 Parts*, within a strict set of rectangular spatial frames (see FIG. 4). *18 Happenings* followed a scenario of disconnected actions and startling disruptions on the basis of chance; but once the script was in place Kaprow's participants were constrained to adhere to it. The place of the audience, which shifted its seated position three times, was equally determined in advance. As a final element, he assembled a crowd of art-world luminaries, effecting the singular coup of enlisting

Johns and Rauschenberg to create a joint painting on a wall of translucent plastic.

Fresh in everyone's mind was the arresting success early in 1958 of Johns's first show at Leo Castelli's new gallery, from which no less than four works were sold directly to the Museum of Modern Art; moves outside the established consensus no longer meant inevitable marginality. A larger group of artists soon helped secure the status of confrontational, non-narrative theater as a recognized option for visual artists. Two who took a lead in this, Red Grooms (b. 1937) and Jim Dine (b. 1935), favored a more energetic, farcical style played out against elaborate pictorial props and sets. The developing imagery of Happenings was largely drawn from the urban surroundings evoked by Kaprow in his eulogy of Pollock, but exuberant painted and sculpted caricatures stood in for the actual stuff of the streets.

Grooms and his improvised City Gallery helped draw the somewhat older Claes Oldenburg (b. 1929) into the Happenings orbit. A Yale graduate, the son of a Swedish diplomat, Oldenburg had acquired some training and facility in a comic mode of figurative drawing in the family's adopted home of Chicago, but he had as yet gained no access to a fine art career in New York. By 1959, he and some friends established a free gallery space in the Judson Memorial Church, a progressive Baptist congregation in Greenwich Village seeking to expand its ministry to include the surrounding community of artists, performers, and writers. In that space, he first conceived an enveloping three-dimensional mural, composed out of large cardboard cut-outs patterned from his caricatural drawings. Entitled *The Street* (FIG. 22) and opened early in 1960, the scorched, crudely fashioned props and figures were intended to evoke the abrasive but vivid life of the poor neighborhoods fringing the Village proper, where he and his close colleagues lived and worked. Combining environment and event, the *Street* installation was the scene of a Happening tailored to its imagery, *Snapshots from the City*, which unfolded in a series of thirty-two individual tableaux suddenly emerging from darkness and just as quickly blacked out.

Looking back on this sequence of work, Oldenburg described himself as "a sensitive person" coming to grips "with the landscape of the city, with the dirt of the city, and the accidental possibilities of the city." That sensitivity required some protection, and this he derived from an invented alter ego, "Ray Gun" (whose initials duplicate those of his antic mentor Red Grooms), conjured into existence through portraits and invented sayings. Ray Gun was both the possessor and embodiment of the fantastic weapon

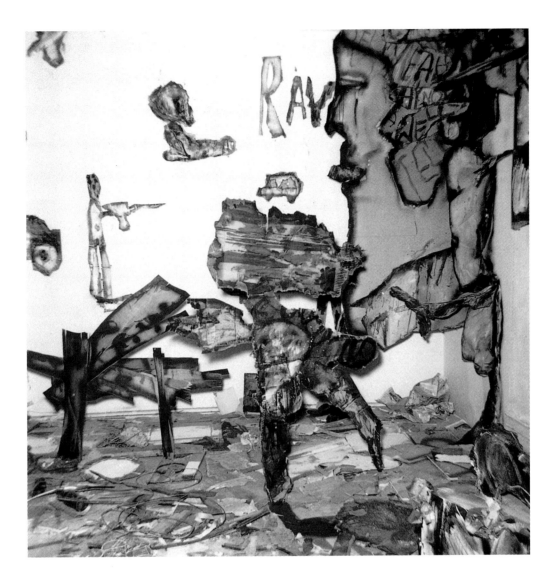

22. CLAES OLDENBURG
View of *The Street*, installed
at the Judson Gallery, New
York, 1960.

(and child's toy) evoked by his name; as priapic trickster and mock hero, he boasts of a freedom and mastery achieved through a clownish submission to the spectacle of urban squalor.

There was an immediate precedent for this sort of maneuver, one that had generated considerable notoriety. In his essay "The White Negro" of 1957, the novelist Norman Mailer (b. 1923) had also sought to renew his artistic resources by submerging his cultivated artistic identity in a fantasized, street-life persona. The Harvard-educated writer boasted of his understanding and identification with the borderline criminal underground of white hipsters, "urban adventurers who drifted out at night looking for action with a black man's code to fit their facts." Plainly

anxious to counter the sudden glamor achieved by the younger Beat writers, he gathered to himself their longstanding familiarity with such figures as the renowned underground hipster Herbert Huncke, along with Kerouac's notable fan's expertise in Bebop jazz, William Burroughs's driven immersion in the drug culture, and Neal Cassady's bisexual charisma. Mailer's ambition was to stake out his own more advanced position alongside the African American as ultimate outsider; his method was to subsume – with the breathtaking arrogance of an urban sophisticate yet to comprehend the civil rights movement – the experience of all blacks into the identity of the Harlem hustler. In Mailer's narrowly sexual version of liberation, the enviable character of "the Negro" was reduced to pure bodily libido.

Oldenburg, having started down the road of outlaw fantasy in his Ray Gun character, shortly afterward turned his invented persona toward activities that he himself could embody with greater credibility. In 1961, he set up his own semi-permanent, low-key Happening, the "Ray Gun Manufacturing Company," in an ordinary neighborhood storefront on the Lower East Side of Manhattan. There the visitor could buy, for nominal prices, the artist's simulations of commonplace goods and foodstuffs, ungainly painted constructions fashioned on the premises from muslin soaked in plaster over wire frames (FIG. 23). His enterprise effected a deft confusion between fine art and ordinary work, between the mystifying value-creation of the art market and the realities of neighborhood commerce, between the studio as a place of production and the gallery as a point of display and consumption. At the same time, however, it had the further effect of domesticating the impermanent props and litter of the Happenings into objects that could be, with whatever irony, sold and displayed as easily as any other work of art.

Ever cognizant of his antecedents, Oldenburg produced in 1960 and 1961 a series of American flags in a variety of materials, including a clumsily miniaturized Store version with just six stars and nine stripes (FIG. 24). The contained dignity of Johns's *Flag* of

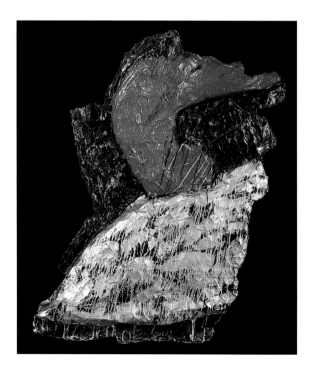

23. CLAES OLDENBURG
*Iron Fragment,* 1961. Muslin soaked in plaster over wire frame, painted with enamel, 6'6" x 3'8" x 8" (1.6 m x 1.1 m x 20.3 cm). The Chrysler Museum, Norfolk, Virginia.

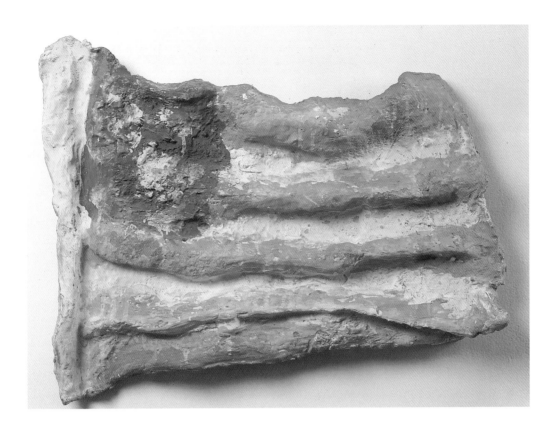

1955, having passed through the Happenings crucible, emerged as something gauche, worn, and childish. Detached from their productive context, Oldenburg's objects manifest a paradox: that an art so often described as an aggressively up-to-date response to the brave new world of postwar prosperity more often conjures up instead a bygone childhood of the Great Depression and wartime. This disparity had already been marked in the earlier development of a Pop art in Great Britain, where the term itself was coined. Nor was this the end of the European anticipations and parallels to be recovered in the next chapter.

24. CLAES OLDENBURG
*U.S.A. Flag*, 1960.
Muslin soaked in plaster over wire frame, painted with tempera, 24 x 30 x 3¹/₂″ (61 x 76.2 x 8.9 cm).
Collection Claes Oldenburg and Coosje van Bruggen, New York.

# TWO

# *Consumers and Spectators*

V iewed from an international perspective, American artists were slow to capitalize on their own vernacular culture of advertising, film, and mass consumer production. The outmoded material that Claes Oldenburg began to exploit in 1961 had in fact been seized on by British artists when it was sparklingly new. In the British economy of the 1950s, still beset by austerity and rationing, where the state was deliberately suppressing consumption in favor of rebuilding through exports, a culture of poverty offered no exotic excitement. For the Scottish artist Eduardo Paolozzi (b. 1924), the most ordinary American articles possessed a subversive glamor. An obsessive collector of imported American magazines, he produced an extensive number of collage compositions from their pages, beginning in the early years of postwar reconstruction. *It's a Psychological Fact Pleasure Helps Your Disposition* of 1948 (FIG. 25) presents a familiar European attitude toward the shallow contentment and fixation on hygiene disdainfully ascribed to Americans; but Paolozzi's title also contains a protest against coerced deprivation, which withheld from Britain's working classes the freedom from drudgery and the sensual excitement that seemed to be nearly universal across the Atlantic.

False as that picture may have been to the facts of economic and racial inequality in the United States, it gained a measure of truth in a British context, particularly as an alternative to an

25. Eduardo Paolozzi
*It's a Psychological Fact Pleasure Helps Your Disposition*, 1948.
Mixed media on paper,
14¼ x 9½" (36.2 x 24.4 cm).
Tate Gallery, London.

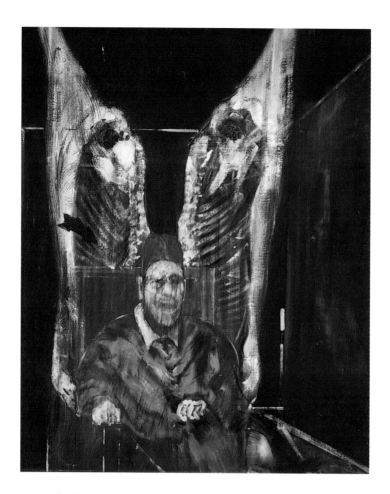

26. FRANCIS BACON
*Head Surrounded by
Sides of Beef (Study
after Velazquez)*, 1954.
Oil on canvas, 4'3" x4'
(130 x 122 cm).
Art Institute of Chicago.

endemically genteel, snobbish, and unadventurous artistic culture. Protest against that culture gave rise to the first recorded uses of the term "Pop Art," (by the artist Richard Hamilton and the critic Lawrence Alloway) to name the aesthetic challenge to Europe posed by American industrial culture – by the flamboyance of Detroit automobiles or the engineer's streamlined utopias found in science fiction illustrations and films. This vision – though naive in retrospect – united an innovative collection of artists, architects, and writers who opposed themselves to a narrow art of neo-Romantic longing promoted by an elite educated in the ancient universities. They took equal distance from the expressionistic example established by Francis Bacon (1909-92), who in their eyes perpetuated an obsolete art of agonized private experience, tied to the antiquated regimes of European power, and fixated on traumatic memories of the Second World War (FIG. 26).

It was not long, however, before the term Pop came to describe various kinds of work conducted in a fine-art context if not accord-

**Opposite**
27. PETER BLAKE
*On the Balcony*, 1955-57.
Oil on canvas, 47³/4 x 35¹/4"
(121.3 x 90.8 cm).
Tate Gallery, London.

28. Alison and Peter Smithson
*Golden Lane City, Great Britain*, drawing and collage, 1952. Drawing and collage with Joe DiMaggio and Marilyn Monroe, 20½ x 38″ (52 x 97.5 cm). Collection Centre Georges Pompidou, Paris.

Joe DiMaggio and Marilyn Monroe were at that moment pursuing a romance, hounded by the press, that culminated in their short-lived marriage. While Monroe was at the beginning of her international celebrity, DiMaggio, star hitter and outfielder for the New York Yankees baseball team, played in a sport with no following whatsoever in England. His Italian background made him a pure symbol of classless glamor and success.

ing to traditionally fine-art criteria. The British precursors to the international movement of the 1960s tended to divide themselves into two types. Peter Blake (b. 1932) began very early with an incorporation of motifs celebrating modest, everyday diversions (FIG. 27): the cult of the British royal family, children's cartoon newspapers, wrestlers outfitted with eccentric names and costumes. That insularity – expressed through traditional easel painting – was not so far from a traditional romance of the English landscape, precisely the sensibility that Paolozzi and Alloway were determined to counter. In 1952, they and a like-minded group of allies formed a loose association within the London Institute of Contemporary Art (ICA), then a bastion of domesticated French Surrealism. The Independent Group, as they came to call themselves, refused to recognize the normal confines of fine art; the group included the architects Alison Smithson (1928-94) and Peter

Smithson (b. 1923) along with the historian of architecture Reyner Banham (1922-88); their discussions accommodated Paolozzi's and Alloway's enthusiasm for American commercial culture alongside the harder matters of how the city's aging and battered fabric could be transformed without violating the actual networks of signs and everyday habits created by its inhabitants.

## London Calling

The Smithsons, who saw their project as one of integrating the clarity of modern industrial design with the unpredictability of human accident and desire, had taken their first inspiration from the all-over gestures in Jackson Pollock's paintings (see FIG. 3). Along with the artists and critics in their circle, they had assembled a working knowledge of large-scale American abstraction

at the beginning of the 1950s, long before it had been triumphantly promoted abroad by the American government at the end of the decade; moreover, they interpreted that knowledge in ways that ran contrary to the dominant critical orthodoxies developing on the other side of the Atlantic. To them, the sheer physical impact of the canvases on them invited comparisons with the cinema screen or with the architectural environment; likewise, the gestural expansiveness of American techniques seemed potentially to radiate beyond the canvas. As a framework for understanding the lessons of the New York School, the emerging London view was founded in the sort of polemic against the immaculate, gallery-bound object not voiced in New York until Kaprow's "The Legacy of Jackson Pollock" was published in *Artnews* in 1958.

In their proposal of 1952 for the Golden Lane housing estate (FIG. 28) the Smithsons had combined perspective renderings of the structure with cut-outs from photographs and magazines intended to convey the vernacular fabric – from the surrounding buildings to an image of Marilyn Monroe and the baseball star Joe DiMaggio – to be condensed and reflected in their design. Although entirely serious in their architectural purpose, the effort of imagination contained in them is close to the contemporary collages of Paolozzi, their friend and working partner. All three participated in the large group exhibition of 1956, *This Is Tomorrow*, at the Whitechapel Gallery, the most public venue for the Independent Group's impatience with divisions between the creative media and the professional forms of visual knowledge: painting, sculpture, architecture, and design. The installation of the show was broken down into twelve groups within which there was no hierarchy of artist, designer, and even critic. The task of the visitor was to sort out a mass of competing signs in his or her physical passage through the environment (this two years in advance of Kaprow's first Happening installation in New York). Each of the groups even designed its own advertisement, and the one created by artist Richard Hamilton (b. 1922) has since come largely to eclipse most of the exhibition's actual content.

In some respects, Hamilton's collage (FIG. 29) offered itself as a parody of the Smithsons' attempts to integrate "found" culture into an unimpeded rationalization of urban housing on principles of structural and economic efficiency. The question that forms its title, *Just what is it that makes today's homes so different, so appealing?*, sneers at the idea that mass-produced possessions and manufactured dreams under the Ford insignia can provide adequate subjective furniture for postwar life: inflation – of muscles, breasts, the impossible extension of a vacuum cleaner hose – is the ruling

order; the window opens onto America's racial hypocrisy in the shape of an advertisement for the blackface mimicry of the singer Al Jolson. But Hamilton, who had a substantial earlier career as an industrial draftsman behind him, was no simple critic of popular culture in the age of mass consumption. His enthusiasm is unmistakable in a list he offered (in a letter to the Smithsons) as his definition of Pop art: "Popular (designed for a mass audience)/Transient (short-term solution)/Expendable (easily forgotten)/Low cost/Mass produced/Young (aimed at youth)/Witty/Sexy/Gimmicky/Glamorous/Big Business..." Jolson's *The Jazz Singer*; produced in 1927 as the first sound film,

29. RICHARD HAMILTON
*Just what is it that makes today's homes so different, so appealing?*, 1956. Collage on paper, 10¹/₄ x 9³/₄" (26 x 25 cm). Kunsthalle Tübingen.

**Above and right**

30. *This is Tomorrow* exhibition at the
Whitechapel Art Gallery, London, 1956.
Group 2 installations (works by Richard
Hamilton, John McHale, and John
Voelker).

is a dawn breaking outside the consumer's interior garden of ephemeral pleasure. Charles Atlas, the model body builder of comic-book back pages, is the naked Adam to the Eve of the pulp pin-up.

The theme of a new Eden and the human race reduced to an elemental pair was common in the science fiction of the time, in both utopian and catastrophic variants. In their contribution to *This Is Tomorrow*, the Smithsons and Paolozzi obliged the second with a primitivized, post-apocalyptic backyard shed, while Hamilton and his collaborators opted for a contemporary garden of delights (FIG. 30); visitors were treated to a funhouse corridor of disorienting optical patterns, surrounded by blown-up, CinemaScope collages of mass-media icons. In this garden, Robbie, the user-friendly film robot from *Forbidden Planet*, stood in for the primal male, alongside the figure of Marilyn Monroe, posed in a still from the pavement grating scene in the film *The Seven Year Itch*, another alluring Hollywood import. The movement from poster to display underscored the endless disposability of the commercial symbols to which, like it or not, the laws of human desire would henceforth be held hostage.

## Europe: the Anti-Consumers

By the later 1950s it was becoming difficult to discern the critical dimension of the Independent Group's "aesthetics of plenty" (to use Alloway's favored term). The economic austerity of the immediately postwar years in Britain had already given way to an intense development of the internal consumer market as the key to continuing electoral success for Prime Minister Harold Macmillan's Conservative Party government, in power from 1957 to 1963. The artists' finely balanced ambivalence toward manufactured culture was overtaken by a political aesthetics of plenty, a promise of abundance, loudly proclaimed by the state.

The theoretical capacity of British art practice was not at this point developed enough for any strong voice to be raised against this convergence. The same could be said for America, where McCarthyism had largely silenced the Left in the early 1950s, when Senator Joseph McCarthy led witchhunts against thousands suspected of Communist sympathies. Such a voice would have to emerge from continental Europe, where more powerful Marxian traditions engendered uncompromising suspicion of the promises lodged in capitalist commodities. Those traditions also had the effect – in the realms of both politics and art – of generating a continual parade of minuscule radical groupings, announc-

31. ASGER JORN
*Opus 2, On the Silent Myth*, 1952. Oil on masonite, 4'5" x 9'10" (1.3 x 3 m). Silkeborg Bibliotek, Denmark.

The CoBrA group included Jorn from Denmark, Karel Appel, Corneille, and Constant (as the latter two artists called themselves) from the Netherlands, and Christian Dotrement from Belgium. Dotrement, a poet and writer, served as publicist and editor of CoBrA's journal. Apart from their political convictions and clashes with orthodox Surrealists, CoBrA artists distinguished themselves by pioneering, in the late 1940s, a counter-cultural mode of life. Its members led a nomadic existence, periodically banding together with their families in shared living and working spaces, where they collaborated on artistic projects intended to dissolve the individual creative ego within communal forms of expression.

ing themselves with grandiose manifestos and anathematizing rivals for the slightest doctrinal differences. Most passed out of existence with few beyond their members noticing their passing; only a handful, like André Breton's Surrealists of the 1920s and 1930s, achieved genuine staying power and any wide influence.

For the art world in the first decade after the war, the CoBrA group of artists (the acronym standing for their origins in Copenhagen, Brussels, and Amsterdam) had set an ideological example by returning to the early Surrealist equation between artistic and social emancipation, including commitment to a Communist revolution. In a litany familiar from a number of earlier avant-gardes, their 1948 manifesto declared that the mission of the liberated artist was to manifest an exceptional, untrammeled spontaneity: the creative potential of the masses, deadened by conventional, bourgeois culture, would "be stimulated by an art which does not define but suggests, ...creating a new and fantastic way of seeing," a prelude to the collective apprehension of new polit-

ical possibilities. Any enactment of this program, however, was beset by two problems, one familiar and the other a novelty of the 1950s. The first was the endemic hostility of the official Communist parties in the West, as they consolidated themselves after the war, to undisciplined experiment, even in the realm of art; the second was the increasing international prominence of the New York School artists, whose expansively gestural painting resembled the loose, primitivizing figuration favored within the CoBrA group (FIG. 31). The Europeans thus found their aesthetic resources transformed into at least a tacit affirmation of American economic and military dominance.

In part for want of alternative means to express its ideal of revolutionary creativity, CoBrA had dissolved itself in 1951. Its most energetic participant, the Danish painter Asger Jorn, remained determined to find new paths toward the same ends within another international network of collaboration. In 1954, with the artist Enrico Baj (b. 1924), he was briefly associated with a European

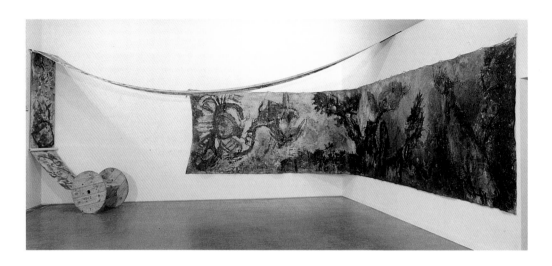

32. GHISEPPE PINOT-GALLIZIO, *Le Temple des Mécréants,* 1959. Oil on canvas environment. Installation at the Centre Georges Pompidou, Paris, 1989.

revival of the Bauhaus – the prewar German institute founded in 1919 with the Weimar ideal of integrating the fine arts with industrial technology – but quickly broke away from a project that seemed to him a further rationalization of capitalist efficiency and social control. Instead, in the same year he declared himself to represent a new entity, grandly titled the International Movement for an Imaginist Bauhaus, the scope of which was to move beyond the exhausted confines of painting into architecture and urban design.

Ever on the lookout for cheap, sympathetic surroundings, Jorn found himself in Italy in 1955 and discovered a ready ally in Giuseppe Pinot-Gallizio (1902-64). Occupying a disused monastery in Pinot-Gallizio's home town of Alba, the two created an experimental laboratory for unconventional departures from artistic norms. Pinot-Gallizio had been an antifascist partisan in the Second World War and combined that political credential with a background in industrial chemistry. He directed both his populist aspirations and scientific skills to the invention of new painting techniques, involving sprays and resins, generating imaginative designs on a massive scale and with seemingly endless productivity; by 1959 he was either selling his output by the yard (FIG. 32) or building the expanses of canvas, some sheets of which extended 145 yards (132 m) into enveloping environments.

For his part, Jorn absorbed the lessons of the American overtaking of CoBrA abstraction by seeking in turn to appropriate an existing body of art for his own transgressive purposes. Borrowing a device from his friend Baj (and duplicating the experiments of Jess in San Francisco), he began in 1959 to paint over naive

naturalist canvases, scavenged in flea markets, to create hybrid works he termed *Modifications* (see FIG. 1). Like Jess (who used the term "salvage"), Jorn saw his intervention as giving life to something congealed and dead in its conformism; but this tactic also conjured up the impasse of Leftist culture; the sophisticated primitivism of Jorn's scrawls and drips addressed the naive accomplishment of the underlying image without finding a bridge between them, that is, without figuring the possible engagement between a self-appointed vanguard of revolution and a popular political base.

Such a link had become increasingly doubtful since the first years after the war when CoBrA had been formed. At that time continental Europe had been suffering enormous privation as the destruction and dislocations of wartime took their toll. Restored parliamentary institutions from the prewar period were shaky: Italy had to reinvent some form of democracy after decades of Fascist rule; Germany and Austria were divided and ruled by the occupying powers, and Communist regimes had been installed by the Soviet Union across eastern and central Europe. With huge unmet social needs and new freedom to manifest discontent, revolutionary Leftist political changes seemed within reach. By the mid-1950s, however, those conditions had been fundamentally transformed. The cash and stimulus to organization provided by the Americans' Marshall Plan of 1948-52 had propelled record levels of production and economic growth on the Continent. The promise of enhanced levels of personal consumption for the general population was a crucial arm of the "Western" confrontation with Communism (FIG. 33), and rapidly increasing access to decent housing, appliances, automobiles, travel, and entertainments appeared to be making the promise good.

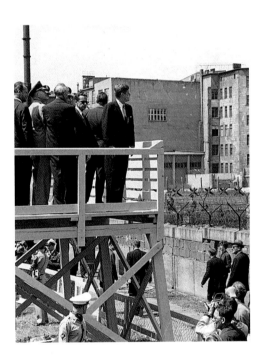

33. President Kennedy in West Berlin, June 1963, looking over the Wall into the East.

Prospective revolutionaries thus had to counter the threat to their following from the pleasures of capitalism as much as they did any overt form of oppression. The activities of the Alba laboratory attracted the attention of a small Leftist faction from Paris which, like Jorn, brooked no illusions about the immense task of political transformation under a triumphant economy of personal consumption. The view of the Lettrist International (a secretive Parisian collective, active since 1953 and largely composed

of Guy-Ernst Debord, Michelle Bernstein, and Gil J. Wolman) was that consumption itself would have to be altered. They accepted no separation between politics and culture (including art): political action had to occupy the terrain of everyday life. If the modern individual had come to consume his or her life rather than live it, then revolutionaries were obliged to intervene in that process (they called this *détournement*), seizing ordinary goods and manufactured experiences and somehow turning them against the requirements of the system. Their own everyday lives were to be themselves transformed, following the dictates of play and desire, to forge new paths through the city, confounding the routine, deadening routes to which its inhabitants are condemned (they called this the *dérive*). Their ultimate aim was to expand the traditionally festive "world turned upside down" and make it a permanent condition of life. Attentive to the findings of anthropology and grasping for alternatives to the programmed acquisitiveness of modern capitalism, the Lettrists named their journal *Potlatch* after the status ceremony of the Native American Kwakiutl people, whose leaders vied with one another in giving away their valuables, even destroying them in what the Lettrists saw as gestures of conspicuous disdain for possessions.

Jorn's *Modifications* and the ultra-abundance of Pinot-Gallizio's environmental painting offered attractive experimental substance for these Lettrist positions, and the two artists had between them decades of experience in fighting from the cultural margins. The result was an alliance forged at an unnoticed "World Congress" in 1957 and consolidated in the following year as the Situationist International. The Parisians, literary and philosophical in their training, were still foundering on shoals of abstract terminology ("constructed situation: A moment of life concretely and deliberately constructed by the collective organization of a unitary ambience and game of events," ran one of Debord's tautological definitions); the visual skills of their allies enabled more persuasive forms of communication. In 1959, Jorn collaborated with Debord on a remarkable memoir of the Lettrists, where his free gestural networks of ink allowed the younger thinker to assemble a history from the compellingly concrete remnants of experience (FIG.

34. ASGER JORN AND GUY-ERNST DEBORD Page from *Mémoires*. Oil, ink, and collage on paper, 10¹/₂ x 8¹/₂" (27.5 x 21.6 cm). Centre Georges Pompidou, Paris.

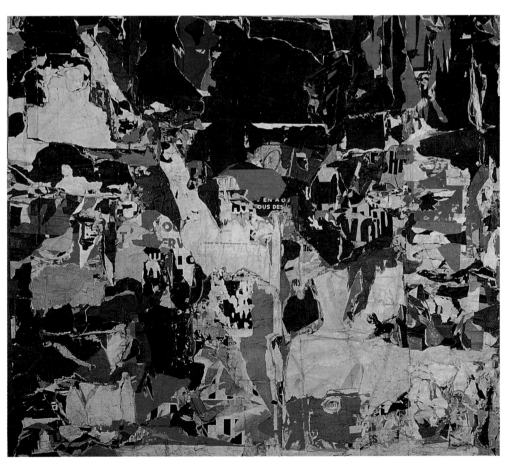

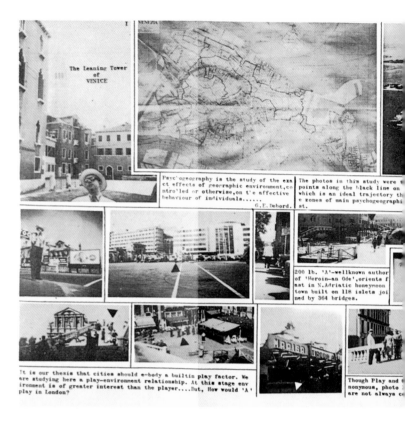

34). But this period of cooperation between art and militant theory did not last beyond 1960, when every artist was either ruthlessly "excluded" from the group (which meant an absolute ban on communication) or left voluntarily. The Situationists (for Debord and company retained the name) carried on, the Parisians enforcing undeviating commitment in terms defined by themselves, enhanced in ideas, visibility, and glamor by their brief alliance with art but unable to tolerate its untidy requirements.

The retrospective prestige enjoyed by Debord's Situationists, largely conferred by their new host body in the French student movement of the 1960s, has obscured the parallel recognitions of many other figures around this time, including artists with no link to the group. The most noteworthy of these were the Italian Mimmo Rotella (b. 1918), and the French Raymond Hains (b. 1926) and Jacques de la Villeglé (b. 1926), whose shared practice came under the heading of *décollage* or "anonymous lacerations." Like the Lettrists/Situationists, they consumed the city in a playful, antiproductive manner derived from Surrealism. Their particular method was to follow the trail of vandals defacing the advertising hoardings that occupied nearly every unused surface. The

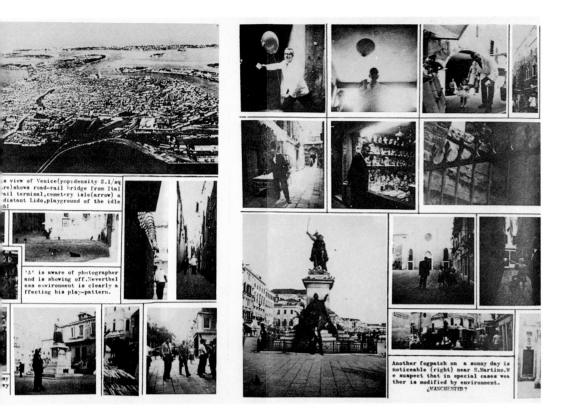

Within the collage, captions read:

a view of Venice(pop:density 2,1/sq
.re)shows road-rail bridge from Ital
.il terminal,cemetery isle(arrow) a
distant Lido,playground of the idle
.h!

'A' is aware of photographer
and is showing off.Neverthel
ess environment is clearly a
ffecting his play-pattern.

Another fogpatch on a sunny day is
noticeable (right) near S.Martino.W
e suspect that in special cases wea
ther is modified by environment.
¿MANCHESTER?

torn-away patches revealed the remnants of previous posters and handbills, which had themselves invariably been lacerated before the latest ephemeral enticement was pasted in place. Their pictorial discoveries were endless, from anti-American protest making pointed use of a Johnsian flag (FIG. 35) to all-over abstractions of extraordinary late-Cubist complexity (FIG. 36). All the artist had to do was select a composition and remove it; the deep subversiveness of the project lay in the fact that no singularly privileged individual could take credit for the fashioning of the work; each *affiche lacérée* served as witness to the creative potential of the *dérive*: in Villeglé's words, "The gestural savagery of a multitude is individualized to become the most remarkable manifestation of 'art made by all and not by one' of this period."

## Situated Painting

There was one British participant in the founding of the Situationist International: Ralph Rumney (b. 1934) had been moving about continental Europe for some years avoiding conscription in Britain, eventually finding a base in Venice through his

37. RALPH RUMNEY
*Psychogeography of Venice* *("Leaning Tower of Venice").* Photocollage, *Ark* magazine (Royal College of Art), no. 24, 1958.

marriage to Pegeen Guggenheim, daughter of Peggy Guggenheim, the famous American heiress and art collector. Attracted to the orbit of the Alba laboratory, he presented himself at the founding conference as the delegate from the "London Psychogeographic Committee." In the brief burst of artistic energy that came after, he staged his own *dérive* through the passageways and bridges of Venice, following the unpredictable wanderings of the American Beat writer Allan Ansen (alias "A"), as recorded in a photographic collage with commentary in columns of type indifferent to the completeness of individual words (FIG. 37). "It is our thesis," Rumney wrote, "that cities should incorporate a built-in play factor. We are studying here a play environment relationship.... But how would 'A' play in London?"

One answer to that question was that he would play in the face of implacable contempt from the anti-American Debord, who was imperiously dismissing the Beats as "mystical cretins." Rumney himself, compromised by such associations, enjoyed the honor of being excluded from the Situationists in 1958, the same year in which he was able to return to London. He published his *Psychogeography of Venice* in *Ark* the journal of the Royal College of Art and quickly established a rapport with its editor, Roger Coleman (b. 1930), and with two students, Robyn Denny (b. 1930)

and Richard Smith (b. 1931). The four set about conceiving a joint project that incorporated the open elements of play and discovery inherent in Rumney's psychogeography, but were obviously constrained by the strong precedent of *This Is Tomorrow*. There was an unbridgeable divide between the Independent Group's fascination with consumer culture as an index of modernity and the Situationist ultimatum that the false blandishments of "the Spectacle" be superseded in every particular.

The Royal College group found their solution in an unlikely quarter: large-scale abstract painting, but painting manufactured and disposed in such a way that both artists and viewers were induced to surrender their customary prerogatives. They called their 1959 exhibition *Place* (FIG. 38), and the three painters agreed to restrict themselves to just two formats (7 by 6 feet and 7 by 4 feet; 2.1 by 1.8 or 2.1 by 1.2 meters) and just two combinations of colors – black and white and the complementary pair of red and green. The experience of the viewer, faced with this environment made of paintings, was gradually to sort out its logic by moving through it and absorbing its visual cues; their rules and arrangement positively militated against prolonged fixation on any one canvas, encouraging instead views past, through, and to the sides. As a rationale for what they called the viewer's "ludic"

38. Three installation views of the *Place* exhibition at the ICA, London, in 1959.

Coleman described the principle of the installation in his guide for visitors: "24 canvases were fixed back-to-back to make 12 double-sided pictures which were on the gallery floor at 45° to the walls and at 90° to each other... This gave four directions in which the pictures faded, three of which were taken, one by each painter, with the fourth side shared."

39. ROBYN DENNY
*7/1960*, 1960. Oil on
canvas, 7′6″ x 4′6″ (2.3 x
1.3 m). Collection of the
artist.

passage (from the Latin "lud-ere," to play), the participants exploited contemporary science fiction's vivid simplifications of cybernetics as well as the hypotheses of popularizing sociologists about new mental states induced by technological change and information bombardment in the modern city.

In contrast to the makers of *This Is Tomorrow*, the *Place* group projected a clean, efficient look in every aspect of visual presentation – from installations to invitations to personal dress. The same was true of a show staged in the following year, tellingly entitled *Situation*, in which Denny (FIG. 39) and Smith were joined by a larger group of painters. In contrast to the New York scene, abstract painters in London were able to think of disciplined painting as a way-station where currents from any quarter of the urban environment might pass through and move on. There was thus little need for the romanticism of the street and the picturesque disorder fostered by contemporary American dissidents like Kaprow, Grooms, and Olden-burg, which in Britain carried overtones of a familiar and despised bohemianism. Peter Hobbs (b. 1930) took the situational aesthetic further into a process of isolated nomadism. Seeking to make manifest the socially marginal condition of painting, he conceived a series of canvases in 1960 which had no fixed home, installing them as freestanding panels on bomb sites and waste ground around the East End of London. The project was a collaboration between Hobbs and the war photographer and social documentarian Don McCullin (b. 1935), the latter creating a remarkable series of installation tableaux recording Hobbs's interventions in these

interstitial city spaces (FIG. 40). Making a work of art with the idea of its being photographed is a markedly different thing from conceiving painting as directed to eyesight alone. The camera's mode of seeing brings out time, accident, and contingency; it is the enemy of the disinterested contemplation prized within traditional aesthetics.

40. DON MCCULLIN
A painting by Peter Hobbs
in a London bombsite.

## Trials of Modernism

Where criticism and theory in London had fostered inclusiveness and boundary-crossing among art, architecture, and industrial design, the dominant American voices were wedded to the preservation of boundaries. Foremost was that of the art critic Clement Greenberg (1909-94), whose immense prestige rested on the incisive finality of his verdicts and on his record of having been an early champion of Jackson Pollock as the leading artist of his generation, long before an international consensus came to ratify that judgment. During the later 1950s, Greenberg was in the process of refining his various commitments into an overarching theory of artistic progress in the modern age. In his view, every art form in a secularized culture was obliged to define

its precise limits in a spirit of self-criticism, justifying its existence by marking out those areas of competence not shared by any other practice. For painting, these lay in its articulation of surface and two-dimensional shape and in a consequent refusal of sculptural or (still worse) literary violations of the manifest integrity of the picture plane. By "literary" he meant all of the narrative uses that painting had served in the past. The synthesis of his ideas amounted, however, to his own grand narrative of the historical necessity of highly self-conscious abstractionism in art, whereby any valid work had more to say about the limits of its own technical procedures than it did about the world outside. For him, the lesson of the previous two centuries of art history was "that the unique and proper area of competence of each art coincided with all that was unique to the nature of its medium" (*Modernist Painting*, 1961).

It needs to be recognized that Greenberg's emphasis on flatness and the integration of literal shape with pictorial field was no reduction of painting to problems of design; the field of painting was still one of expressive communication between artist and contemplative spectator, but the persuasiveness of that expression was to be secured by dramatizing the technical preconditions, and it was this alone that the critic could describe. No writer in Europe was at this point offering the rigor of Greenberg's vision of triumphant Modernism; its effect in New York was to polarize opinion and even practice. Those who pursued a time-bound, environmental practice, the Kaprows and Oldenburgs, specifically set aside any concern with the pictorial and were condemned in turn by the advocates of high Modernism, who equated aesthetic seriousness with exclusive fidelity to the traditional media of fine art.

The practice of art, even within a traditional medium, will nonetheless outrun the grasp of any theoretical system, however pertinent and powerful it may have been at the start. At the end of the 1950s, Greenberg himself was facing certain problems induced by the very success of New York School painting, the object of his earlier advocacy. One was the absence of new expressive discoveries within a formal vocabulary increasingly circumscribed by de Kooning's example. What was more, de Kooning's characteristic interleaving of illusionistic planes, each established by a discrete stroke of color, proved to be rich with figurative suggestion – as his *Woman* series (see FIG. 10) had made all too evident; nor was the irony implicit in Johns's treatment of painterly gesture a possibility within Greenberg's value system (he placed both de Kooning and Johns under the dismissive

category of "homeless representation"). Even Pollock had retreated into his own form of figuration in the years before his death in 1956.

Greenberg's first response was to recover the neglected art of Barnett Newman (1905-70), who had actually been one of the initial innovators in large-scale abstract painting during the 1940s. Newman had played his part, however, as much through his writings as through his art; that mixed identity left him vulnerable when he made the first extensive showing of his mature work in 1950 at the Betty Parsons Gallery, New York. His expansive fields of uniform color, interrupted only by a few thin vertical lines (sometimes only one), were so austere that they alienated even the avant-garde, which still sought signs of emotion and struggle in a painter's marks; Newman found himself widely dismissed as no more than an intellectual provocateur, and he had virtually given up painting by the latter part of the decade. While Greenberg had given Newman little comfort in the early days, the artist's particular commitments – his impersonality and utter refusal of naturalistic reference – answered the need for a counterweight to both de Kooning and Johns. Active as a commercial gallery consultant, Greenberg arranged for a Newman retrospective in 1959 at French and Company Inc. in New York and motivated him again

41. Barnett Newman *Shining Forth (To George)*, 1961. Oil on canvas, 9'6" x 14'6" (2.9 x 4.4 m). Centre Georges Pompidou, Paris.

to pursue painting in earnest. Greenberg also wrote the introduction to the exhibition catalogue.

Newman began more or less where he had suspended his career (FIG. 41), which both answered and complicated the Modernist agenda. Undoubtedly he had made the colored ground and framing edge of the canvas into the fundamental content of his art; at the same time, however, the expansive horizontal reach of many of his paintings – which could be over seventeen feet (5.4 m) long – made them difficult to accommodate within the attitude of stationary contemplation fundamental to Modernist thought. They would not resolve themselves into a purely "optical," disembodied experience for the spectator; they extended beyond any single coherent aspect, compelling physical movement and a progressive engagement with their sheer material presence, their quasi-architectural monumentality. The environmental aesthetic despised by Greenberg (but embraced by London's abstract painters in the *Place* and *Situation* exhibitions) emerged out of what seemed to be the most uncompromising limitation of painting to matters of surface and edge.

The same can be said of another artist, Morris Louis (1912–62), whom Greenberg also advised and encouraged in these years. Settled in Washington, D.C., Louis operated with conspicuous independence from the dominant currents in New York. Although he was habitually secretive about his precise techniques, the basic procedure underlying all of his mature art was staining thinned paint directly into raw cotton duck (his development of its possibilities being accelerated by the arrival of fast-drying, water-based acrylic paint). For Modernist purposes, this simple device accomplished at a stroke the indissoluble union of a suggestively hovering image with the literal plane of the stretched canvas. Pollock and Hans Hofmann (1880–1966) had used the device as background to paint textures resting on the surface; it had taken a young artist in the early 1950s, Helen Frankenthaler (b. 1928), to see this as a complete system of marking the canvas. Greenberg responded with enormous enthusiasm and brought Louis along with other artists to see her work as showing the most promising way forward.

Frankenthaler has consistently used the device (FIG. 42) to

42. HELEN FRANKENTHALER
*Seascape with Dunes*,
1962. Oil on canvas, 5′10″
x 11′8″ (1.7 x 3.5 m). Grey
Art Gallery & Study Center,
New York University Art
Collection, New York.

43. MORRIS LOUIS
*Alpha Tau*, 1961. Acrylic on canvas, 8′6″ x 19′6″ (2.6 x 5.9 m). The Saint Louis Art Museum, Missouri.

elude the grip of de Kooning-style cut-and-slash brushwork while maintaining an approach to painting based on improvisation and complex, surprising adjustments of one form to another within the compositional frame. The merging of pigment and support was sufficient to allow organic and landscape metaphors to escape Modernist censure (the pools of seeping oil that surround the colored patches can even read as shadows without implying illusionistic space). Louis followed a parallel path through the mid-1950s; but his "solution" to sustaining the expressive requirements of the New York School depended on spectators maintaining the fiction that the cotton duck had no substance of its own, at least none demanding particular attention.

That assumption was tested to the breaking point in Louis's last series of paintings before his premature death in 1962, the so-called "Unfurleds" (FIG. 43). The rivulets of staining pigment, which he had once bunched and overlaid at the center of his compositions, now were dispersed to the edges of the visual field, threatening entirely to lose compositional contact with one another. Their rhyming symmetry just held the picture together, but demanded in turn that the central emptiness be taken into account. In one respect, a painting like *Alpha Tau* accomplished the supreme feat of conjuring literal means into a mirage-like mental image, as the unmarked expanse of cloth becomes the work's central event, defined by stuttering contours at its rim. In another, however, Louis followed Newman in laterally stretching the pictorial field beyond the perceptual field of vision. As a result, the fact of the painting as "nothing but" its physical constituents became inescapable: the weave of the commercial textile and the suspension of an industrial dye assume

equivalent importance to the artist's unique improvisations with form and color.

This outcome was again in diametric opposition to Greenberg's expectations, but no sophisticated viewer could have come to Louis's canvases after 1959 unprepared for the latter interpretation. At the very end of that year, the Museum of Modern Art in New York hung four large paintings by Frank Stella (b. 1936) in *Sixteen Americans*, the group showing of new American work (an exceptional selection that, as we have seen, put Wally Hedrick and Jay DeFeo alongside Johns and Rauschenberg). As a gesture of official endorsement at the bare beginnings of a career, this accolade surpassed even the museum's embrace of Johns the year before; and Stella's implicit dissent from prevailing norms was arguably greater in that he synthesized into one implacable unity (FIG. 44) the most extreme implications of both Flag and the stained-field painting represented by Louis.

As Johns had done, Stella simply set aside the problem of compositional invention by settling at the outset on a predetermined pattern, in this case an entirely regular grid composed of uniform stripes (FIG. 45); as Louis was doing, he painted directly onto unprimed canvas, further emphasizing the objecthood of the work by eliminating frames and making the stretcher bars for each canvas wider than was usual (the same 2¹/₂ inches or 6.3 cm as the stripes) so that they stood out from the wall like shallow boxes. Beyond these precedents, in a way not yet seen in New York, the total effect of Stella's "black paintings" paralleled the *Place* exhibition in London, both in the suppression of individual

44. FRANK STELLA
Installation from the exhibition *Sixteen Americans*, 16 December 1959 to 17 February 1960. Museum of Modern Art, New York.

Stella's paintings included in the show were *Arundel Castle* and *Tomlinson Park Court* (shown here) with *Die Fahne Hoch!* (see over page) and *The Marriage of Reason and Squalor.*

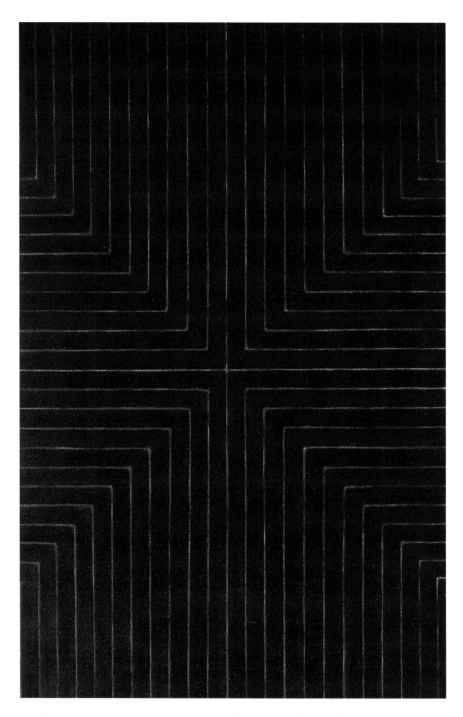

45. FRANK STELLA *Die Fahne Hoch!* (*The Flag High!*), 1959. Black enamel on canvas, 10'1¹/₂" x 6'1" (3 x 1.8 m). Whitney Museum of American Art, New York.

From the beginning of his career to the present, Stella has used unexpected and evocative titles for his paintings. For many abstract artists, titles serve largely as a convenient form of cataloguing notation. Stella's titles test the viewer's ability to distinguish between private associations and suggestive metaphor.

personality and the use of a congruent series of canvases to dominate an environment. The American's insistence on an impersonal procedure went even further: he applied his stripes in industrial enamel using a housepainter's brush of the same width, the thin gaps between their edges exposing the raw support and ruled pencil guidelines. And the variations of pattern from canvas to canvas remained within the narrowest range of permutations on the grid/cruciform theme.

The lasting impact of the works lay in their tense suspension on the very edge of what could be taken as a painting, poised as they are between two and three dimensions, between pictorial composition and utilitarian marking. Early in the century, the Russian artist Kazimir Malevich (1878-1935) had produced his *Black Square* (1915) and *Black Cross* (FIG. 46) as the zero or end points of abstraction. Stella's *Die Fahne Hoch!* (*The Flag High!*) of 1959, the most basic, symmetrically stable unit in Stella's series, intentionally subsumed both. But the mordant and awkward playfulness of its title, borrowed from a German Nazi anthem, undercuts the apparent formal confidence of the whole. No phrase with such abhorrent connotations can be set aside in confronting the visual matter of the work; it draws the absence of color into conventions of dread and funereal mourning, projecting that association into a pathos at the very limits of human imagination. That train of allusion lay beyond any conceivable resolution. Indeed, the radical character of Stella's debut proved to be one he could not sustain in his own practice, which retreated to more conventional Modernist preoccupations with shape and abstract illusionism. But the tense and complex ambivalence of his Black paintings, held in the spotlight of New York curatorial attention, stimulated other artists toward further dramatic departures.

46. KAZIMIR MALEVICH
*Black Cross*, 1923, (artist's replica of 1913 original).
Oil on canvas, 3'6" x 3'6" (106 x 106 cm).
State Russian Museum, St. Petersburg.

THREE

# *Living with Pop*

I n an insistent, pointed contrast to Frank Stella's flat assertion that "What you see is what you see," in the early 1960s Barnett Newman (then approaching sixty) laid claim to the same reduced materials of raw cotton duck and black paint in the name of spiritual aspiration. Over the course of the decade he gathered a series of canvases, interrupted only by a few of his vertical "zips," under the title *Stations of the Cross* (FIG. 48). Each of the fourteen paintings was conceived, in its sharply minimal interplay of dark against light, as a visual equivalent to Jesus' cry, "My God, why hast thou forsaken me?" Newman singled out Christ's lapse into uncertainty and doubt, that instant in the gospel at which the faceless character of the Old Testament deity momentarily reasserts itself. The concept melded the aniconic imperative of the Jewish prohibition against the making of likenesses of God with the quest for profound subject-matter beyond natural resemblance, the founding mandate for the Abstract Expressionists.

## The Sacred and the Profane

Newman confirmed his late-arriving authority by employing means that gave nothing away to the rigor and restraint of Stella and Louis. The overt scriptural support for his enterprise struck an awkward, even embarrassingly pious note beside the cool concentration on pictorial means espoused by Greenberg and his followers; but in fact a parallel strain of moralizing earnestness lay

47. DAVID HOCKNEY
*A Bigger Splash*, 1967. Acrylic on canvas, 8′ x 8′ (2.4 x 2.4 m). Tate Gallery, London.

48. BARNETT NEWMAN
Exhibition view: *The
Stations of the Cross: lema
sabachthani*, Solomon R.
Guggenheim Museum,
New York, 23 April to
19 June 1966.

The interior of Frank Lloyd
Wright's Guggenheim
Museum in New York,
organized around one
continuously spiralling
ramp, has a built-in
processional character,
which resonated with the
theme of sacrificial
progress in Newman's
series.

just beneath the surface of Modernist thinking. One of its most articulate younger voices, the art historian Michael Fried, wrote of Louis as an ethical exemplar for whom "painting consisted in far more than the production of sensually pleasing or arresting objects. Rather, it was an enterprise which unless inspired by moral and intellectual passion was doomed to triviality, and unless informed by uncommon powers of moral and intellectual discrimination was doomed to failure." In New York, this stringent tenor helped foster the sense that the Modernists occupied a defensive camp, contemptuous of other directions in art; that perception in turn intensified, by way of reaction, offhand and ironic attitudes on the part of those artists who trafficked in vernacular materials and recognizable subject-matter.

But American artists did not consistently divide themselves along these lines: on the West Coast, by contrast, hostility to profanation of popular symbols on the part of the local police and officialdom meant that questions of risk and commitment impressed themselves far more strongly upon the assemblage artists. Wallace Berman (1926-76) was a long-admired free spirit in Los Angeles, a tireless disseminator of Beat writing and a maker of assemblage art, who had always fought shy of exhibiting his work. In 1957, the newly opened Ferus Gallery in Los Angeles induced him to mount a solo exhibition as its second public offering. Berman had for some years been making "Combine" constructions with features similar to those of Rauschenberg in New York, including the use of compartments to contain objects and books borrowed from other contexts. The nature

of those borrowings, however, exemplifies directly the mystical enthusiasms (frequently spurred by psychotropic drugs) that animated the developing counter-culture in California; in the southern Topanga Canyon colony of writers and artists, of which Berman was a leading figure, attraction to the occult was less tempered by hard political commitments than was the case in northern California.

The spare installation at Ferus was dominated by the repeated use of Hebrew letters arranged according to kabbalistic lore rather than lexical sense: Berman had taken on board the mystical tradition in Judaism whereby each letter contains in itself an endless resonance of meaning, bridging the human and divine, the alphabet being the sign and instrument of creation itself. One such panel, printed on rough parchment, hung from the arm of a wooden cross (FIG. 49), bluntly actual in contrast to Newman's metaphor. Untutored in theology, Berman not only confounded religious categories but conflated sacred and profane generation into one: the opposite arm carried a framed close-up photograph, cropped so as to suggest a symmetrical mandala, representing male-female intercourse; its inscription read "Factum Fidei" (Act of Faith).

That spiritualization of sexual freedom reflected familiar Beat attitudes; as with the publication of Ginsberg's *Howl* in 1956, the exhibition invited official censorship. Warned in advance of a raid by police, the other Ferus artists kept a vigil with Berman until he was seized, handcuffed, and jailed. Although *Cross* had prompted the original "citizen's complaint," Berman was prosecuted for the contents of his magazine, *Semina*, which he had placed within another construction. The obscene publication charge paralleled that brought against *Howl*, but Berman was convicted in the more right-wing, southern California jurisdiction (by the same judge who had previously convicted Henry Miller's writing of obscenity). In any event, the show had already been effectively suppressed, demonstrating the artist's greater vulnerability to hostility from the authorities. Berman compounded his fine by writing, at the announcement of the verdict, the words "There is no justice, only revenge" on a courtroom chalkboard; he then fled the city for a more tolerant San Francisco.

The Ferus Gallery survived the incident and went on to establish a new level of ambition and longevity for the artist-inspired

49. WALLACE BERMAN
*Cross*, 1956-57. Wood, parchment, photograph, ink. Destroyed.

exhibiting space. It was a joint project between an artist, Edward Kienholz (1927-94), and a young entrepreneurial curator, Walter Hopps, that brought together an extraordinary combination of contrasting talents. Kienholz was an entirely self-taught arrival in Los Angeles in 1953 from the rural mountain west, who had set up his first studio in a shed behind a car repair shop. But when established commercial galleries refused his lumberjack-style relief paintings, he resolved to shake himself free of the underground and create a space that would compete with them on their own terms. Their first show in Los Angeles was in 1955. Hopps, for his part, brought an art historian's education and a network of influential contacts in the city acquired since youth: even as an adolescent he had cultivated Walter and Louise Arensberg, major collectors of Cubist, Dada, and Surrealist art, who had set up residence in the Hollywood hills.

The roots of Ferus (evoking the Latin word *fera* for wild beast) were in precedents like the King Ubu Gallery and Six Gallery, but its presentation defied stereotypes of bohemian seediness and ephemerality. Kienholz turned his handyman's competence in carpentry to creating an impressively polished, white-walled interior in a central district of upscale antique dealers and restaurants. In return for running the reception desk, he occupied a studio in the rear of the premises – which made Ferus a real-world anticipation of Oldenberg's *Store*, minus the play acting and ultimately enfeebling irony.

The enhanced visibility and credibility conferred by Ferus did not induce Kienholz in any way to subdue his outsider's sensibility (he satirized his partner's social and business acumen in a portrait sculpture, *Walter Hopps, Hopps, Hopps*; 1959). The opening of Ferus coincided with Kienholz dropping anything resembling painting in favor of a profane and disabused vocabulary in found-object sculpture, one purged of every Beat tendency toward mystical transcendence. Improved circumstances set off more sharply the unrelenting anger that fueled his work, which the Berman prosecution can only have confirmed. That motivation led him into territory occupied by Bruce Conner, but Kienholz took greater liberties in turning viewers into implicated witnesses. While Conner's response to Caryl Chessman's death sentence, *The Child* (see FIG. 20), forced viewers to contemplate a ghastly spectacle, Kienholz's *The Psycho-Vendetta Case* of 1960 (FIG. 50) insists on a mocking series of disclosures that renders all the more powerfully a condition of unremitting disgust.

The conception of the piece began with two low puns: one on an infamous and legendary miscarriage of American justice,

50. EDWARD KIENHOLZ
*The Psycho-Vendetta Case,*
1960. Mixed media, 23 x
22 x 17″ (58.5 x 56.5 x
43 cm). Museum Moderner
Kunst Stiftung Ludwig,
Vienna.

the 1927 Sacco-Vanzetti case, in which two Italian immigrants were wrongly executed for murder in punitive retribution for their anarchist political beliefs; the other simply on the word "case," which dictated the utilitarian form of the sculpture. The artist himself provided the most vivid possible description of its operation:

> It's just a box that swings open, made out of tin cans... It's got the great seal of approval of California on the surface of it, and when you open it up, it's Chessman with just his ass exposed. The hands are holding a tank periscope. And when you look in that, you read down there, and it says "If you believe in an eye for an eye and a tooth for a tooth, stick your tongue out. Limit three times." And you realize while you're reading that you're lined up exactly with his ass.

This was a completely other Old Testament. Viewing the work in its entirety became an exercise in obscene symbolic degradation. And one of its political strengths is that, in addition to enlisting the humiliation of the viewer into the completion of the work, its carnal body keeps open the question of Chessman's guilt or innocence; for it was only by separating the crime from the penalty that sentimentality could be set aside and capital punishment confronted as stark ethical choice.

*Psycho-Vendetta Case,* though freestanding and ostensibly portable, preserves the planar character of Kienholz's earlier reliefs. Subsequent years brought out his real gift as a sculptor, which was

for expansive tableaux "on a scale to compete with the world."
That ability allowed him to deploy sheer size as an expressive
response to the enormity of the evils he perceived. In 1964, his cor-
rosive humor once again brought out the forces of censorship
against the Los Angeles avant-garde: outraged officials threatened
to close the Los Angeles County Museum when it showed an early
retrospective of his work, the prime offender being *Backseat Dodge
'38* of 1964 (FIG. 51), in which the door of a chopped car body
opened to reveal two mutilated lovers in a grim sexual embrace.
He called it a recollection of his small-town Idaho adolescence,
but official condemnation only confirmed the power of mem-
ory to frame an all-too-contemporary allegory of stunted lives
and hopes conveyed in a brutally "customized" hot rod, the magic
vehicle of working-class aspiration. (The show was allowed to
proceed on the condition that a guard open the door of the car
only at fifteen-minute intervals to allow the curious a brief glimpse
into its interior.)

## Dada Hollywood

The energetic current of assemblage art that ran through Cali-
fornia art over the course of the 1960s stayed closer to Berman's
example than to that of Kienholz; that is, it tended to reinforce
the subjectivized, mystical enthusiasms of the counter-culture tak-
ing root in the mountain canyons of the south and in a variety
of pockets around the San Francisco Bay area. The first identi-
fiable Hippies were following the old Beats to the cheap and (then)
obscure neighborhood of the Haight-Ashbury in San Francisco.
Centers of alternative psychological therapy, collectively couched
as the "human potential" movement, were purveying an eclec-
tic mix of Eastern meditative disciplines in their exhortations to
inward self-discovery; locations of spectacular natural beauty, like
that of the Esalen Institute on the Big Sur coast, encouraged a fur-
ther incorporation of nature pantheism.

At the same time, an expanding system of free university edu-
cation was doing its part to swell the numbers of aspiring artists,
poets, and musicians; the mild climate and rising prosperity of the
state provided an environment and economic surplus sufficient to
make the adventurous bohemia pioneered by the likes of Jess
and Robert Duncan into an attractive option for many more aspi-
rants. In domesticated form, some of the same attitudes of per-
sonal liberation eventually passed into the official ideology of a
culture in which personal optimism was virtually legislated. Both
the universities and schools required for the state's growing

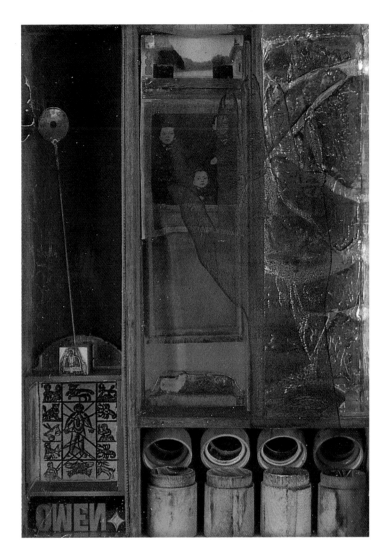

52. BETYE SAAR
*Omen*, 1967. Mixed media
assemblage box, 12³/₄ x 9¹/₄
x 3″ (32 x 23.4 x 7.6 cm).
Faith and Richard Flam
Collection, California.

population emphasized visual art in the name of self-expression
and individual development. The public educational sector in
turn offered artists a new abundance of economic support and
exhibiting possibilities separate from the normal channels of the
art economy centered in New York.

Artists could thus come to at least regional prominence who
would have had little access to a serious career. One such was Betye
Saar (b. 1926), who passed through the state university system
to gain a schoolteaching qualification in graphics. Being both
female and African-American (her family had migrated to Los
Angeles from New Orleans) might have entirely frustrated her
career in a less expansive environment: as it was, she was in her
forties before finding a distinctive idiom and the beginnings of

recognition. It suited her purposes to evoke unseen forces determining human destinies; her art took up cues from Berman in the fashioning of pictorial assemblages, sealed behind glass and thick with tokens of folkloric occultism: *Omen* of 1967 (FIG. 52) announces an other-worldly significance in its title and is built from the fortune-teller's array of palmistry, tarot reading, and clairvoyance. As the 1960s progressed, however, she followed the more militant turn in the Civil Rights movement, with its increasing emphasis on black identity and pride; her fascination with occult symbols and alternative realities shifted toward the tokens of belief and healing carried by the African diaspora to the New World. In an area then just beginning to receive serious attention from historians and anthropologists, Saar undertook her own ambitious research to answer the developing demands of her art.

At the other end of the scale of privilege and attention, the art world of Los Angeles could accommodate without condescension an interloper from the film colony that surrounded it. Around 1960 the young actor Dennis Hopper (b. 1936), protégé of the late James Dean, took an extended break from playing juvenile film roles in order to absorb some charisma from the magnetic personalities in the art underground. Berman, by this time having returned from San Francisco, radiated the authority of a guru, which his voluntary poverty only enhanced: Hopper took a reverent photographic portrait of him astride his motorcycle, hand on a helmet emblazoned with the kabbalistic initial *aleph* (FIG. 53). And Berman was not the only model who would eventually be synthesized into the drug-cowboy seekers who are the protagonists of the cult film *Easy Rider*, Hopper's enormous marketplace

53. DENNIS HOPPER
*Wallace Berman*, 1963.

54. Billy Al Bengston *Buster*, 1962. Oil and sprayed lacquer on masonite, 5′ x 5′ (1.5 x 1.5 m). Museum of Contemporary Art, San Diego.

success as a director and actor in 1969. The Ferus Gallery stable also included Billy Al Bengston (b. 1934), who actually raced motorcycles to a professional level and cultivated a flamboyant, dare-devil persona that competed with the aura of Hollywood celebrity. Such competitive, extra-artistic exploits marked the dominant art scene with an aggressively masculine stance, a vanguard posture alien to the presence and sensibility of an artist like Saar.

But Bengston for one pursued, with deliberate paradox, a delicate and modest approach to his art. Key to the early definition of his project was exposure to the laconic, centralized motifs of Jasper Johns; but it is a mark of the imperfect channels of communication prevailing in the period that Bengston had to make a trip to the Venice Biennale in 1958 before seeing them. He then systematically built on two aspects of the work that Johns himself had begun to relax: the first was a disciplined adherence to unassuming physical dimensions; the second was the incessantly repeated, obsessively worked emblem as implicit refusal of demands for expressive discoveries. He settled on a motif – a set of sergeant's stripes – that seems at first no more than a derivative of those of Johns; but its blank, unvarying appearance in panel after symmetrical panel, such as *Buster* of 1962 (FIG. 54), made it

more arbitrary, more free from referential value, than any abstract mark could be. He also reversed the archaism of Johns's early use of wax encaustic with an embrace of industrial materials and the artisanal techniques used to decorate motorcycle tanks and surfboards. Moving on from applying spray lacquer to panels of rigid masonite, he offhandedly harried Modernist belief in the neutrality of the support by painting over intentionally dented aluminium sheets or on formica intended for kitchen countertops, with its glossy mimicry of natural surfaces.

There is nothing of the visionary in the radiances that shine from the celestial disc in *Buster*: the occult is present only by negative implication; it speaks only of wizardry with the airbrush and eye-popping embellishments favored by equipment – proud bikers, hot-rodders, and surfers. The fraternity of Los Angeles artists largely turned its back on the counter culture's romantic yearnings in favor, to use Bengston's words, of "man-made things that we see in harsh California light." Hopper turned his camera on the generally soulless results in photographs like the wide-angle *Double Standard* of 1961 (FIG. 55). The major motif and the punning title is supplied by the dominant West Coast oil corporation. The streetscape serves as a token for the ruthless industrial development, with attendant schemes of mass-produced housing, that had spread over the coastal desert terrain. That dramatic

55. DENNIS HOPPER
*Double Standard*, 1961.

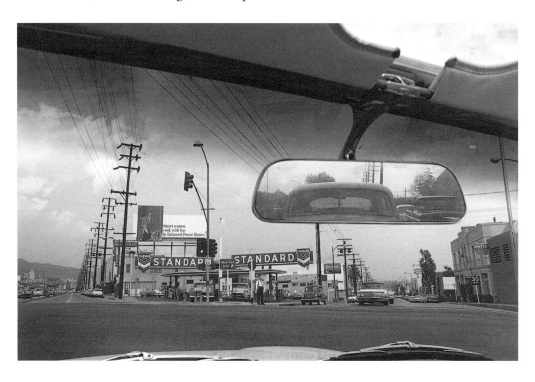

56. EDWARD RUSCHA
*Standard Station, Amarillo, Texas*, 1963. Oil on canvas, 6′5″ x 10′2″ (1.9 x 3 m). Hood Museum of Art, Hanover, New Hampshire.

subordination of nature to technology began in wartime emergency, which built up the region's lead in aircraft and electronic technology, and had been exponentially accelerated in the 1950s by the vast military expenditures of the Cold War.

The strong military stamp on life in southern California thus extended well into civilian life. Hopper's photograph plays with the pervasive values of efficiency and standardization as embodied in the vast grid of the city's plan. Edward Ruscha (b. 1937), a later arrival to the Ferus group, painted the Standard gasoline station (FIG. 56) in 1963 in dead-pan mimicry of an engineer's projection: standard as commercial brand on an undifferentiated commodity; standard as type of endlessly repeated building (there was a time when a major street intersection would typically have gasoline outlets on all four corners). For an artist of any awareness and subtlety, the road past the Standard station led straight to Marcel Duchamp. And the Ferus group did not fail the test. Walter Hopps, having moved on to assume the directorship of the small, suburban Pasadena Museum of Art, was in a position to supply historical context. In 1963, he conceived what was, astonishingly, Duchamp's first museum retrospective: *By or of Marcel Duchamp or Rrose Sélavy*, held in October of that year.

The show represented the first opportunity for American artists to see Duchamp's work with any comprehensiveness: replicas of the famous early pieces made before his public rejection of art for chess in 1923 (FIG. 57), alongside the later evidence that his work had never actually ceased. Perhaps most important in the light of the preoccupations of local artists were the so-called readymade sculptures from the first wave of Dada in the 1910s – ordinary "man-made things" like combs, snow shovels, and urinals

57. MARCEL DUCHAMP
*Bicycle Wheel*, 1951 (third version after lost original of 1913). Assemblage, metal wheel mounted on painted wood stool, overall 4′2¹/₂″ x 25¹/₂″ x 16″ (1.3 m x 63.8 cm x 42 cm). Museum of Modern Art, New York.

simply nominated as works of art. With the ready-made, the industrial logic of serial repetition and impersonality had broken through the barriers of cultivated fine art (in keeping with that logic, these were later replicas). From 1913 to 1914 and conceived in a similar spirit were precise measuring units (*Standard Stoppages*) generated from random accidents. The kinetic optical illusions of the motorized *Roto-reliefs* from 1920 were equally distant from the norm of art as expressive and uniquely fashioned by hand. Duchamp's mock compliance with the requirements of ordinary commerce took form in *Boîte en Valise* (*Box in a Valise*), completed in 1941, in which all of his earlier work reappeared as so many miniaturized, portable goods.

In a further assault on the value of originality, the exhibition featured a scrupulous reconstruction in transparent plastic of the shattered *Large Glass* of 1915-23, with its dehumanized sexual drama of compulsive, unsatisfied repetition (and any viewer is visible in that drama when seen from the other side). Most spectacularly, the exhibition offered the presence of the enigmatic septuagenarian Duchamp in the flesh: in one impromptu performance, he played chess with the local collage artist Eve Babitz, who was nude, for the voyeur-photographer from *Time* magazine, re-enacting in the present a tangled set of themes obsessively repeated in the art all around them.

That piece of raffish exploitation formed one sideshow in a manic festival atmosphere that surrounded the show, a rush of

enthusiasm that contrasted wildly with Duchamp's modest, over-looked existence in Manhattan. The event became a magnet for much of the suppressed and dispersed knowledge of the artist that had been cultivated in relative isolation across America and Europe. One such strand emerged from the defunct Independent Group in Great Britain. Richard Hamilton had spent most of the seven intervening years since his participation in *This Is Tomorrow* (see chapter two) in dedicated study of Duchamp's manuscript in *The Green Box* of 1934; this baffling "explanation" of the *Large Glass* consisting of ninety-four unordered sheets. Laboring in provincial Newcastle, he entered into a long-distance collaboration with the patrician American art historian George Heard Hamilton (no relation) to produce the first typographical rendering of the cryptic notes. The Pasadena retrospective became the occasion for Hamilton's first visit to the country he had so vividly imagined in his art; he flew the long leg from New York to Los Angeles with Duchamp himself; the master of nominating unaltered objects into art spent the journey, Hamilton recalled, "venturing names for rivers and mountains and cities."

## Death on the Production Line

If the Duchamp exhibition was revelatory for Richard Hamilton, it was no less so for the younger Los Angeles artists, who saw directions in their own work ratified and sharpened by art his-

58. EDWARD RUSCHA
*Every Building on the Sunset Strip*, 1966. Fold-out photobook, closed 7¼ x 5⅝" (18.2 x 14.3 cm), total work extended 7¼" x 24'9" (18.2 cm x 7.5 m).

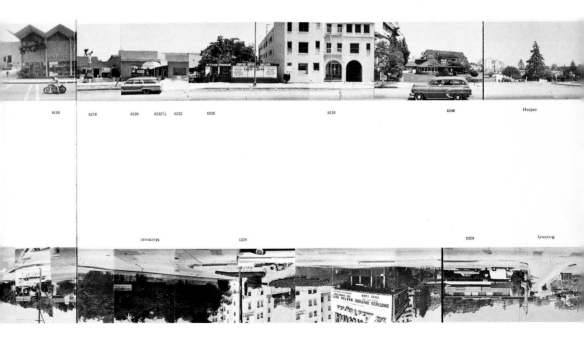

tory in the making. The established museum world would catch up with further retrospectives of Duchamp's work in London and Philadelphia within the decade, but nowhere else would the connection linking practice to the scholarly recovery of Duchamp's inheritance be nearly as close. Edward Ruscha, who had established a livelihood as a designer alongside his painting, began in that same year, 1963, several laconic books of photographs, each documenting a variety of anonymous structures in the local landscape: *Twenty-six Gasoline Stations* was the appropriate first effort. Among the parallel works that followed was the fold-out production *Every Building on the Sunset Strip* (1966; FIG. 58). The treatment of that uniquely linear and discrete urban district as a ready-made, the refusal of artful arrangement or commentary, distribution through cheap, endlessly duplicatable means, all made for fresh application of Duchampian stratagems. And its further yield was descriptive accuracy, at an underlying structural level, in its account of the city: Ruscha's surrender to serial accumulation in place of composition comes to grips with an architectural environment in which the replacement of any individual building would have no effect whatsoever on the whole. Its cognitive rewards and formal acuity put in the shade better-known "Pop" appropriations of the Los Angeles landscape, such as David Hockney's (b. 1937) embodiment of the northern Englishman in paradise: his *A Bigger Splash* of 1967 (see FIG. 47, page 69) returns to the more accessible precedents of de Kooning and Franz Kline, turning the broad, expressive movement of the loaded brush into a souvenir of exuberantly chlorinated tourism.

An earlier visitor far more in tune with the art of the city was Andy Warhol (1928-87), who was showing at the Ferus Gallery in 1963 during the Duchamp retrospective (it is again a mark of the circuitous paths of art-world communication that the two artists, both longtime residents of New York, met there for the

59. ANDY WARHOL
Installation of Campbell Soup Cans exhibition, Ferus Gallery, Los Angeles, 1962. Each painting synthetic polymer on canvas, 20 x 16" (50.8 x 40.6 cm).

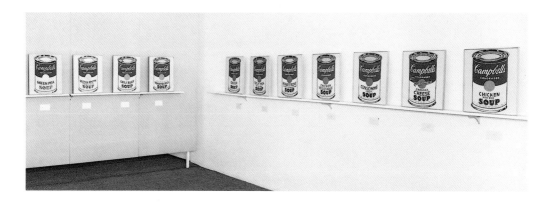

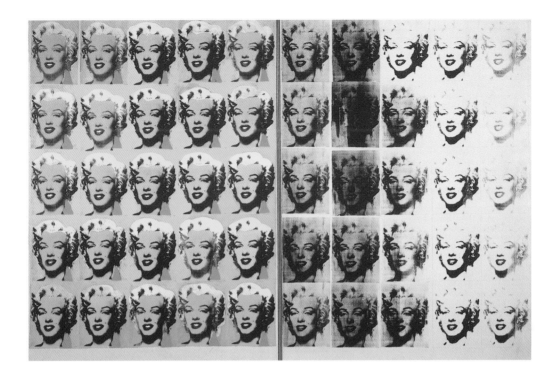

first time). The Ferus Gallery had also given Warhol his first major exhibition in July 1962; Irving Blum, the successor to Hopps as director, had taken him on when no other gallery would represent his work. Within the New York scene, both his earlier commercial career and his frankly gay persona still excluded him from serious consideration; but neither was any impediment to acceptance by Los Angeles's advanced artists and dealers. Warhol's first exhibition for Blum precisely anticipated Ruscha's photobooks in revealing the diagnostic capacity of repetitive, serial procedures: the gallery was given over to the entire series of thirty-two individual Campbell's Soup can portraits, displayed at even intervals on one line of narrow shelving that snaked around the walls at eye level (FIG. 59). For his next exhibition, scheduled to coincide with Duchamp's Pasadena show, Warhol sent Blum an uncut roll of canvas on which the same photographic stencil of Elvis Presley had been repeated over and over; he left it to his dealer to decide how the images would be packaged into individual paintings.

The Duchampian turn in Los Angeles art can be taken as a departure from the committed political expression more prevalent in San Francisco. But Kienholz, the great local exception, suffered no hesitation in pronouncing Warhol's simulation of mass production and distribution an act of "social protest," and that per-

60. ANDY WARHOL
*Marilyn Diptych*, 1962.
Acrylic silkscreen on canvas, each panel 6'8" x 4'9" (2 x 1.4 m).
Tate Gallery, London.

The left side is a monument; color and life are restored, but as a secondary and invariant mask added to something far more fugitive. Against the quasi-official regularity and uniformity of the left panel, the right concedes the absence of its subject, displaying openly the elusive and uninformative trace underneath.

ception gains credence in the light of the artist's work over the next few years. Continuing to ground his art in the ubiquity of the packaged commodity, Warhol came to produce his most powerful paintings by dramatizing the hollowness of the consumer icon: that is, events in which the mass-produced image as the bearer of desires was exposed in its inadequacy by the reality of suffering and death.

Into this category, for example, falls his most famous portrait series, that of Marilyn Monroe, which is as much about the pathos of celebrity identification as about celebration of the star. He painted the first of them within weeks of the actress's suicide in August 1962 and that project coincided with his first full commitment to the photo-silkscreen technique. In his reduction of the fine-grained color of the Monroe photograph to a one-dimensional monochrome, the imaginary life is drawn out of it. The most basic trace, whole and uninflected, is left behind, a trace that he can arrange and endlessly repeat in relationships of relative presence and absence. The *Marilyn Diptych* of that year (FIG. 60) lays out a stark and unresolved dialectic of presence and absence, of life and death.

Warhol's 1963 paintings of a falling suicide victim extracted

61. ANDY WARHOL
*Silver Disaster: Electric Chair*, 1963. Acrylic and silkscreen on canvas, 3′6″ x 5′ (1 x 1.5 m). Sonnabend Collection, New York.

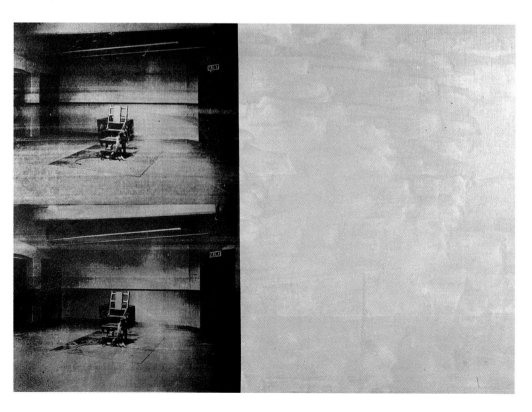

the underlying dread in its rawest form. The contemporaneous electric-chair pictures (FIG. 61) likewise played with the stark juxtaposition of fullness and void, marking the point where the brutal fact of violent death entered the realm of contemporary politics. The early 1960s were seeing, in the wake of the Chessman execution, agitation against the death penalty grow to an unprecedented intensity. Answering the same moral imperative as the outspoken Kienholz, Warhol gave these images the collective title *Disasters*, and thus tied a political subject to the slaughter of innocents in the highway, airplane, and supermarket accidents he memorialized elsewhere. He was attracted to the open sores in American political life, the issues that were most problematic for liberal Democratic politicians such as John and Robert Kennedy, and the elder Edmund Brown, the California governor who denied clemency to Chessman. In the series on the most violent phase of civil-rights demonstrations in the South, the Race Riot paintings of 1963, political life took on the same nightmare coloring that saturates so much of his other work.

What this body of painting added up to was a kind of *peinture noire* in the sense that the adjective applies to the *film noir* genre of the forties and early fifties – a stark, disabused, pessimistic vision of American life, produced from the knowing rearrangement of pulp materials by an artist who did not opt for the easier paths of irony or condescension. There was a threat in this art to create a true "pop" art in the most positive sense of that term – a pulp-derived, bleakly monochrome vision that held to a tradition of truth-telling all but buried in American commercial culture.

## A Dealer's World

The assassination of President John F. Kennedy on 22 November 1963 had the effect of puncturing America's habitual optimism and allowing the guilt and mistrust of *noir* much further into the mainstream (and it still retains this potential, as Oliver Stone's fevered 1992 film *JFK* amply demonstrated). But Warhol's pictures derived from the murder (FIG. 62) pulled back from that edge. Despite relying on rough, relatively impoverished raw material – eight grainy photographs from popular magazines – he managed to conjure from those ubiquitous images moving evocations of shock, dismay, mourning, and sympathy for the widowed Jacqueline Kennedy's ordeal.

Warhol was not entirely finished with the old abrasive imagery: in the spring of 1964 he found himself in his only public clash with

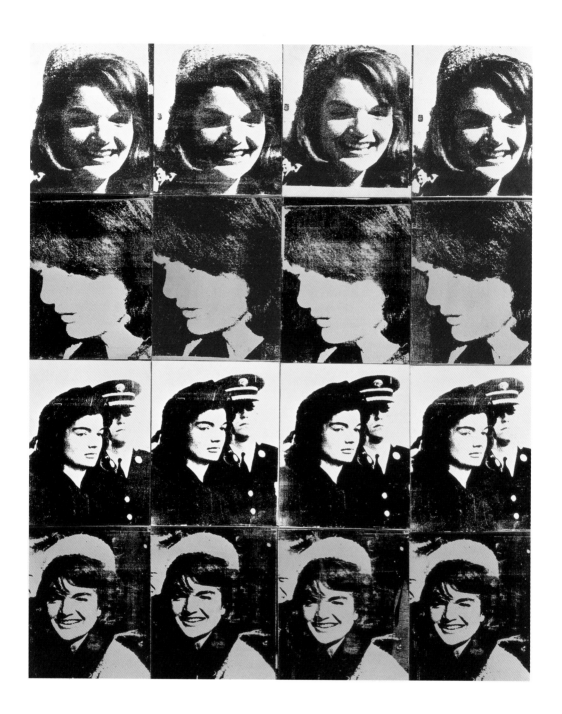

62. ANDY WARHOL
*16 Jackies*, 1964. Synthetic polymer paint and
silkscreen ink on canvas, 6'8" x 5'4" (2 x 1.6 m).
Walker Art Center, Minneapolis.

authority over a painting. The work in this case was a mural-size (36 feet or 11 meters square) painting derived from the "wanted" posters for the thirteen most dangerous American criminals; it had been commissioned for the New York State pavilion at the New York World's Fair, but the sponsors' protests over such a perverse official advertisement meant it was whitewashed over within hours of its installation. Before the end of the year, however, Warhol had moved his serial, reproductive procedures to a source that posed none of the dangers of his earlier choices: an innocuous photograph of flowers by a well-meaning "art" photographer named Patricia Caulfield. The effect of this change on his commercial fortunes was dramatic; having sold almost none of the death and disaster subjects in America, the exhibition of *Flowers* held in November 1964 sold out at good prices.

That change coincided with a move to a new gallery in New York, that of the worldly transplanted Italian Leo Castelli (b. 1907). Having achieved his first spectacular reputation as the sponsor of Jasper Johns in 1958, Castelli had gone on to orchestrate the reception of Pop artists in New York. As early as 1960 he had made a strong investment in the career of Roy Lichtenstein (b. 1923), who subsequently developed his signature style in painting by cropping, enlarging, and refining the graphic panels from American comic books (FIG. 63). The ready comprehensibility of such art drew new collectors and media interest to the New York scene. Lawrence Alloway (1926-90), who had recently migrated from London to take a curatorial post at the Guggenheim Museum in New York, popularized the term Pop art, which by itself lent an aura of excitement and desirability to the work it came to designate. The commercial ascension of New York Pop then proceeded to feed on itself. Castelli's astute promotion of his stable of artists meant that many prospective collectors began to associate vernacular subject matter with canny anticipation of the marketplace, and the press, drawn by the news value of Pop, gave the purchasers of the art some of the same personal attention and publicity it gave the artists.

The major clash of artistic tendencies in New York, the color-field abstraction represented by Helen Frankenthaler and Morris Louis versus the various forms of Pop-art figuration, entailed more than a disagreement over aesthetic values; it represented competition between rival dealers, each with a roster of loyal clients. For Modernist abstraction, one generally went to André Emmerich; for everything between Rauschenberg and Warhol, one went to Castelli, who relished the competitive atmosphere: "There were two camps," he later recalled, "mine and Green-

63. ROY LICHTENSTEIN
*M-Maybe (A Girl's Picture)*,
1965. Magna on canvas,
4'11¾" x 4'11¾" (1.5 x
1.5 m). Ludwig Museum,
Cologne.

berg's." And his turned out to have the greater numbers and commitment to the art he represented.

Part of that success came from skillful organization of exhibitions as events and talking points; another was a quick grasp of wider markets. Warhol's breaking through to serious recognition in Los Angeles was not lost on Castelli; he then brought the artist into the New York limelight and before long was showing others of his artists at the Ferus Gallery in a cooperative arrangement with Blum. Such alliances allowed Castelli both wider exposure and knowledge of differing tastes in other centers of actual or potential collecting. He gained a key outpost in 1960 when his former wife, Ileana Sonnabend, relocated to Paris and opened a gallery there; their relations were amicable enough for her to

exhibit the full range of Castelli artists in an impressive European showcase.

The Abstract Expressionists had begun to acquire a strong following in Europe by the close of the 1950s; once cultural prejudice against America had been eased, the opportunity was there for the major collectors, largely German and Italian, to be moved on to the more current products. These early enthusiasts achieved disproportionate impact, despite their small numbers, by buying in extraordinary quantity, hoping to compensate in this way for the more immediate access enjoyed by their New York competitors. The resulting buoyancy of demand pushed prices up further, drew in a host of smaller collectors, and, by the later 1960s, had generated the first international boom in contemporary art.

The hostility to Pop expressed by many guardians of cultivated taste proved to be an open invitation to enthusiastic collectors from unconventional backgrounds, whose choices were subject to no expert scrutiny; they felt themselves, with Castelli's artful assistance, to be defining new territory. The most prominent such figures in New York were Robert and Ethel Scull, whose fortune came from a lucrative fleet of taxicabs. More than consumers, the Sculls sponsored their own gallery (the Green Gallery) but remained behind the scenes, hiring an astute young dealer, Richard Bellamy, to direct its operations and scout new talent. Bellamy (late of the Hansa Gallery) endowed this space with a cutting-edge reputation, giving Oldenburg, for one, his first mainstream New York showing in 1962. The primary benefit for the Sculls was early access to some of the best new work at prices they essentially controlled.

The accelerating pace of deal making and the new media interest tended to encourage bright, attention-grabbing works of art. Warhol did not hesitate to glorify the new patrons, producing the smiling, multiple portrait *Ethel Scull 36 Times* in 1963. Oldenburg's work also evolved over the 1960s in an ingratiating direction. The crude mimicry of household products from his *Store* days gave way to comic exaggerations in scale and flexibility, which became an easily recognizable trademark. With crucial assistance

64. CLAES OLDENBURG
*Giant Soft Fan — Ghost Version*, 1967. Canvas filled with polyurethane foam, wood, metal, and plastic. Fan: 12′ x 5′ x 5′4″ (3 x 1.5 x 1.6 m); cord and plug: 24′2″ (7.3 m) long.
The Museum of Fine Arts, Houston.

The fashioning and stitching of Oldenburg's soft sculptures depended on techniques developed in close collaboration with Pat Muschinski Oldenburg. "Ghost Versions" of these household motifs were ones sewn out of plain canvas.

from his wife Pat (Muschinski) Oldenburg (b. 1935), he constructed works like *Giant Soft Fan-Ghost Version* (FIG. 64) out of stuffed fabrics; the discreet disorder of their draping and their quasi-magical magnification in size lent them a friendly, lifelike presence, evocative of children's fantasy creations (like the scarecrow in the *Wizard of Oz*).

Warhol, for his part, used his more reliable and rising income from the sale of friendlier art to support his experimental films and the cultivation of spontaneous theater, largely sexual and frequently cruel, among his growing entourage: it was in this sphere that he maintained the dark themes that had largely disappeared from his painting. One regular dubbed his studio "the Factory," and the name stuck. In certain respects a cross between Oldenburg's *Store* and a continuous Happening, the Factory's collaborative work ethic shifted the bohemian spontaneity of experiments like San Francisco's Six Gallery into the register of industrial production, maintained with a mixture of sincerity and parody that recognized the market forces and depersonalization that the success of Pop was bringing into avant-garde art generally.

## Capitalist Realisms

Much has been made of efforts by the United States government, from the later 1950s onwards, to promote Abstract Expressionism abroad as a symbolic emblem of American freedom; but Castelli's astute expansion of his clientele had a greater effect in opening Europe to an affirmation of his adopted country. In 1964 a museum exhibition, entitled *Amerikansk pop-kunst* (*American Pop art*) and drawn largely from artists showing with Ileana Sonnabend in Paris, traveled to Holland, Sweden, Belgium, and West Germany; in the same year Robert Rauschenberg, long a Castelli artist, became the first American to win the Grand Prize for Painting at the Venice Biennale (FIG. 65), then the most comprehensive and prestigious international festival of contemporary art. Europe, in fact, proved to be open to a broader range of subject matter than the American market. Lichtenstein's bright cartoon paintings had quickly become popular in West Germany and elsewhere on the Continent; but so were Warhol's "Death" and "Disaster" canvases of 1963, which had found next to no support at home. For a country still subject to opprobrium over Nazi crimes, with Allied armies on its soil, and beholden to American direction in foreign policy, there must have been some comfort in seeing the self-appointed guardian of the West acknowledged as also a landscape of suicide, highway carnage, racism, and

65. ROBERT RAUSCHENBERG
*Retroactive II*, 1964.
Oil and silkscreen ink on canvas, 7' x 5' (2.1 x 1.5 m). Stefan T. Edlis Collection, Chicago.

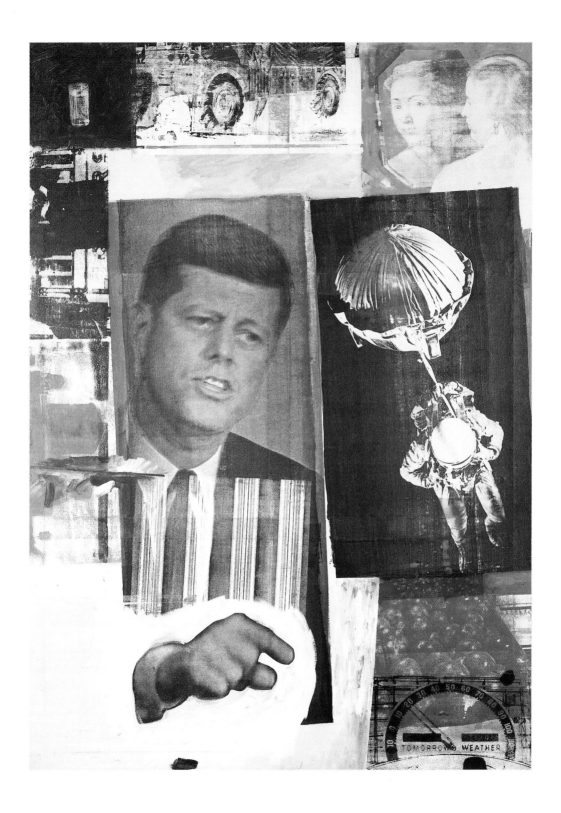

66. GEORGE SEGAL
*Cinema*, 1963. Plaster, illuminated plexiglass,
and metal, 9′10″ x 8′ x 30″ (3 m x 2.4 m x 76 cm).
Albright-Knox Gallery, New York.

legal murder. On a more disinterested level, the balance between celebratory and bleak visions of American modernity answered a serious demand from continental viewers for a complexity, comprehensiveness, and descriptive accuracy that could justify the name "realism," which remained a particularly honored term in European aesthetic thinking.

It was in that context that the American George Segal (b. 1924), still a secondary figure in New York, found himself accorded leading status when in 1963 his sculpture was shown for the first time in Europe, by Sonnabend in Paris. His signature procedure was a simple one: he would cast a human figure in rough white plaster from a living model posed as if performing some repetitive, everyday activity; that figure would then be set, in a way that recalls Kienholz, within an environment built from actual furniture and architectural elements (FIG. 66). The identity of his figures – occupation, class, sex, age – are defined as much by setting and social code as by any clues emanating from the plaster cast of the body. The human shape functions as an effective void – denying its physical monumentality – against the more vivid background provided by the absolutely particularized, but impersonal equipment manufactured to satisfy bodily and psychological needs.

67. ARMAN
*Jim Dine's Garbage Pail* (*La Poubelle de Jim Dine*), 1961. Mixed media and plexiglass, 20 x 11 x 11″ (51 x 30 x 30 cm). Sonnabend Collection, New York.

Segal had begun his career in the Happenings milieu around Allan Kaprow (Segal's family farm in New Jersey had been the scene of several of them). Where Kaprow reduced the human presence in his art to a fleeting occurrence, Segal froze his life-scaled figures in time (even their actions are ones always repeated and without permanent consequence) but drained them of particulars in such a way that standardized things could compete for the viewer's attention on equal terms (thus without need for Oldenburg's theatrical manipulations). The plain, flatly declarative quality of his sculpture, its confident austerity of means, offers greater insight into the powers of art by letting the viewer know just how little he needed to use them.

This proved to be a fine line for any artist to walk. Since the end of the 1950s, a group of artists had been operating in France under the name of "Nouveaux Réalistes" (New Realists). Under this banner, sculptors such as Arman (b. 1928) accumulated dis-

68. GERHARD RICHTER
*Ten Large Color Charts
(work no. 144)*, 1966. In
ten parts, enamel paint on
canvas, 8'2" x 31'2" (2.5
x 9.5 m). Kunstsammlung
Nordrhein-Westfalen,
Düsseldorf.

carded consumer goods in constructions that stressed the themes of over-production and waste (FIG. 67). In Europe around 1960, where Communist parties were still strong, the term was being deployed in order to create a third term between the ideological opposites of a "free" abstraction, inevitably linked to America, and the "socialist" realism of Stalinist cultural orthodoxy. To be a New Realist was to set that ideological impasse aside and face the facts of postwar materialism. Arman's sculpture *Jim Dine's Garbage Pail* of 1961 (a barbed homage to the American artist from the Happenings circle) seeks to reduce the allure of consumer abundance to its spent discards, but in the end cannot distance itself sufficiently from artfulness, from a thousand earlier discoveries of picturesque accidents in framed arrangements of junk. Social interpretation of such work needs to be tempered by a recognition that the New Realists' choice of materials was largely dictated by tactical concerns – the need to counter the undisciplined emotivism and cultivation of subjectivity they despised in contemporary forms of abstract painting, while creating a space for themselves of maximum difference from it.

Even where apparent convergence existed, the rivalry between American and French artists was intense, colored by art-political

struggles over the challenge of New York to the traditional dominance of Paris as center and arbiter of advanced art. Artistic relations between West Germany and America were less confrontational though shot through with ambivalence. Gerhard Richter (b. 1932), who had emigrated to West Germany from the East in 1961 (just before the building of the Berlin Wall made such movement impossible), was one artist whom the booming West of the "economic miracle" struck with full force. He had already undergone thorough training in the backward-looking techniques of socialist realism as an art student in Dresden. Soon after his emigration, he abandoned that manner and all of his previous work in it, adopting a mode of painting he called, with fine irony and eyes on both the Soviet Union and the Western powers, "capitalist realism." His work at first consisted of copies of advertisements and amateur photographs, painted in gray and blurred by combing across the wet oil surface. Like the French New Realists, Richter exploited sources that seemed to possess a near-zero expressive charge, which had for him the paradoxical effect of euphoric personal liberation: "Do you know what was great?" he mused in a notebook entry of 1964-65:

> Finding out that a stupid, ridiculous thing like copying a post-card could lead to a picture. And then the freedom to paint whatever you felt like. Stags, aircraft, kings, secretaries. Not having to invent anything anymore, forgetting everything you meant by painting – color, composition, space – and all the things you previously knew and thought. Suddenly none of this was a prior necessity for art.

Unlike the New Realists, however, Richter's discovery of the everyday pointed toward a renewal of painting – the traditional business of picture-making – not its obsolescence. His sights extended beyond American Pop to take in the most ambitious examples of Modernist abstraction.

In 1966 he completed ten vertical canvases, shown together to compose an ensemble some 31 feet (9.5 m) wide by 8 feet (2.5 m) high, precisely duplicating the color chart of a commercial paint manufacturer, and using the paints themselves in the process (FIG. 68). The source is quintessentially Pop, recalling the prosaic manufactured components used by Segal, but the gargantuan scale, strict geometry, and dramatization of color effects pull the work just as strongly in the direction of Newman, Stella, and other American exemplars of formal Modernism. The *Color Charts* identified the point at which the least referential mode of painting was subject to redescription in Warholian terms of serial, anonymous production for a market. Faced with the first wave of Castelli's conquests in the European marketplace, Richter responded with a work that found a bridge across the rancorous divide that prevailed in New York between vernacular imagery and Modernist abstraction, though both parties were protected by their insularity from any knowledge of what he was doing.

Even an American artist who effectively suspended his work between Pop and abstract impulses faced the prospect of incomprehension and neglect in his native country. Cy Twombly (b. 1928) had been Rauschenberg's close friend and collaborator during the early 1950s, but had moved to Rome in 1957 and missed the shift in direction of New York art following the public debut of Jasper Johns in 1958. For some years Twombly had been redirecting the free gestural marking of Pollock and de Kooning toward an untidy, calligraphic scrawl in pencil and crayon on a large-scale prepared surface (usually canvas). Alongside large loops effected with the whole arm, he began to add small notations, ranging from places, dates, and titles of paintings (frequently evoking Mediterranean classicism) to seemingly random and artless doodles: in some passages, his drawing instrument glided over the ground; in others, it cut grooves into it. He underscored the obvious resemblance of his technique to the defacing gestures of graffiti by incorporating crudely scandalous motifs into his calligraphy, such as cheerily pink buttocks floating like balloons, raining faeces onto the ancient splendor of the Bay of Naples (FIG. 69). When he supplemented his spidery line with such rich displays of paintwork, the result was as likely to trigger disgust as delight in an unsuspecting viewer.

Settled in Italy, Twombly transformed himself into a European rather than American artist, and West Germany in particular proved to be more prepared than was New York to respect such liberties with the Abstract Expressionist legacy and applaud the return of censored bodily impulses. A show of Twombly's

work in West Berlin in 1962 made a particularly strong impact on a younger artist who was working alongside Richter in Düsseldorf, Sigmar Polke (b. 1941). Polke seized on the alternative understanding of Pop suggested by Twombly, that is, an alignment with that invisible populace denied any sanctioned means of artistic expression. By 1963 Polke's preferred media were ballpoint pen (favorite weapon of the toilet-stall graffitist), rubber stamp, and children's poster-paint on cheap, unmounted paper. No major American artist had as yet proved so willing to renounce the slightest advertisement of expertise and refinement, to court the disreputable anonymity of society's unskilled and unwanted.

Where signs of sophistication show through, they are invariably borrowed: Polke took over and enlarged the commercial printer's dot screen in a way that conflated both Lichtenstein and Warhol (with a deliberateness not lost on his local audience). His affinity with the latter extended to the theme of the Kennedy assassination: his 1963 portrait of Kennedy's presumed assassin, Lee Harvey Oswald, (FIG. 70), represents the reverse of Warhol's reverential portrayal of the widow's passage from light to darkness. The

69. CY TWOMBLY
*Bay of Naples*, 1961. Oil paint, oil-based house paint, wax crayon, lead pencil on canvas, 8′ x 9′9″ (2.4 x 2.9 m). Cy Twombly Gallery, Houston.

enlarged pattern of dots both enacts and mocks all efforts to discover the assassin through the representations made of him. Subsequent efforts to write the history of the assassination have only borne out Polke's prescience that the record of Oswald's life would defeat every attempt to assign him a coherent identity, that he would prove to be nothing beyond the contradictory, unrevealing traces in a dozen yellowing archives.

That overtly public image was of a piece with Polke's general undermining of the concept of artistic identity. One conspicuous feature of the American artists promoted by Castelli in Europe was that the work of each carried a look that was unmistakable and from which deviation was evidently dangerous to sales and reputation. The analogy to the function of brand names in the consumer marketplace was inescapable. In 1963, Richter and a colleague, Konrad Lueg (who was to change his name to Konrad Fischer when he became himself a dealer in the avant-garde), staged a performance, which they called *Leben mit Pop* (*Living with Pop*), in the display area of a Düsseldorf furniture store (FIG. 71). There they put themselves on display alongside the other

70. SIGMAR POLKE
*Rasterzeichnung (Portrait of Lee Harvey Oswald)*, 1963.
Poster paint, pencil and rubber stamp on paper, 3'1" x 2'3½" (94.8 x 69.6 cm).
Private collection, Cologne.

Programme and Report:

The Exhibition Leben mit Pop – eine Demonstration für den Kapitalistischen Realismus, Düsseldorf, 11 October 1963. Please note that the number assigned to you is: PROGRAMME (roman numerals)    CATALOGUE (letters) for a Demonstration for Capitalist Realism

Living with Pop
Friday, 11 October 1963, Flingerstrasse 11, Düsseldorf
I)      Start 8 p.m. Report to 3rd floor.
A      Waiting room, 3rd floor (decor by Lueg and Richter)
II)     When your number is called, visit Room No. 1, 3rd floor. Disciplined behaviour is requested.
B      Room No. 1: sculptures by Lueg and Richter
        (plus one work on loan from Professor Beuys)
        (*Couch with Cushions and Artist*
        *Floor Lamp with Foot Switch*
        *Trolley Table*
        *Chair with an Artist*
        *Gas stove*
        *Chair*
        *Table, Adjustable, with Table Setting and Flowers*
        *Tea Trolley, Laid*
        *Large Cupboard with Contents and Television*
        *Wardrobe* with loan from Professor Beuys)
III)    When your number is called (approx. 8:45 p.m.), visit other exhibition rooms on 2nd and 1st floors and ground floor. During this tour (Polonaise), please refrain from smoking.
C      Exhibition rooms on several floors (selected by Lueg and Richter)
        (52 bedrooms, 78 living rooms, kitchens and nurseries, paintings by both painters; guests of honour, Messrs. Schmela and Kennedy)
IV)    On completion of tour, see A etc.
        Subject to alteration.
                                    Thank you for your attention
                                    Konrad Lueg and Gerd Richter

71. From *Gerhard Richter: The Daily Practise of Painting, Writings and Interviews* (ed.) Hans-Ulrich Obrist, trans. David Britt. Anthony d'Offay Gallery, London, 1995.

objects in the room, each mounted on a sculptural plinth; the artist as brand identity joined the ideal private decor of a society defined by its acquisitive success.

In his work over the course of the 1960s, Richter elevated his departures from any norm of stylistic consistency into a principle, but Polke endeavored to avoid establishing even a point of departure from which a secure identity might be gauged. He

Höhere Wesen befahlen: rechte obere Ecke schwarz malen!

72. SIGMAR POLKE
*Higher Powers Command:*
*Paint the Upper Right*
*Corner Black!,* 1969.
Lacquer on canvas,
5′ x 4′1″ (1.5 x 1.2 m).
Froehlich Collection,
Stuttgart.

came to lead a deliberately withdrawn and enigmatic life, periodically issuing allusive artistic signals made from rudimentary, appropriated signs and materials. Printed commercial fabrics, for example, frequently served as supports for his paintings; he was as likely to turn over actual execution to friends staying at his rural commune. But his retreat was no pastoral Factory, in that its production was only fitfully offered to the marketplace, which naturally could not comprehend what it was being offered.

Polke's personal elusiveness, along with the unfixed style and frequently parodic nature of his work, brings him closer to the status of Marcel Duchamp than any of his contemporaries. Also like Duchamp, he toyed with mysticism as yet another way of suspending the sovereign powers traditionally assigned to the artist. Polke's invocation of "higher powers" laid a stronger false trail because of the occult trappings of the hippie counter-culture, to which his mode of life joined him in many ways. But there is no doubting that he maintained an acute eye on metropolitan developments: a painting of 1969 consists only of an inscription, in imitation typescript, which translates as *Higher Powers Command: Paint the Upper Right Corner Black!* (FIG. 72); the relevant section of the canvas is duly painted according to this instruction. In part, the painting renders in absurd form the metaphysical aspiration still embedded in German ideas of art. In the process, it unwittingly took the measure of that intense elevation of mind insisted upon by the American Modernist critics who looked for cues from Clement Greenberg; it finds a comic redescription of their guiding belief that artist and viewer alike must be passionately engaged with certain necessary abstract arrangements of form and color, thereby exercising, in Michael Fried's words, "uncommon powers of moral and intellectual discrimination." And in yet a third direction, Polke alludes to the intervening rise of Conceptual art, in which a work of art could be said to exist entirely through its textual definition or stipulation. The purpose of the next chapter will be to describe the interaction of all three of these tendencies, so deftly superimposed by *Higher Powers Command*, in forming the characteristic vanguardist art of the 1960s.

# FOUR

# *Vision and Performance*

To understand Pop in the early 1960s as a new realism or a return to figuration meant accepting a devalued status for the human body, which had traditionally been the central concern and focus of figurative art. The restoration of reference to the world, offered in defiance of the long march of advanced art toward abstraction, entailed granting manufactured products equal or superior status to the human beings who purchased and used them; Andy Warhol offered, albeit with a certain poignancy, the human figure already transformed into inert products. For sculptors more than for painters, this was a practical difficulty as well, in that their medium had always functioned on the basis of a fundamental analogy with the human figure or its key identifying elements: the torso, the head. And the most innovative work of the period demonstrates how difficult it was to put this convention aside. Claes Oldenburg, in his soft sculptures, turned household products themselves into comic versions of the body or its parts; Edward Kienholz made his figures into warped extensions of dehumanizing environments; George Segal had to grant his subjects their full coherence and physical monumentality in order to signal their relative absence against the backdrop of the product world.

## *Eye of the Beholder*

73. KENNETH NOLAND *Across*, 1964. Acrylic on canvas, 8'1" x 10'6" (2.4 x 3.2 m). Collection of the artist.

The problem proved to be equally difficult on the other, Modernist, side of the American art world. The theory of a progressive reduction of reference to external nature in favor of dramatizing the media of art fitted a persuasive range of actual painting.

Sculpture, on the other hand, remained something of an embarrassment for the theorists. Even the most abstract configurations of forms in space remained planted on a pedestal, which always betrayed its ultimate origins as the base of a statue. To dramatize the medium of sculpture seemed inescapably to conjure up a nostalgia for human resemblance and, even more scandalously, for the civic heroes, saints, and gods to whom the honor of such likeness was traditionally bestowed.

A solution to this impasse arrived from an unexpected quarter, in the person of a younger English sculptor, Anthony Caro (b. 1924), who from 1954 had been fashioning expressive effigies in clay of human and animal figures. Early experience as an assistant to Henry Moore (1898-1986) placed him in a vein of domesticated British Surrealism, seeking organic metaphors in stone and clay likening bodily shapes to geological and biological processes in the landscape. A chance meeting with Clement Greenberg in London spurred him in 1959 to undertake a journey to the United States, where he encountered a number of artists in the orbit of the critic. The immediate result was *Twenty-Four Hours* of 1960 (FIG. 74), a work that contradicted the premises underlying all his previous work. The title of course suggests strong representational connotations that remain in the work: the disk as

74. ANTHONY CARO
*Twenty-Four Hours,* 1960.
Painted steel, 4′6½″ x 7′4″
x 33″ (1.4 m x 2.2 m x
83.8 cm). Tate Gallery,
London.

clock-face, cycle, and sun rising over a hill against a panel of sky. Caro's means, however, denied all expectations that a sculpture be a compact, unified volume. Nor was there any inherent illusionism or disguise lodged in his frank technique: three flat sheets of steel welded to produce a certain visual effect rather than a gravity-bound shape.

Shortly after completing *Twenty-Four Hours*, Caro reflected on his transformation: "There's a fine-art quality about European art, even when it's made from junk. America made me see that there are no barriers and no regulations." He made that remark to Lawrence Alloway, who had brokered an earlier wave of American artefacts into English art. Caro, however, was responding to a different, more refined stimulus than the racy product designs embraced by the Independent Group; he saw instead the sharpening of a sophisticated market in fine art, a set of new models for achieving a cosmopolitan professionalism. And in his determination to discard forever "encrusted art-like objects," he succeeded over the next two years in steering sculpture away from any dependency on either plinth or picture plane. *Early One Morning* of 1962 (FIG. 75) features an upright rectangle evocative of a painting on its easel, but that silhouette takes its place as one free-standing object within an open relational structure joining it to bits of girder, conduit, pipe, and plating, each component detached from any prior functional context. Requiring no mediating base and occupying next to no actual volume the sculpture creates and occupies its own considerable space (over 20 feet or 6 meters long); its spare structure ensures that passage around the work will yield an unfolding sequence of surprising new visual configurations; the clean application of a single hue over the entire ensemble of the steel and aluminium sculpture effectively guides the viewer's attention toward relationships between the elements rather than toward their utilitarian origins (it is indeed on noticing the preformed components with their plain bolts and welds that the viewer fully comprehends the unlikely degree of lightness achieved in the work).

Caro's taking of inspiration from the emerging color-field painting in America (his improvised balancing of disparate parts is closest in approach to Helen Frankenthaler) proved to be only half the story; Modernism in New York proved just as much in need of him. Michael Fried was at this point a young postgraduate student in Oxford and London; temporarily cut off from his formative associations (such as his university friend Frank Stella), he reacted to his first encounter with Caro's sculpture as if seized by sheer force of revelation. Greenberg, too, was reported to have been thrilled on first seeing photographs of the work. The

critics' need for a dramatic breakthrough – that was the term they used – is understandable. The use of recognizable, vernacular imagery in the art so ably promoted by Castelli posed a threat to their most fundamental values. With the marketplace moving so one-sidedly in that direction, it had become doubly important to shore up support for Modernist abstraction in other centers of power, notably in public museums and university departments of art history.

In that endeavor it was obviously important that its intellectual theory be developed and sharpened. Greenberg's founding ideas had been bound by a rather old-fashioned concern for policing the boundaries between media (a preoccupation as old as the eighteenth-century philosopher Gotthold Ephraim Lessing); it also lacked a persuasive set of technical norms for sculpture on a par with the bracing clarity of picture plane and framing edge.

The "radical unlikeness to nature" that Greenberg identified in Caro's work, rendered less in particular shapes than through "vectors, lines of force, and direction," finally completed the sculptural side of the ledger: Fried concurred that Caro, while decisively occupying three-dimensional volumes of space, had successfully removed all analogies to the earthbound human body and instead offered disembodied vistas directed to eye and mind. "Opticality" was his word for that paradoxical achievement, and it gave the Modernists a positive term to designate and draw together the work they valued in both media.

The reciprocal action of Caro upon his American sources was far from limited to ideas. The early stained paintings of Kenneth Noland (b. 1924), composed of concentric circles, had made an evident impact on Caro's *Twenty-Four Hours*. Like Morris Louis, Noland was both a Washington resident and much cultivated by Greenberg. On Louis's death in 1962, a great deal was expected of Noland. His work at that moment turned away from round, centralized motifs to more solid bars of color suspended diagonally from the top of the canvas and meeting at sharp angles (see FIG. 73, page 105). These "Chevron" paintings (as they came to be called) ventured into the territory of emphatic compositional structure with all of its potential analogies to architecture – as had Caro's plates and girders. The burden now shared by Noland was how to exploit the visual strength of those components within an internal, self-governing structure that could be recognized nowhere else but in a work of art. In his case, this meant that the edges of the bars had to be perceived as merely a cessation of the stain rather than a boundary to the color areas; that is, form and color had to be indistinguishable from one another. By extension, the composition "worked" – which is to say, promised satisfying visual discoveries – through contrasts in hue and intensity of color. The crucial unity of the painting was secured by minutely judged, unexpected choices in placement and interval (as in the

75. ANTHONY CARO
*Early One Morning*, 1962.
Steel and aluminium
painted red, 9'6"x 20'4"
x 11' (2.9 x 6.1 x 3.3 m).
Tate Gallery, London.

Works such as this served as the focus of collective discussion at the St. Martin's Sculpture Forum, which brought together faculty and students at the St. Martin's School of Art. One former student has underscored its resolute concentration on formal questions, recalling that its dominant personalities "would avoid every broader issue, discussing for hours the position of one piece of metal in relation to another. . . . Twelve adult men with pipes would walk for hours around sculpture and mumble."

distance from the point of the lowest chevron and the bottom of the canvas).

Success in harnessing this thoroughly "optical" approach was supposed to be apparent, without conscious reflection, to any sensitive observer. That recognition was its own reward; it permitted vicarious participation in the moral and emotional force that underlay the artist's discipline and ceaseless self-questioning. In the increasingly contentious atmosphere of the 1960s art world, however, the conditions under which such delicate psychological transformations might take place were always under threat. Fried produced a manifesto exhibition in 1965, *Three American Painters*, in which he sought both to argue in the catalogue and demonstrate his case on the walls; it took place in the Fogg Art Museum of Harvard University. That venue put him safely outside the main line of fire in New York, provided an audience that was both provincial (in art terms) and amenable to verbal persuasion, while sheltering the art in question (Noland and Stella, along with Jules Olitski) within an academic aura of objective historical and philosophical inquiry.

The power conferred by such institutional affiliations was a key, recurrent element in the history of art developments in the 1960s. It was especially useful in bolstering the watchful vigilance required of the 1960s version of the Modernist critic. The exact character and value of the inner experience he most valued remained stubbornly beyond description; what could be described were the impurities and mistakes that distracted the viewer from achieving the required state of concentrated mental alertness. These were manifold, and the critic was charged with policing the boundaries of suitably "ambitious" art – a task seen by the Modernist critics as virtually equal in importance to the work of the artists themselves.

But it remains an open question whether that resort to the power of an identifiable establishment served the ultimate interests of the artists so protected. Institutions like Harvard were fast losing their reputation as seats of disinterested intellectual inquiry. That university and others like it had provided John F. Kennedy with arrogant advisers who were fast pushing his successor Lyndon Johnson into an open-ended war against the insurgency in Vietnam. The promise of 1960, when Kennedy's victory seemed to give intellectuals from the leading universities the chance at real influence in policy, a short time later turned sour, as those same intellectuals became objects of opprobrium for student activists. Within the confines of the art world, the painting and sculpture that came under the umbrella of Mod-

ernism began to suffer dismissal, in part because its exclusion of the outside world and its cult of fine discrimination seemed a mocking irrelevance in a time of political crisis. But just as important were its indelible associations with the interlocking structures of power in America, which linked the White House, Congress and official agencies to Wall Street banks and law firms to international corporations to universities and charitable foundations to the governing boards of the great museums.

## Monochromes

The defensiveness that defined the Modernist position during the 1960s becomes doubly understandable when one realizes that threats to it seemed to multiply almost to infinity. Challenges came not only from the obvious scoffers in the ranks of traditionalists and the Happenings or Pop artists; they also arrived in the guise of paintings that bore a strong family resemblance to works admitted to the canon. Bridget Riley (b. 1931), an English artist with a background in advertising and commercial design, offered a case in point. In the mid-1960s, she undertook works such as *Burn* (FIG. 76) that rest on a grid of repeated, nearly identical units. She acknowledged the late-Modernist tenet that composition should be all of a piece, banning divisions between large internal parts and any domination of figure over ground; but the sum of her calculated variations in shape and tone was to induce an encompassing optical illusion that seized the viewer's perceptive faculty with disorienting results.

This was in every respect an art of psychological transformation: her technical manner of constructing a painting is sober and unassuming; close inspection of *Burn* blocks the optical illusion but reveals a strong visual statement rendered in the modulated tones of grey and the refined rhythms of shape in the small triangles. Extended contemplation, of the kind Riley intended, allows a viewer momentarily to attend to the pattern of construction before being again seized by the involuntary visual response, that is, to negotiate and comprehend the electric jump that occurs between her discreet pictorial means and her spectacular effects.

Attentive inspection is further invited by the modest size – just under two feet (55 cm) on a side – of a painting like *Burn*, but that reticent quality did not prevent its brand of illusionism from being seized in turn by a media circus when her paintings were first shown at the Richard Feigen Gallery in New York. Fashion and graphic designers extracted the eye-fooling devices

76. BRIDGET RILEY
*Burn*, 1964. Emulsion on
hardboard, 22 x 22″ (55.8 x
55.8 cm). Collection of the
artist.

and adapted them to fit every sort of ephemeral product. Op
art became its name, the rhyme with Pop being inevitable (despite
the entirely different bases of the two tendencies); in no other
case had a fine-art innovation been so quickly appropriated as
a marker of novelty in mass-produced merchandise. It was one
further sign of the new aura of success surrounding art in general
that such a label could instantly signify youth and smart sophis-
tication to a broad marketplace.

Riley herself recoiled from the Op explosion (going so far as
to threaten a lawsuit against one opportunistic American fabric
designer who copied the precise pattern of one of her paintings).
She could see that the disposability of such a sudden commercial
trend would rapidly cause her painting to appear dated by asso-

ciation (FIG. 77). The media spectacle – and the demeaning link of a woman artist with fashion – also gave opinion makers in the American art world a ready reason to dismiss her work out of hand as tricks and gimmicks, in contrast to the welcome given her countryman Caro as a virtual savior.

In this these critics were themselves willing victims of the same trend-mongering. But there was a deeper reason for their unease, in that Riley's work called the bluff of much vague and unspecific talk of "expressive content" in Modernist painting. For a critic like Fried, the exact character of the psychological transformation induced in the viewer by a suitably serious and ambitious painting lay beyond articulation, in large part because no precise description could ever equal the enormous moral importance placed on the consummation of the experience. Riley filled in the psychological component, and it turned out to be neither trivial nor transcendent, but rather some interesting place in between. She had the temerity to exercise a certain control over the viewer's mental state, to trigger palpable physical experiences of heightened alertness: she meant the viewer's involuntary cognitive responses to recall sensations, in her words, of "running...early morning...cold water...fresh things, slightly astringent." For taking that reasonable measure of the powers of abstract painting, as well as for recognizing the inherently physical, bodily character of optical perception, the Modernists could never forgive her.

Riley's work of this period also rigorously eliminated color, an exclusion that evoked drawing and further set it apart from the example of a painter like Noland. Her principle of repeating small units of one geometrical type established a stabilizing grid beneath her startling optical effects. Both of these underlying consistencies were simultaneously being intensified and refined by another artist, Canadian-born Agnes Martin (b. 1912). Living most of her first forty-five years in western North America, she depended (as Betye Saar did) on the opportunities offered women in school teaching and remained outside the notice of metropolitan centers. In 1957 her friendship with Betty Parsons, Jackson Pollock's former dealer, brought her back to New York (where she had twice been a student in the early 1940s and 1950s). From that point, her paintings quickly evolved from freely painted organic abstractions to all-over grids, drawn onto muted gray or white fields of pigment.

It is striking that two women artists, operating on opposite sides of the Atlantic, should have drawn parallel lessons from the all-over compositions of Pollock and de Kooning, should both

77. Evening ensemble from the Carpucci Winter Collection, Paris, 1965.

have seen the finely controlled, abstract grid as the next logical step for painting, should both have seen emotionalized rhetoric and self-exposure as superfluous to the task at hand, and should both have opted for pure tone over color. The visual qualities of Martin's paintings, on the other hand, were a world away from Riley's. Instead of seeking to subdue the medium of paint in an even skin, the Canadian-born artist let her pigments soak into the raw duck; that rough ground was necessary to the real pictorial events in a work like *Harvest* (FIG. 78), created by dragging a graphite pencil over the surface according to a predetermined scheme of continuous, perpendicular lines.

That manual act of ruling is key to the paradox of the work: the impersonal geometry generates a quasi-infinity of minute accidents as the lead leaves its track over the tiny hills and valleys of the canvas weave. Her varying force behind the pencil, as muscles tire and stiffen, introduces further irregularities. Such painting is simultaneously modest in its claims and exceedingly demanding of the viewer's time and powers of concentration, requiring surrender to a subdued, contemplative state, that is, if the painting is to reward attention at all. The dense accumulation of closely spaced lines in Harvest creates thousands of rectangles, each one an identical artefact of the governing system and simultaneously a unique, unrepeatable thing (in contrast to the mass-production logic seized upon by Warhol and Ruscha). One commentator aptly likened them in this respect to snowflakes, an analogy that captures the fundamental naturalism of Martin's approach to painting, one consistent with her emotional tie to the far Western terrain that again drew her away from New York in 1967. Conventional landscape sentiment is rigorously excluded; instead her paintings stand as intensely concrete metaphors for the principle by which infinite natural variety is generated from a small number of physical laws and an iron determinism in which human feeling plays no part.

Both Riley and Martin ultimately appeal to the authority of nature: the former's arresting illusionism depends upon triggering complex neurological mechanisms belonging to the higher reaches of biological evolution; the latter's sensual concreteness plays on the divide separating human subjective faculties from the underlying natural order. It is characteristic of the grid-based, generally monochrome painting of the 1960s that it could accommodate, within an apparent formal kinship, the most disparate intentions and effects. It was also a meeting ground for artists who came to the discipline from idiosyncratic directions. Robert Ryman (b. 1930) had come to New York in 1950 from Tennessee in the

78. AGNES MARTIN
*Harvest*, 1965. Acrylic and
pencil on canvas, 6' x 6'
(1.8 x 1.8 m). Vassar
College Art Gallery, New
York.

hope of establishing himself as a jazz musician. Among the sub-
sistence jobs he took to support this pursuit was temporary work
as a guard in the Museum of Modern Art, which he held from 1953
to 1960. Exposure to the museum's collections turned his aes-
thetic ambitions toward the visual, but he avoided all of the nor-
mal paths of training in his new discipline. Instead he simply acquired
his own materials and began to work. His approach was to begin
with painting's simplest components, which he took to be thick
paint in a single hue. Early experiments in green and orange
gave way to variations of white, and he has remained within
that self-imposed limitation for his entire career to date (FIG. 79).

Painting after painting, in a variety of media and support-

79. ROBERT RYMAN
*Untitled*, 1960. Oil on
cotton, 42 x 42″ (109 x
109 cm). Hallen für neue
Kunst, Schaffhausen,
Switzerland.

ing surfaces, worked through the most subtle chromatic, tex-
tural, and reflective possibilities of white pigment. His approach
subsumed all the subordinate elements of a painting's presentation
– the treatment of the canvas edges, the artist's signature, the mech-
anisms of fastening the work to the wall, the surrounding surfaces
– as equal elements in a single-mindedly visual statement. It is fit-
ting that Ryman's career should have taken shape within the white,
cubical galleries of the Museum of Modern Art. His work not only
requires those highly specialized viewing conditions; it concen-
trates them into its very substance. And his ability so to delimit
the concerns of his art depended on the newly authoritative his-
tory of twentieth-century painting which that institution had done
most to create. Any history promulgated by a museum will entail
the necessary fiction that works of art generate other works of art

with little mediation of historical context, which cannot be displayed on its walls. Ryman made his art out of the same assumption; he could form a valid project through the *consumption* of certain ideas about what mattered in recent practice, while forgoing anything like the traditional apprenticeship in the *production* of paintings.

This phenomenon is yet another example of the elusiveness of meaning in monochrome work. Ryman's paintings present themselves as nothing but declarative, self-evident surfaces, but the viewer's access to them depends upon grasping complex sequences and permutations of other, absent works, such that the experience resembles handling a language more than surrendering to immediate, phenomenal sensation. A useful contrast can be made with a painting by the Scottish artist William Turnbull (b. 1922) made after a first visit to New York in 1957 (FIG. 80). His first response to encounters with the painting of Pollock and Rothko was to animate the entire surface of his canvas in swirls of thickened white oil paint. The deft assurance of handling and sensitivity to the play of shadow and reflection within the painted field went far beyond anything Ryman had achieved at the same date (though he would catch up later). It would do no good, however, to advance a claim for priority for Turnbull. The older artist, with a thorough studio training behind him, regarded the monochrome as one experimental move within an eclectic set of options (including biomorphic sculpture). The viewer therefore looks for – and finds – a traditional kind of painterly performance, one that happens to be unexpectedly and impressively conjured from a single hue.

80. WILLIAM TURNBULL
*29-1958,* 1958. Oil on canvas, 5′ x 5′ (1.5 x 1.5 m). Collection of the artist.

Ryman's implicit devaluation of immediate visual experience excluded him from the canon of approved Modernist painters in the early 1960s; it was after all the critic who was supposed to provide the mental construct within which any individual work was to be placed. But Ryman nonetheless shared certain fundamental assumptions with Clement Greenberg and his followers; his art implicitly endorses the view that the logic of art is to be

discovered in an exemplary series of high aesthetic moments and that this logic can be persuasively displayed within the pristine confines of the white-walled modern museum. Few painters had the means, will, and intellect to contest these assumptions. Ad Reinhardt (1913-67) was the most prominent artist who could and did contest them, and that stance brought him increasing influence among younger artists over the course of the decade.

Of his generation, only Barnett Newman enjoyed a similar standing. Both of these native New Yorkers carried an authority born of earlier trials and neglect; Reinhardt offered an even greater depth of experience as a practitioner – extending back to the geometric abstractions he painted from 1936 to 1941 – along with decades of political commitment to the beleaguered cause of the American Left. In the latter pursuit, he carried on a parallel career as a satirical draftsman, aiming many of his cartoons at the hypocrisies of the art world. But he refused to subordinate his painting to any sort of instrumental commitment, least of all social commentary. Instead, only the most extreme refusal of art's normal blandishments were for him a sufficient moral response to the plight of the artist in a society ruled by capital.

In his eyes, even the drastically reduced procedures of the self-taught Ryman signified a virtually Baroque excess. In the set of negative rules laid down in his 1957 manifesto entitled *Twelve Rules for a New Academy*, he ruled out as trivially ingratiating both visible patterns of brushwork and any use of the color white. By 1962, he had arrived at what he regarded as the final, ethically and logically impeccable form of painting (FIG. 81):

> A Square (*neutral, shapeless*) canvas, five feet wide, five feet high ...(*not large, not small, sizeless*), trisected (*no composition*), one horizontal form negating one vertical form (*formless, no top, no bottom, directionless*), three (*more or less*) dark (*lightless*) non-contrasting (*colorless*) colors, brushwork brushed out to remove brushwork, a matte, flat, free-hand painted surface (*glossless, textureless, non-linear, no hard edge, no soft edge*).

The apparent blackness of such works comes from a patient, self-cancelling overlay of colored pigments, applied in such a way as to be almost drained of their oil binder. In comparison to Reinhardt's black(ish) canvases, Frank Stella's *Die Fahne Hoch!* of 1959 (see FIG. 45) registers as showy and obvious in its iconoclasm; its lurid title itself would have been an anathema to the older artist. Reinhardt's imagined viewer sheds every sort of baggage in allowing the smallest perceptual variations to enlarge themselves in pro-

longed encounter with the object, in his words again, "a free, unmanipulated and unmanipulatable, useless, unmarketable, irreducible, unphotographable, unreproducible, inexplicable icon." Ironic confirmation of his stance came from viewers who received the message and reacted violently against it: in a 1963 Paris exhibition, his paintings had to be roped off from visitors to prevent their being defaced; the same vandalism recurred at shows in New York and London. After his death in 1967, Reinhardt's severe example burgeoned in importance for the succeeding generation. Not for the last time, disgust with the venality of the art world and with the endemic corruption of political life manifested itself in art that approached a blank and featureless state.

81. AD REINHARDT
*Abstract Painting No. 5,*
1962. Oil on canvas, 5′ x 5′
(1.5 x 1.5 m). Tate Gallery,
London.

## Blues

Blank and featureless, it should be recognized, were conditions that Martin, Ryman, and Reinhardt risked but never fell into; their radicality was all about altering the time and tenor of the viewer's act of contemplation. That distinction became all the more apparent when a group of truly blank monochrome paintings arrived in New York in 1961.

The occasion was an exhibition mounted by Leo Castelli of a group of paintings by the French artist Yves Klein (1928-62). By 1958, Klein had declared a particular deep shade of ultramarine blue to be his personal signature: "International Klein Blue" (IKB). He applied the color to rectangular panels rounded at the corners to distinguish them from the format of a normal easel painting. Instead of brushes, he used a housepainter's roller; instead of oil, he employed a modern chemical binder that produced a desiccated surface devoid of painterly traces (FIG. 82). The varied ripples and bumps in the minute granules of pigment appeared as random reactions of the material itself rather than conscious (or unconscious) interventions by the artist.

Mild interest was the most positive response that Klein received, the rest ranging from indifferent to hostile. The undeniable intensity generated by Klein's nonrelational fields of intense hue might have won him more sympathetic adherents had it not been for the style of relentless self-promotion with which he surrounded the show (much to Castelli's evident embarrassment). He had come to art in the later 1950s after an earlier, largely failed attempt to establish himself as the leading judo expert in France. (He had studied in Japan from 1952 to 1953 and later worked as a judo teacher in Madrid and Paris.) He carried over into his painting and performance activities the claims of the adept in some branch of esoteric knowledge, a calling that lent the bearer some mystical superiority over his uninitiated audience (he was also a lover of Catholic ritual). In Klein's personal symbolism, expanses of blue stood for surrender to the limitless atmosphere. The blue monochromes were conceived as embodiments of air. In his "fire paintings," first shown in 1961, he directed flame-throwers at sheets of thick cardboard or wood. The artist was a shaman who called his works into being, deploying the fundamental elements of creation, rather than prosaically painting or sculpting them.

His evocation of earth, another of the four ancient elements, had brought him his greatest notoriety: the sceptical reception of New Yorkers was perhaps most conditioned by the series of

82. YVES KLEIN
*Blue monochrome* (*IKB 83*), 1960.
Pigment and synthetic resin on canvas
and wood, 36¹/₂ x 29″ (92.7 x 73.7 cm).

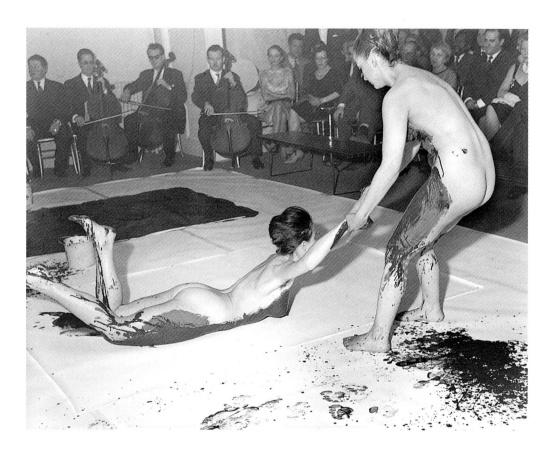

83. YVES KLEIN
*Anthropométries de
l'Epoque bleue.*
Performance at the Galérie
Internationale d'Art
Contemporain, Paris,
9 March 1960.

performances that Klein dubbed *Anthropométries* (FIG. 83), in which he created paintings in public and on film employing the naked bodies of female models smeared with International Klein Blue paint. Appearing in formal dress that unwittingly evoked a sex-club master of ceremonies, he acted out his exalted belief that the true, male creator directs energies and materials from a distance, in this case using the bodies of women as instruments suited to soil themselves and surrender their dignity in the actual production of the work: "I no longer dirtied myself with color," he declared, "not even the tips of my fingers."

Within the Castelli circle, Klein encountered the objection that the monochrome had long been anticipated in Robert Rauschenberg's white canvases of 1951. Working in the same period with Susan Weil, Rauschenberg had also caught life-size images of the nude model against large rolls of light-sensitive blueprint paper. He was himself quick to raise the issue of priority and confronted Klein with sharp words in public. Part of this antagonism arose from an American pragmatism and personal reticence offended by Klein's trailing, extra-artistic claims to

importance. Above all, it was a clear sign that the New York scene now possessed the ability to define key artistic devices in the service of its own priorities and interests; that new confidence on the home front was the complement to Castelli's successful incursions into Europe (using the Ileana Sonnabend gallery in Paris as his base).

In one respect, however, Klein had already acknowledged one important American precedent, though not in the visual sphere. His most public *Anthropométrie* performance, held in Paris in 1960, had been accompanied by a group of musicians playing his own *Monotone Symphony*, twenty minutes of one held tone interrupted by twenty minutes of silence. Two years before, in 1958, John Cage had toured Europe to considerable acclaim, and the principle of Klein's foray into musical composition bore a plainly Cagean stamp. The composer's involvement with visual artists had, of course, already been long-standing and fruitful: he had conceived his famous silence piece, *4'33"* (1952), as a direct response and homage to Rauschenberg's white monochrome canvases. By the beginning of the 1960s (and unknown to Klein), his approach to musical performance had altered a substantial area of artistic practice in America. It was giving a particular impetus to active participation by women, no longer instruments but primary creators, and it succeeded in making the human body again a fundamental matter for art.

## Stage Directions

The cultural movement in this case had proceeded from West to East, beginning in the fluid artistic exchanges taking place in San Francisco during the later 1950s. Its point of departure had been the one area of art practice where women had historically played a dominant role: modern dance. Anna Halprin (b. 1920), in her Dancers' Workshop Company, formed in 1955 outside San Francisco, had gathered around her a remarkable group, incorporating not only young dancers like Simone Forti (b. 1935), Yvonne Rainer (b. 1934), and Trisha Brown (b. 1936), but also attracting practitioners of other arts, among them the composer La Monte Young (b. 1935) and Robert Morris (b. 1931), who was then a student of Abstract Expressionist painting. Halprin's approach to choreography offered ample scope for participation by performers without professional training; she encouraged movements, through improvisation and other devices, to develop according to inherent principles of physiology and everyday functions, unconstrained by musical meter, narrative, or predetermined

84. SIMONE FORTI
*Slant Board,* 1961.
Performance with prop by
Robert Morris, restaged at
the Stedelijk Museum
Amsterdam in 1981.

expressive ideas. Many of the details of performance were minimally transformed versions of ordinary tasks: walking, carrying, pouring, or changing clothes.

Between 1956 and 1961, the younger members of the company decamped virtually en masse to New York. There they found an immediate reception less within the established world of modern dance, with its intermittent seasons of performance, than within the continuous, open-ended activity of the visual arts and the Happenings milieu. In the first half of 1961, a first series of events took place in the downtown Manhattan loft space that belonged to the young expatriate Japanese artist Yoko Ono (b. 1933). Forti took the lead in refining, practically and theoretically, the direction established by Halprin, seeking to demote the dancer as trained professional from center stage, extending the use of tasks and games as the basis of choreography, and substituting in place of music the prosaic rhythms and information of the spoken word.

One means to this end was to use props that imposed some

restriction or distortion of the performer's normal repertoire of movement. In *Slant Board* (FIG. 84), that constraint came from the dancers' need to maintain their positions on the incline by holding onto ropes. The functional, geometric carpentry of these devices helped turn her then-husband Morris away from painting toward sculpture. During this same phase of events in Ono's loft, he constructed a passageway out of plywood that curved for some fifty feet (15.2 m), narrowing to a closed point at the end; the progressively squeezed spectator had no choice, on discovering the dead end, but to return to the entry, where he or she appeared on emergence as an inadvertent performer before an audience of those waiting to undergo the same process.

These kinds of activities preceded and overlapped with Klein's advent at the Castelli Gallery, and their anti-romantic sophistication cast a pronounced shadow over the aura of the French artist. At the same time, in another uptown art space called the AG Gallery, an aspiring composer and entrepreneur named George Maciunas (1931-78) was also organizing a series of experimental events. His followed a more literary bent, but also drew on dance and musical talents like Forti, Rainer, Young, and the Cage protégé Robert Dunn (b. 1939). These two foci of activity soon resolved themselves into distinct centers of activity, the Judson Dance Group and the protean international movement called Fluxus. Together they laid out a great many of the coming possibilities in advanced art for the 1960s, and both did so in the name of committed egalitarianism in both art and in political life.

## Out of Many One

In Yvonne Rainer's performance *We Shall Run* (FIG. 85), first staged in 1963, the participants (who included a number of visual artists) acted out simple, repeated actions that any spectator might have been enlisted to perform. Their found, all-of-a-piece quality stood in pointed contrast to the studied trajectories and internal accents of trained movement. Dressed in ordinary street clothing, the performers also abandoned that permitted zone of discreet sexual display permitted by the customary form-fitting leotard. Carolee Schneemann's (b. 1939) *Meat Joy* (FIG. 86), first performed in 1964, took its massed participants entirely in the opposite direction, to a scandalous degree of nudity and forbidden bodily contact with the raw flesh of fish and chickens; individual actions were lost in continual change; blood and paint smeared male and female bodies alike, the numbers of which varied as onlookers were enlisted into the mêlée.

85. YVONNE RAINER
*We Shall Run*, dance
performance, 1965.

Moving between the recognized territory of dance and new terrain of the visual-arts Happening, both Rainer's and Schneemann's events had in common a willed distance from the sort of performance that offered, in Rainer's words, "nuance and skilled accomplishment,...accessibility to comparison and interpretation, ...introversion, narcissism, and self-congratulatoriness." Both undercut the standard spectacle of the self by multiplying the numbers of dancers and distributing actions among them on equal terms. These ideas emerged from the intense workshops of the Judson Dance Theater, which had formed itself from Cage and Halprin adherents and taken up residence in the same accommodating Judson Memorial Church where Oldenburg had installed his first version of *Street* in 1960. In the church's various underused spaces – basements, a gymnasium – performances took place on a monthly basis, often made up of short pieces by a number of choreographers, who in turn danced in one another's compositions.

In this collaborative venture, contemporary dissent on the political Left – propelled by the escalation of the Cold War between the U.S. and U.S.S.R. during the 1962 Cuban Missile Crisis and by growing U.S. intervention in Vietnam – made its active contribution. In the weekly workshops where new works were reviewed,

the decision-making process was consciously based on the anti-hierarchical model of consensus fostered among pacifist groups like the American Friends (Quakers) Service Committee (AFSC) and the Women's Strike for Peace. No individual or faction was to assume a dominant role, and the principle of inclusion meant that no one who wanted to participate would be turned away. For many artists in other media, the Judson workshop became for a time their primary intellectual focus.

The cross-over with the American Friends group, which was also energetic in sponsoring Gandhian non-violence in the bloody civil rights struggles in the South, represented a rare instance of active interchange between the art avant-garde and organized politics. That, channeled by the need for dancers continually to confer and collaborate, gave a providential focus to the emerging community of artists in downtown Manhattan, as the 1940s preoccupations of the Abstract Expressionist generation reached the end of their usefulness for younger artists. The workshops accelerated the emerging self-consciousness of that generation by taking its floating discussions out of the bar-rooms and individual studios into a focused, demanding forum: "All I could think about, for about a year," recalled one male painter, "was the

86. CAROLEE SCHNEEMANN
*Meat Joy*, performance,
1964.

Judson workshop." The values that were to lend a distinct character to much 1960s art-making – rejection of hierarchy in favor of serial repetition, equality of parts, anonymous surfaces, suspicion of self-aggrandizing emotion – first came together as ethical imperatives in the conduct of the Judson circle. In any full account of the period, the impact of its reflective, proto-feminist variant of avant-gardism needs to be set against the far more prominent example offered by Warhol's contemporaneous Factory.

## In Flux

George Maciunas, for his part, had transferred his operations to West Germany, opening up avenues of collaborative work that extended from America to Europe and even the Far East. The reasons for his hasty departure from the AG Gallery are obscure; what is certain is that he parlayed his experience in designing its concert and exhibition announcements into a job as a graphic designer for the United States military base in Wiesbaden. From his curiously official position, Maciunas promptly launched himself into organizing events like the ones he had so recently witnessed or promoted in New York, drawing on certain American expatriates but also attracting a collection of unconventional artists and performers from all over the Rhineland into the neighboring low countries. The circle of musicians around the composer Karlheinz Stockhausen (b. 1928), centered in nearby Darmstadt, had already established itself as West Germany's leading avant-garde in any medium, so it was in the area of experimental sound and performance that the most use could be made of American innovations. John Cage's European tour in 1958 (which had so impressed Yves Klein) had been received there with acclaim and encouraged demand for more experimental work in a similar vein.

While engaged in promoting concerts in West Germany, Maciunas was concerned – no doubt because of his exile from New York – to reinforce his lines of communication. To this end he seized on a long-simmering publishing project begun by La Monte Young, who had undertaken in 1961 to edit a number of a journal called *Beatitude East* (the title signalling its origins in the San Francisco Beat poetry scene). The journal died before his issue could appear, but Young had in the meantime dutifully canvassed several dozen friends and acquaintances in music, dance, and the visual arts for any textual matter they might contribute. That material gave rise, some two years on, to a weighty, hand-set publication, designed by Maciunas and carrying the simple

main title, *An Anthology*, and the capacious subtitle, *of chance oper-ations concept art anti-art indeterminacy improvisation meaningless work natural disasters plans of action stories diagrams music poetry essays dance constructions mathematics compositions*. In keeping with this unpunctuated, open-ended list (and the non-linear typography makes this rendering only provisional), Maciunas hit on the word Fluxus to designate both the published and performed work by *An Anthology*'s contributors.

In his particular brand of Leftism, he evoked the organizations of early Soviet artists, who had attempted a utopian transformation of the visual environment, down to the most everyday objects and media. The publication in particular advanced his central ambition that the precious, unique art object and the whole art economy – based as it is on scarcity – be displaced by cheap, commonplace, and mutable substitutes. To this end, artists in the Fluxus camp went on to experiment with various kinds of found-object and assemblage pieces that fit these criteria, but the most trenchant redefinition of the work of art was present from the beginning in the pages of *An Anthology*, in Young's own contributions along with those of the composer and sculptor George Brecht (b. 1926). Young could render his pieces in a few words without recourse to conventional musical notation, as in

Piano Piece for David Tudor #2:

Open the keyboard cover without
making, from the operation, any
sound that is audible to you.
Try as many times as you like.
The piece is over either when
you succeed or when you decide
to stop trying. It is not
necessary to explain to the
audience. Simply do what you
do and, when the piece is over,
indicate it in a customary way.

October 1960

In order to comprehend the logic of the performance, an audience would need to sit through it many times and indeed might never succeed; the subjectivity of the artist – far from being the ultimate source of expressive interest – is the destabilizing component that can render the work indecipherable. The writ-

**Above and right**

87. NAM JUNE PAIK
Performance of La Monte
Young's *Composition
1960 #10 to Bob Morris*
as Paik's *Zen for Head* at
the Fluxus Internationale
Festspiele Neuester Musik,
Wiesbaden, 1962.

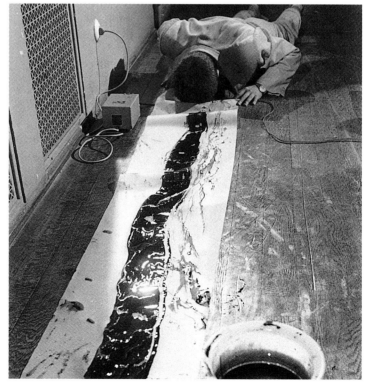

ten version leaves the essential strangeness of the described performance intact, but completes itself when the reader/viewer comes to recognize its paradoxical logic.

Though the outcome may not have been entirely intended, these written renderings succeeded in surpassing the normal categories of notation or reproduction. The performance need never take place for the piece to exist, though it is crucial that its enactment in time and space be realizable and repeatable (this is enough to distinguish such work from poetry). Brecht's "Event Scores" went further and largely eliminated even imaginary duration, as in

CONCERTO FOR CLARINET

• nearby

G. Brecht
1962

The presentation of these compositions in compact chunks of plain sans-serif type (produced on the standard IBM office typewriter of the day) lent them a visual finality and concreteness without recourse to the physical aura of traditional painting or sculpture. Another contributor to *An Anthology*, Henry Flynt, responded by coining the term "Concept Art" in 1961 as an attempt to encompass the new form: in his own short-hand definition, "an art of which the material 'concepts,' as the material of for ex music is sound."

The force of this category began to be apparent from the first moment that one of these works moved from the page to the realm of actual enactment. Perhaps the most spectacular early instance of this translation came in 1962 at a public festival in Wiesbaden organized by Maciunas to celebrate the newly christened Fluxus sensibility. Nam June Paik (b. 1932), a young South Korean artist then living in Cologne, undertook to act out Young's *Composition 1960 #10 to Bob Morris*, the text of which consisted of the simple instruction: "Draw a straight line and follow it." Paik exploited all the latitude permitted by that laconic directive in a realization he entitled *Zen for Head* (FIG. 87): placing on the stage a long roll of paper and a large bowl containing ink and tomato juice, he began by dipping his head, necktie, and hands into the mixture, then used his whole body to trace a path with the liquid along the length of the paper.

In contrast to the blunt objectivity and concreteness of Young's

88. YOKO ONO
*Cut Piece*, performance at
the Yamaichi Concert Hall,
Kyoto, Japan, 1964.

terse stipulation, such a performance – indeed any performance
involving the human body – introduced a strong field of asso-
ciative metaphor. While Paik's supine posture and drenching in
the repellent, blood-like substance absolutely reversed the terms
of Klein's self-created magus, arrogantly standing apart from
the female model paintbrushes in his *Anthropométries*, it is impor-
tant to recognize that abjection can offer an equivalent drama
of the sovereign self. The audience for Young's composition in its
written form had retained a sovereignty over the (imaginative)
completion of the piece; their counterparts in the auditorium of
the civic museum in Wiesbaden, ceded that right to the solo

performer, who returned an alarming spectacle of primitive abasement. The pattern persisted in subsequent Fluxus performance, which found enthusiastic participants and audiences across the world. Yoko Ono's *Cut Piece* (FIG. 88), performed in Kyoto, Japan, in 1964, allowed the audience a more active role but one that similarly disturbed cognitive comprehension by generating extreme emotional and physical tension in her audience: as she kneeled motionless and statue-like on the stage, members of the audience were enlisted one by one to approach her and then to cut away a portion of her clothing.

In this case, however, the change in sexual identity of the performer maintained a troubled balance between mind and feeling. It is difficult to think of an earlier work of art that so acutely pinpoints (at the very point when modern feminist activism was just emerging) the political question of women's physical vulnerability as mediated by regimes of vision. For male artists in the Fluxus orbit, on the other hand, aspiring to a comparable level of social resonance required strenuous exertions. A case in point was Joseph Beuys (1921-86), an already charismatic figure, newly appointed as professor of sculpture at the Art Academy in Düsseldorf. On the look-out for more vivid avenues of self-assertion, he quickly seized on Maciunas's Fluxus events to project himself from behind the work of art to a visible position in front of it, to the point of becoming its very embodiment. That development was to have its parallel in America, and neither proved to be encouraging for anyone hoping to see a relaxation of competitive egoism as the model for artistic success.

# Artists and Workers

The advent of the public Joseph Beuys came at the beginning of 1963 in the context of the same cycle of Fluxus events in which Nam June Paik had unveiled his *Zen for Head*. In one piece, called *Concert for Two Musicians*, the German artist continued the demotion of the artist's authority that La Monte Young and George Brecht had advanced in the pages of *An Anthology*: having surreptitiously placed two mechanical toy musicians on top of a piano, he entered and sat solemnly at the instrument, doing nothing, until their clockwork movement wound down. His second performance, however, turned in an opposing direction. Entitled *Siberian Symphony, 1st Movement*, it began with Beuys actually displaying his skills as a musician, playing on the grand piano a piece by Erik Satie in a vein of fin-de-siècle spiritualism. He then rose and tied a dead hare to the top of a chalkboard at the rear of the stage and ran a string from the carcass to a series of pine twigs that he placed in mounds of soft clay on the closed cover of the piano. Other actions consisted of writing and then immediately erasing a series of messages on the board, then cutting the heart from the hare and hanging that up alongside the body.

He had originally hoped to drag on a dead stag, which he symbolically linked to the sun; practicalities dictated that he settle for the lunar hare instead. The evocation of Siberia and the enactment of animal sacrifice were intended to signal ancient tribal origins in the vast eastern landscape (*Eurasie*) opposed to the constrained rationalism of the West. For Beuys, the expanded range that per-

formance offered the visual artist did not encompass the contemporaneity and playfulness with which American artists from Kaprow forward had invested the form: when the artist revealed himself in performance, it was as the bearer of healing wisdom and guardian of forgotten mythology. He took from Maciunas the credo that the means of creativity could be spread so widely that art would cease to exist as a privileged category: everyone, he declared famously, would become an artist. But he refused Fluxus-style anonymity and systematically set out to create a larger-than-life personal myth, narrated in his choice of materials and objects, through which he appeared as a symbolic conduit between the inchoate aspirations of the modern body politic and the abiding realities of biological existence.

## The Spectacular Artist

90. JOSEPH BEUYS
*Fat Chair*, 1963. Wood chair with fat, height 35″ (89.9 cm). Hessisches Landesmuseum Darmstadt.

While Beuys's message was couched in universal terms, the shattered self-image of a divided Germany, beguiled by the colorful trinkets of American capitalism, was his constant concern. The manufactured objects in his sculpture tended to evoke the era and the traumas of World War II; his binding materials tended to be dun-colored and primitively organic, pre-eminently coarse felt and mounds of fat, as in *Fat Chair* of 1963 (FIG. 90). Intuitively aware that myth making in preliterate societies weaves its narratives around such basic material markers, Beuys incorporated them into an elaborate personal myth of heroism, self-sacrifice, and redemption: as a downed Luftwaffe fighter pilot in the Crimea, so he claimed, his freezing body had been wrapped in fat and felt by Tartar people. Despite the implausibility of the details of the story (for example, that someone arrived equipped with a camera to record the event), Beuys's charisma has guaranteed its continuing credibility for his numerous devotees. What is undeniable is his success in turning even the most amorphous stuff of the world into the articulateness of writing, that is, into the signature of the sovereign artist.

With the untimely death of Yves Klein at the age of thirty-four in 1962, Beuys assumed an unchallenged position in Europe as artistic seer and myth maker. The following year saw the equally premature death of the Italian artist Piero Manzoni (1933–63), which deprived the Continent of its principal antidote to the grandiosity and absence of irony shared by Klein and Beuys. When the former laid claim to ultramarine blue (and with it sky and sea) as his personal signature, Manzoni responded from around 1957 with a series of white canvases and reliefs he called *Achromes*, that is, works meant to be drained of all color.

At the same time, he had been moving toward work in which the aesthetic reward was entirely withheld, the only visible aspect being its packaging and the artist's uncorroborated guarantee of authenticity.

Earliest among these were small cardboard canisters, begun in April 1958, each holding a roll of paper and bearing a simple, printed label: "CONTAINS A LINE...METRES MADE BY PIERO MANZONI THE...," the blanks to be filled in with the length and date in each particular case. In 1960, he monumentalized this cylindrical container into a sealed zinc and lead monster containing a line over four miles (7 km) long, but this was a monument in the sense of a lead coffin for the artist's defining mark on the world (reduced in any event to its purely physical dimension), which was then ceremonially buried. His greatest notoriety came the next year when he anticipated Beuys's embrace of amorphously organic matter, issuing a set of sealed tins labelled *merda d'artista* (the artist's shit). At the same moment, he created the *Base Magica* (*Magic Base*; FIG. 91), where helpful footprints invited the onlooker to step up and be elevated into a living monument simply by taking advantage of the height and majestic aura conferred by the space of art.

91. PIERO MANZONI *Base Magica* (*Magic Base*), 1961. Wood and felt, height 23¹/₂″ (60 cm), base 32 x 31¹/₂″ (81 x 80 cm).

As with many radical gestures in European art of the period, clear antecedents existed for Manzoni's ideas, ultimately in Duchamp and more immediately in Rauschenberg's youthful output. The same can be said of the pieces enacted in 1962 by Stanley Brouwn (b. 1935), a Dutch artist as reticent as Manzoni was extroverted: taking up the same idea of the hidden trajectory implicit in Manzoni's lines, he designated as art his walking from one place to another, along with the marks on paper left by random passers-

92. ROBERT MORRIS
*Site*, performance with
Carolee Schneeman, 1965.

by or directions solicited from them (*This Way Brouwn*). But
no deflation of artistic mystique-mongering can ever be perma-
nent, just as no form or procedure, however unconventional, is
proof against the irrational aura of art. Beuys's career was to go
on demonstrating the point; Manzoni's packages and Brouwn's
ephemeral trajectories stood at least as anticipatory, insightful cau-
tions against that outcome.

The mid-1960s in New York saw something of the same strug-
gle between sceptical self-denial and the reinvention of the sov-
ereign artist as spectacular body; and this argument could be played
out in the work of a single artist. The continuing career of Robert
Morris offered a signal case in point. At the time of his partici-
pation in Simone Forti's dance works, he produced *Box with
the Sound of Its Own Making*, a work that put in the way of the
viewer, much as Manzoni was doing, a prosaic container for an
invisible creative effort. Morris's version of the idea was a blank
cube, nailed together from pieces of plain hardwood some ten
inches (25 cm) on a side; concealed within was a tape recorder end-
lessly playing back the sounds of the work – sawing, sanding, ham-
mering – that had gone into making the object.

In May 1965, Morris used a similar noise-producing cube as
a key prop in a performance of his own, entitled *Site* (FIG. 92),
which he repeated to considerable acclaim over ten performances

in America and Europe. This larger box, painted white along with every other prop, signaled the start of the performance with the sound of a jackhammer drill. The artist entered in plain workman's clothing to face three standard sheets of plywood. Handling the unwieldy panels with impressive muscularity, he seized, turned, and shifted them to reveal the reclining figure of Carolee Schneemann, nude and covered in white makeup, exposed against a fourth panel in the exact pose and accessories of *Olympia*, Edouard Manet's famous 1863 painting of a naked prostitute in the pose of a Renaissance Venus. Then the dance with the plywood sheets repeated itself until Schneemann's figure was again hidden from view. Any trace of his expression was hidden by a mask molded (by Jasper Johns, no less) from Morris's own face.

In one almost trivial sense, the work was a deliberately absurd acting out of the Modernist cult of the flat picture plane. Numerous art historians – led by Greenberg and Fried – have traced the progressive revelation of painting's essential nature specifically back to Manet's painting of the 1860s, citing its broad, emphatic brushwork, its simplifying elimination of half-tones, and the impassive, psychologically ambiguous quality of his figures, which made his handling of the pigment stand out all the more. But, more seriously for coming developments in art, Morris laid claim to the area of performance for the individual – and male – artist, much as Fluxus performance had done in Europe. As Schneemann's generous participation indicates, Morris staged the piece within the Judson Dance Theater setting; but the egalitarianism of her or Yvonne Rainer's choreography was reduced in *Site* to an insistent display of singular masculine physicality.

## *Primary Artifacts*

That physicality also was yielding permanent artifacts. Few in the audiences for *Site* (at least in New York) would have missed the connection with Morris's 1963 exhibition (FIG. 93) of the large geometric solids, constructed in gray-painted plywood, which he had been building as performance props for Forti and other dancers since 1961. Arrayed around the Green Gallery (the space backed by the collectors Robert and Ethel Scull and devoted to exploring forward developments), Morris's structures functioned as sculpture, but sculpture with a difference. Neither a pedestal nor Caro's optical envelope demarcated the shapes from the surrounding environment. This turned out to be the effective advent of Minimalism, though the term itself was not yet current. Michael Fried, by then the leading voice among Modernist critics, reacted to

93. ROBERT MORRIS
Installation at the Green
Gallery, 1963,

Morris's work with something approaching horror: in a landmark polemic in the journal *Artforum*, he declared that these large, simple shapes were not properly art at all, but belonged to the realm of theater; what was more, Fried's conception of theater, rather than being an equivalent sister art to painting and sculpture, was actually a compromised location *between* the arts and as such the antithesis of aesthetic integrity.

The power of the Modernists was resented and feared. Morris himself had moved to preempt their authority in the pages of the same journal: yes, he asserted in a series of lengthy, erudite articles, his objects contested the idea that a painting or piece of sculpture could offer an experience transcending the material conditions of its existence. Their surfaces were plain and unvarying; their materials those of the factory or building site, offered without disguise; their shapes and arrangements obvious at an initial glance, mocking any search for internal intricacies or visual surprises. These harbingers of Minimalism were intended to be intruders in the space of aesthetic delectation, which no longer seemed to insulate the work of art from contingent space and time. The surrender of bodily awareness to delicate optical fictions – on which the Modernist transcendental idea of the art experience depended – became excluded from the gallery.

In Morris's particular case, the origins of his objects in performance were well known, and even when exhibited on their own they loom, hover, and obstruct in such a way as to retain the strong sense of being props in some unknown scenario into which the onlooker has wandered unawares. But Fried's nightmare was that a number of other artists were converging from very different directions to produce similarly unclassifiable, "literal" objects (not traditionally sculptural objects, not architecture, certainly not painting) with no ties to performance at all. Donald Judd (1928-94) had pursued a fitful career as a painter through the

later 1950s and early 1960s, while adding an art-history degree to his earlier university training in philosophy. He earned his living largely as an art critic between 1959 and 1965, honing a precise, spare prose style, and was as undeterred as Morris by the verbal brilliance of the academic Modernists. Asserting that "actual space is intrinsically more powerful and specific than paint on a flat surface," he offered his best arguments in practice. His aim was the defeat of illusionism, and he regarded any internal relations of parts not directly dictated by the shape of the whole to be illusionistic. When Frank Stella had first shown his "black paintings" in 1959 (see FIGS 44 and 45), Judd had been impressed by the deductive interrelationship between the symmetrical patterns and the shapes of Stella's canvases; he had been equally taken by the fact that the stretcher bars extended well out from the wall, a full inch wider than the norm. The monochrome surface, however blank it might be, could not by itself be the antidote to illusion: the work had to occupy actual space but at the same time elude the category of sculpture, which lay in wait with another set of illusionistic expectations.

Judd's *Untitled* of 1965 (FIG. 94) stands as an early resolution of these self-imposed demands. Its strict symmetry and industrial fabrication banish any search for complex inner relationships of form. Anthony Caro was, at this same moment, also using industrial materials, but conspicuously transformed them – welding them together in unexpected combinations and angles, coating

94. DONALD JUDD *Untitled*, 1965. Light cadmium red enamel on cold-rolled steel, floor piece, 15¹/₂″ x 11′6″ x 9′9″ (36.9 cm x 3.5 m x 2.9 m). The artist's estate.

them in a skin of bright pigment – so that their origins became something secondary rather than something forthrightly declared. Caro's mode of composition was the static equivalent of the posed, accented dance movements that Rainer had excluded from her performances; in words that exactly echoed hers, Judd declared, "It isn't necessary for a work to have a lot of things to look at, to compare, to analyze one by one, to contemplate." He transferred the aesthetic of task and function from Judson-style dance to the gallery. The task was what mattered, not who performed it. Judd relied on skilled specialists to construct – following exacting specifications – his subsequent works in sheet metal, Plexiglas, and plywood.

Other artists soon to be grouped under the label of Minimalism were equally prepared to rely upon prefabricated components from the industrial sector, among them Dan Flavin (b. 1933) and Carl Andre (b. 1935). The early careers of both had been much like that of Robert Ryman: living on the fringes of the burgeoning New York avant-garde, teaching themselves, absorbing ideas more than techniques, dabbling in concrete poetry, and generally specializing in cheap, ephemeral work on paper. Where Ryman, however, had gradually grown into his individual vocation, Flavin and Andre each hit on theirs in a sudden epiphany. Flavin even made the date of that event the title of his breakthrough piece, *Diagonal of May 25, 1963* (FIG. 95), a single fluorescent light-fixture, purchased as a standard commercial unit and hung on the gallery wall at a 45° angle. In Andre's case, after a tentative start using rough-hewn pieces of timber (a careless friend mistakenly burned his first efforts as firewood), the defining moment came with his adoption of standard mass-produced bricks, simply lined or stacked on the gallery floor (FIG. 96) as his signature material. Later he added to his repertoire arrays of adjacent, identical square metal plates, which took possession of the space beneath the feet of the spectator. As with Judd and Flavin, his arrangements presented one simple, unmistakable shape to the onlooker; he went one step further toward eliminating artifice in that gravity did all the work in holding these pieces together: when an exhibition was finished, the components were stacked, crated, and hauled away.

Andre was not alone in believing that such practice carried an edge of social criticism, even of political dissent. There was a laconic eloquence in the Minimalists' preference for everyday materials, which carried with them a certain common-man poetics; more than this, refusal of a fine-art "look" was deemed a subversion of the gallery as a marketplace for rare and precious goods; and compositional qualities of anonymity, repetition, and equality of

parts continued to supply basic metaphors for altruism and egalitarianism in politics.

Minimalist art, however, was not being arrayed in the free spaces of a philanthropic institution like the Judson Church. After Happenings and Fluxus, it represented a firm return of the experimental artist to the confines of the commercial gallery and pristine museum. While these artists may have set out to upset the normal conduct of such spaces, they were not blind to their dependence on them; in an art without significant internal relationships, it was necessary to dominate a context of sufficient order and clarity to make a light-fixture or a stack of bricks register as an art event. The gallery, moreover, was replacing the studio as the space in which the work was actually brought into being: if the Min-

95. DAN FLAVIN
*Diagonal of May 25, 1963.*
Cool white fluorescent light, length 8′ (2.4 m). Saatchi Collection, London.

96. CARL ANDRE
*Equivalent VIII*, 1966.
Firebricks, 120-unit
rectangular solid, 2 high
x 6 header x 10 stretcher,
5" x 27" x 7'6" (12.7 cm
x 68.6 cm x 2.3 m) overall.
Tate Gallery, London.

imalists were interrupting the supply of rare, portable objects, they were conferring an importance on the traditional space of display – and on curatorial activity in general – that no one had ever witnessed before.

This practical dependence on the established system meant that the group life of these artists had to become more aggressive – and it certainly became more male. In place of the inclusive and egalitarian Judson workshops, by 1966 their interaction increasingly centered on the frantic atmosphere of a Manhattan nightclub called Max's Kansas City, an establishment that not only catered to the Minimalist crowd, but also provided spaces for the Warhol entourage, older artists in de Kooning's circle, the rock-music aristocracy, and visiting Hollywood celebrities. It was in this competitive fishbowl that artists had to establish and maintain a dominating personal aura, that is, if dealers were to be successfully cultivated, critics cajoled or intimidated, and fascinated collectors convinced that supporting this art offered an entrée to flattering recognition and a share of the glamor for themselves. For a time, the flexing and controlling art-worker, as dramatized in Robert Morris's *Site* performance (see FIG. 92), was the public identity that worked.

## Guerrillas in the Gallery

The rapid exchange of information within the international art world, fostered in large part by the commercial acumen of Castelli and the utopian energy of Maciunas, meant that the Minimalists' sudden rise to prominence sent immediate waves both eastward and westward from New York. European collectors and galleries were embracing the new "primary structures" within a few years of their first appearance. But in this instance, their receptivity was conditioned by the feeling that work on the Continent, particularly that of a new generation of Italian sculptors, had now placed them on something like equal footing with the Americans.

Beuys had deployed his found materials, with their organic origins and intimations of historical or mythical profundity, against the superficiality that he and other provoked Europeans perceived in the export success of American Pop. The Italians felt this keenly when Rauschenberg took the prize at the 1964 Venice Biennale. Content to ignore the degree to which the American's earlier work informed that of Klein, Beuys, and Manzoni, they regarded this honor as the successful outcome of American skill in marketing (that the expatriate Italian Castelli had been the moving force behind it doubtless sharpened their sense of grievance). Nationalistic chauvinism aside, it was plain that strong promotional efforts were now required for any group of artists hoping to gain a significant foothold in an increasingly volatile and internationalized art economy – and further that the arena of active competition was Europe, in that America remained largely closed to imports from the Continent.

Where dealers had taken the lead in expanding the economic horizons of American artists, that role in Europe fell to another kind of entrepreneur, the star freelance curator, who was and remains a distinctly European type. Such individuals need not attach themselves to any one institution, but tirelessly work through commercial galleries and public museums as opportunities present themselves; they discover, group, and advance their chosen artists in the service of an argument about the needs of art and the state of the culture. Uncompromised by overt commercial interests, they also lay claim as writers to the normal channels of published criticism. In societies where intellectuals play a prominent part in the general culture, the star curator orchestrates ideas in as many public venues as possible in order to generate exposure and, ultimately, patronage for the artists enlisted into the curator's vision of the moment. Effectiveness in this endeavor depends upon building a plausible intellectual foun-

dation that links the art to as many exciting cultural trends as possible, while hitting upon a simplifying rhetoric that the press, the collectors, and the interested public can readily grasp and remember.

The Lithuanian-born Maciunas found that his projects in this vein worked much better in Europe than they had in America; both Klein and Beuys (and Gerhard Richter, in his way) had incorporated aspects of this activity directly into their practice as artists. In Italy, there were long-established precedents for this role extending back to the later nineteenth century, and the division of labor between artist and curator was clearer. At the end of 1967, the latest successful aspirant, the Genoese critic Germano Celant (b. 1940), emerged with a published manifesto tied to illustrative exhibitions in Genoa (1967) and Bologna (1968), all bearing the title "Arte Povera" (poor art). In print and as a curator, Celant was rounding up and putting his own stamp on a body of Italian work that had emerged with distinctive traits following the Pop watershed of 1964. Taking certain cues from Beuys, these artists offered up unchanging mineral elements or tokens of the biological life cycle as an alternative to the manufactured subject matter of Pop; they even found ingenious ways to introduce the tension and surprise of performance into a static work of art. Giovanni Anselmo's (b. 1934) untitled 1968 sculpture (see FIG. 89, page 135) induces its inanimate elements to promise, if not actually perform, a drama in real time: if left alone, the lettuce will decay and disintegrate, loosening the grip of the wire on the smaller block of granite, which will fall, cushioned by the pile of sawdust. In the beginning state of the piece, the intense contrasts of texture, mass, color, extension, and origin transform each material into a startling presence, as if offering themselves for some primal naming; but if the piece is maintained (that is, if the lettuce is continually replaced), that work of preservation will be in the awareness of its natural decomposition and against that outcome.

Jannis Kounellis (b. 1936 in Greece, resident in Italy since 1956) had already introduced living plant and animal organisms into the regularity of the Minimalist grid. His sprawling untitled work of 1967 (FIG. 97) fills a series of troughs that might have come from the metalsmiths employed by Judd with a bed of sand planted with some twenty varieties of cacti; against a monochrome panel on the wall sits a live macaw on a projecting perch; and, lest the arrangement be confused with an interior garden or menagerie, a roughly cubical sculptural form imposes itself over an overflowing mound of cotton, appearing barely to contain the natural abundance within. The *povera* ("poor") in Celant's phrase may have

been taken as the opposite term to the imagined wealth that had propelled American art into such alarming visibility; but that simple interpretation is difficult to square with the extravagance, in every sense, of Kounellis's conception (not to mention the fact that the Arte Povera group as a whole was drawn from the north of Italy, which was enjoying buoyant economic expansion, not from the impoverished south).

But Celant was advancing another, more indirect notion of poverty: a deliberate impoverishment or emptying-out of pre-existing codes of meaning. In American art, he objected equally to Pop and to Minimalism, in that both partook of the abstract systems of industrial production and distribution that governed modern consciousness. These were systems that were as available to linguistic description as to artistic representation. The aim of the Arte Povera sculptors, he claimed, was in fact to remove the "re-" from "represent," to force the viewer to confront the naked reality of the object, its likeness to nothing but itself. From the corpus of Pop art, Celant endorsed only Warhol's having turned the camera on a sleeping man and simply left it running for six hours (*Sleep*, 1963).

This attitude had been informed by the counter-cultural and student agitation against social engineering in education, housing, welfare, and, in the United States, military conscription to support the Vietnam mobilization. Naked apprehension of things in themselves stood for knowledge unfiltered and undistorted by authorities – parents, priests, teachers, policemen, generals, and politicians. May 1968 in Paris saw the growing discontent of students, Leftists, and significant numbers of the general public erupt with unprecedented fury in the university occupations, demonstrations, and strikes by sympathetic trade unions, which provoked a near-fatal crisis of legitimacy for President Charles de Gaulle's Fifth Republic (see FIG. 6). As the French uprising was echoed across Western Europe, Arte Povera presented itself as the most contemporaneous development – perhaps the only one – that could persuasively claim to be advancing the spirit of '68 in the realm of art. Certainly it captured some of the vivid strain of romantically anarchistic longing entailed in the revolts, the cult of direct experience and continual improvisation that Celant dubbed a "new humanism." Mario Merz (b. 1925), another adherent, began in 1968 to fashion mock igloos or huts in a variety of materials, ranging from dried saplings to jagged panes of glass. These amounted to a Beuysian evocation of a nomadic, primitive substratum recoverable from a corrupting modernity; the cultural guerrilla of the present would likewise need to travel light

97. JANNIS KOUNNELIS
*Untitled*, 1967. Earth in steel
troughs, cacti, live macaw,
troughs 15³/₄" x 13'1" x 13'1"
(40 cm x 4 m x 4 m), structure
5' x 4' x 4' (1.5 x 1.2 x 1.2 m),
panel 4' x 31" (120 x 80 cm).
Hallen für neue Kunst,
Schaffhausen, Switzerland.

LA POLICE S'AFFICHE AUX BEAUX ARTS

LES BEAUX ARTS AFFICHENT dans la RUE

and use any material to hand.

But the street-level activism of the late 1960s had raised the stakes beyond what any gallery-bound art could offer, those stakes being some visible contribution to mobilizing support for radical political change and undermining entrenched authority. It was one thing to fashion arresting visual emblems of emancipated perception and response; it was an entirely different – and unattainable – thing to break free from the space of contemplation and the posture of sympathetic witness into the arena of action using the cumbersome means of monumental sculpture. From the later 1950s forward, artists could rightly claim to have provided important opportunities to rehearse the attitudes that came into play during the rebellions of 1968, but little that was genuinely new in art followed from it. In the actual event, it was perhaps only Maciunas's allegiance to cheap, provocative, and proliferating graphic design that provided a working map for artists committed to political struggle: the most visible and memorable visual accompaniment to political action in Paris came from the impressively bold and concise posters churned out in monochrome screenprint by the student occupiers of the National School of Fine Arts (FIG. 98).

## Language Games

During the same period in America, Kienholz's *Portable War Memorial* of 1968 (FIG. 99) stood out as an exception in its ability to confront the historical moment. As in most of his comparable work of the 1960s, the fact that his eye for material was always at one with his unrelenting outrage (he held the cultivated ambiguities of Rauschenberg's assemblages in particular contempt) meant that no political issue registered as wilfully inserted "content" divorced from a work's organizational logic. It is nonetheless important to recognize that the didacticism of the piece is distinctly muted; little or no direct reference to the Vietnam War of 1954 to 1975 intrudes. The artist had sense enough to realize that he could not match the searing photographs and video footage

issuing from the conflict every day, images that were already doing their work to undermine public support for the war. The matter of the piece is rather the perversion of memory in the suburbanized political mind of the country, in particular the potent but distorted recollection of patriotic solidarity fostered during World War II.

For American artists who lacked the Kienholzes' authority and experience in manipulating large historical themes, it was all the more difficult to approach the explosive political issues of the later 1960s in any direct manner. And the internal complexities of dissenting politics were multiplying at an exponential rate. The emergence of black separatism within the civil rights movement, effected under the "Black Power" slogan, had left white activists and sympathizers confused and defensive. The rapidly emerging women's movement cut the dissenting community in another direction. The most visible attempt to negotiate this terrain in New York was the emergence in 1969 of a loosely organized pressure group called the Art Workers Coalition (AWC), the prime movers of which included Carl Andre and the activist critic and curator Lucy Lippard (b. 1937). The Coalition kept with the consensus model in forming aims and tactics, rejecting a designated leadership and any suggestion of direction from above. Its activities were correspondingly eclectic, ranging from pressuring New York museums and galleries to close on national strike days against the Vietnam War, to calls on government to grant extensive welfare rights for artists. More practically and closer to home, the AWC used demonstrations and staff strikes to press for change in museum policies: among the demands were substantial representation of artists on boards of directors, the extension of museum activities away from the wealthy center of Manhattan into poor and minority neighborhoods, and the setting aside of gallery space for women and minority artists, along with giving those groups a say in how their work was selected and shown.

One thing that the group explicitly refrained from doing was to suggest any specific connection between political activism and the nature of the art made by its members. There was in this a healthy measure of realism about the powers of art that contrasts with Joseph Beuys's 1967 launching of an entity he called the German Students Party, the largely fanciful nature of which became clear when he described the party as his own "social sculpture" (for good measure, he recommended that his female art students would be better occupied perfecting their child-rearing skills). Social criticism in advanced American art took the more

Opposite
98. Poster produced by striking students at the National School of Fine Arts (the "Atelier Populaire") during the 1968 uprising. Silkscreen on paper.

The figure wears the helmet and goggles of the C.R.S., the French national riot police, which had occupied the school after it fell under student insurgent occupation. The slogan plays on the two meanings of the verb *afficher* in its simple and reflexive forms. A literal English translation loses the assonance: "The Police Parade Themselves in the Academy. The Academy is Hanging Posters in the Streets." The force of the pun derives from the irony that armed riot squads are patrolling a precinct from which the radical artistic energy had long since escaped into the city and beyond their powers of repression.

99. EDWARD KIENHOLZ
*The Portable War Memorial*,
1968. Mixed media, 9'4"
x 7'10" x 31'2" (2.8 x 2.4
x 9.5 m). Museum Ludwig,
Cologne.

restrained form of seizing upon points of unacknowledged complicity between artists and the machinery of ideological distortion and social repression.

Minimalism, having used this tactic against Modernist painting and sculpture, now found itself subject to the same reproach. That these primary structures withheld the normal varieties of visual pleasure had raised the possibility of a critical awareness of institutional power in the art world, but their residual formal purity allowed them too readily to be drawn into the normal relation of discrete figure against neutral ground that the museum traditionally imposes on the objects it contains: so at least ran the

thinking of a number of younger artists. And the Minimalists were also vulnerable to the charge that the irony entailed in their mimicking industrial regularities of form had declined to a helpless echo of the government's own grotesque misapplication of systems logic to the Vietnamese conflict, with the Pentagon supplying nightly newscasts with body counts and abstract cost/benefit analyses applied to what had turned into ungovernable slaughter and devastation.

Celant had not been the first to observe that Minimalism invited redescription in language that was embedded in the larger economic and political machinery of the capitalist West.

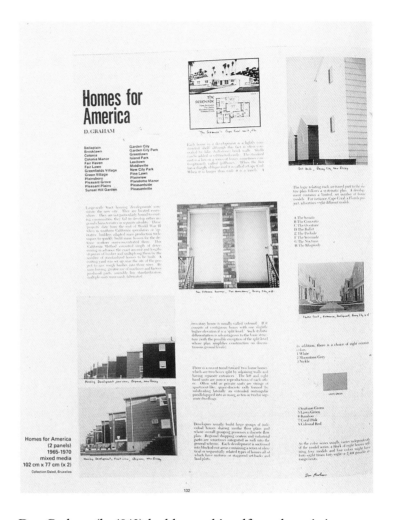

Homes for America
(2 panels)
1965-1970
mixed media
102 cm x 77 cm (x 2)
Collection Daled, Bruxelles

Dan Graham (b. 1942) had begun his self-taught artistic career as an assistant in one of the first galleries to show Flavin, Judd, and Andre; he then ran a gallery of his own from 1964 to 1965. On the heels of that experience, he submitted in 1966 an article entitled *Homes for America* (FIG. 100) to *Arts* magazine, a widely read journal in the American art world. The text begins with an alphabetical list of twenty-four names given by property developers to clusters of private, single-family houses ("Belleplain, Brooklawn, Colonia, Colonia Manor," etc.). It then describes, in prose of emphatic plainness and declarative simplicity, a brief history of mass-produced housing in the postwar period and the economies of scale determining every formal feature of these manufactured communities. Interspersed are charts demonstrating the possible permutations of consumer choice. Toward the end of the piece, Graham deduces that they:

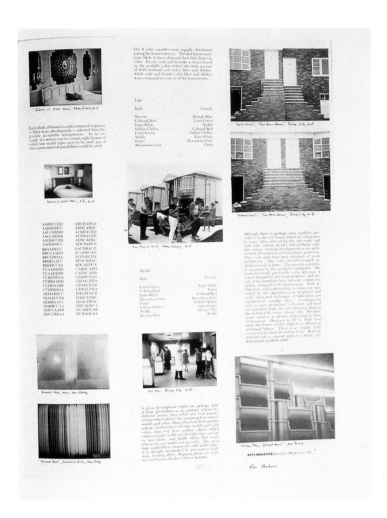

100. DAN GRAHAM
*"Homes for America."*
Artist's layout for article
from *Arts* magazine,
December-January 1966-67.

As published, the article
was substantially different
from Graham's first
conception. The editors'
alterations, however, only
confirmed the work in its
sceptism toward any fetish
of final visual form.

exist apart from prior standards of "good" architecture. They were
not built to satisfy individual needs or tastes. The owner is
completely tangential to the product's completion. His home isn't
really possessable in the old sense; it wasn't designed to "last
for generations"; and outside of its immediate "here and now"
context it is useless, designed to be thrown away. Both archi-
tecture and craftsmanship as values are subverted by the depen-
dence on simplified and easily duplicated techniques of fabrica-
tion and standardized modular plans.

Although the tone of the text is straight-faced throughout,
the pedantic exposition of its facts, along with the subject's
marginal appropriateness to a fine-art periodical, signals to the
reader that this is something entirely other than a normal piece of
journalism, that it is in fact a work of art in its own right. Recast-

ing the standard matter of journalistic description much as Flavin reorganized lighting fixtures or Andre reorganized bricks, Graham took up the most radical implications of Minimalism: that art could be made from anything and sited anywhere within a recognizable art context, the pages of a magazine serving just as conveniently as a gallery. Further, as the passage quoted underlines, Graham saw that to parallel the mechanism of industrialized housing in a form of language was at the same time to generate descriptive terms that applied precisely to Minimalist works themselves.

*Homes for America* implicitly recognized that the most extreme expressions of blunt materiality in art transformed themselves most readily into the immaterial signs of language: where could one

of Andre's brick *Equivalents* be said to exist between exhibitions except in a set of instructions? This linguistic "equivalent" effectively became the work; the presence or absence of any particular set of bricks was irrelevant. Earlier in the same year that Graham's article work appeared, Ruscha had assembled his *Every Building on the Sunset Strip* (FIG. 101). In the terms established by La Monte Young and George Brecht in *An Anthology*, the title of the work was the work; it succeeded in nominating a semi-discrete, serial accumulation of real architecture as a coherent object of formal thought. Its manifestation in a reproducible strip of deadpan documentary photographs belonged to the same family of objects as any Minimalist object: fidelity to a prior textual event, actual or possible, was what they held in common.

101. EDWARD RUSCHA *Every Building on the Sunset Strip* (detail of FIG. 58, pages 83-84), 1966. Fold-out photobook, closed 7¹/₄ x 5⁵/₈″ (18.2 x 14.3 cm), total work extended 7¹/₄″ x 24′9″ (18.2 cm x 7.5 m).

Making good on earlier, Fluxus-sponsored initiatives, such work marked the beginning of Conceptual art, much as Henry Flynt had imagined the category in 1961. Lawrence Weiner (b. 1940) was one who drew the next logical inference in a series of word pieces entitled *Statements*, simultaneously published and exhibited in 1968. Each of these was a terse description of a discrete action altering the physical environment, but one so simple as to pre-exist any claim to art. These he divided into *General Statements*, as in "One standard dye marker thrown into the sea," and *Specific Statements*, as in "Two minutes of spray paint directly upon the floor from a standard aerosol spray can." His sole transformative operation on these elements came in an appended "Declaration of Intent":

1. The artist may construct the piece.
2. The piece may be fabricated.
3. The piece need not be built.
Each being equal and consistent with the intent of the artist
the decision as to condition rests with the receiver on the
occasion of ownership.

The distinction between Weiner's *Statements* and the precisely
analogous performance scores published by La Monte Young and
George Brecht in 1963 may seem subtle to the point of invisi-
bility. All three artists placed the burden of completing the
work on its receivers – among whom could be counted the artist
himself, as the identity of the person enacting or making the piece
is left unspecified. But it is the essence of this attitude to art
that no fetish be made of originality. For Weiner, in the con-
text of 1968, it was again imperative that the definition of a
work be seen to lie in a transparent agreement between maker and
receiver, a relationship uncorrupted by the exchange of pre-
cious goods or any mystification of the creative process. His reca-
pitulation may indeed have gained a sharper application and a
heightened sense of paradox because, like Minimalist object mak-
ers, he used the existing gallery network. Individual *Statements*
were sold, and all have since been catalogued as belonging to spe-
cific collections. This no more than refined the anomalous sta-
tus of an Andre piece stored among a collection of permanent
works of painting or sculpture, and Weiner followed the spirit of
the moment in inviting his works to be hijacked by anyone
with a desire to make them.

Weiner and some other artists, in keeping with emerging eco-
logical awareness at the end of the 1960s, also offered the off-
hand argument that abstention from object making had something
to do with conservation of natural resources. No such thought
of everyday utility, however lightly expressed, would have been
entertained by Joseph Kosuth (b. 1945), the youngest and most
combative of Conceptualism's first American cohort. Gaining his
first public attention while still virtually a student, Kosuth argued
that current demands of art required a greatly increased measure
of academic rigor. Disdaining traditional nomenclature, he chose
instead to use the terms "art condition," "art proposition," and
"art function." Something of a disciple of Ad Reinhardt, on whom
he wrote a degree thesis, he believed that these entities were to be
identified through a relentless elimination of every function or
attribute that was not absolutely specific to art. He went one large
step further – citing Duchamp's ready-mades as his anchor in

history – to categorize the traditional forms of painting and sculpture as one more set of superfluous and expendable attributes.

The making of the work was then to follow as "the formal consequence" of such a distilled art proposition, the validity of which, like its counterparts in mathematics and formal logic, would have to be self-affirming, which is to say, tautological. *The First Investigation, Titled (Art as Idea as Idea), (meaning)* of 1967 (FIG. 102) was one proposal for such a consequence. The ground supplied by the black, square photostat bears an unmistakable family resemblance to a Reinhardt canvas; but, in place of any sensory stimulus, the viewer's desire for visual experience in depth is denied by its abstraction in a word, a substitution affirmed by a set of further abstractions given by language and therefore beyond appeal to sensory evidence.

Since the University of California revolt in 1964, student protesters had decried excessive specialization of knowledge, which they claimed led teachers and researchers to retreat into the protocols of individual academic disciplines and thus to surrender control over knowledge to bureaucrats, politicians, and the military. Kosuth set himself against the grain of activist politics in the 1960s by longing for a context in which the artists could follow

102. JOSEPH KOSUTH
*The First Investigation,
Titled (Art as Idea as Idea),
(meaning)*, 1967.
Photostat on cardboard,
4′ x 4′ (1.2 m x 1.2 m).

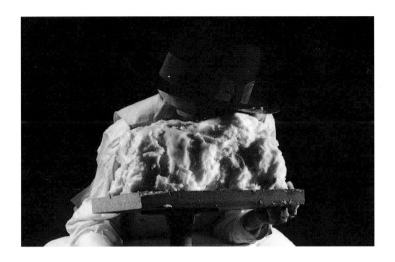

103. Sturtevant
*Beuys Fat Meditation*, 1971.
Photograph.

In 1967, Sturtevant restaged a 1924 dance performance by Marcel Duchamp entitled *Relâche*. In both cases, the audience arrived to find the door of the hall locked and a notice reading "relâche" (cancelled). The frustrated spectators at Sturtevant's event, milling in the corridor, were surprised to see Duchamp appear in their midst, take brief note of the sign, and descend to his taxi where the driver waited with the meter running.

"that same obsessed interest in art that the physicist has in physics and the philosopher in philosophy." But this was not the only possible consequence following from a devotion to tautology (that is, equivalence with no remainder) as a method of logical inquiry. The contemporaneous work of Sturtevant (b. 1930; she prefers to be known by her surname only) used her technical skill and her gender to give that term a more robust meaning, one that carried both philosophical and social import.

From 1964, Sturtevant devoted herself to producing exact replicas of works by the art luminaries of the day from Frank Stella to Roy Lichtenstein. The artists subjected to her own replicating regard had reacted variously: Warhol, joining in the spirit of the venture, had lent her his own screenprints for the *Flowers*, so that no significant physical difference existed between her work and his; Oldenburg, on the other hand, allegedly reacted with vehement hostility when she restaged his *Store Days* performance in 1967 in New York's East Village. Both were tributes to her enterprise, which she extended in a 1971 performance to the international notoriety of Beuys (FIG. 103). If, as artists from Morris and Andre to Weiner and Kosuth agreed, the seductive visual packaging of painting or sculpture had become an obstacle to the integrity of the artist's gesture, then what better way to expel that unwanted quality than by reducing it to pure redundancy? This was tautology that released a potent surplus of meaning into the world, immaterial but inseparable from visual means: and indelibly coded with the sexual inequalities that still prevailed as much within the avant-garde as in the larger society: everything, indeed, that one could ask of a "conceptual" art.

# *1969*

It was in the nature of Conceptual art that it could not be tied for long to any one artistic center. The global network of congruent activities carried out under the Fluxus aegis had already marked out manifold paths of communication and exchange, which proliferated further toward the end of the decade. The low material requirements of work that could be realized in any of a hundred ephemeral ways accelerated this process. The Canadian Conceptual artists Iain and Ingrid Baxter (b. 1936 and 1938), operating in Vancouver as the N. E. Thing Company, coined the operative, double-edged slogan for the era: "Art is All Over."

## *Verb Forms*

In London, with sculpture remaining largely under the dominance of Anthony Caro, Minimalism had been little exhibited or understood. In the second half of the 1960s, however, students in his own classes at the St. Martin's School of Art, London, were advancing projects based on notional properties which could not be verified in visual experience. There is a story that Caro, on encountering some bits of twig in the gallery, asked the student responsible what he was looking at. "One part of a two-part work," came the answer. "Show me the other half," demanded Caro. "It's on top of Ben Nevis," said the student, referring to the mountain in Scotland several hundreds of miles away. The reported maker of this piece was the English artist Richard Long (b. 1945), who has gone

104. RICHARD SERRA
*One-Ton Prop (House of Cards)*, 1969. Lead plates, each 49 x 49 x 1" (125 x 125 x 2.3 cm). Galerie m, Bochum.

105. GILBERT AND GEORGE
*The Singing Sculpture,*
performance, London 1970.

on to considerable fame by applying an Arte Povera organicism to Stanley Brouwn's laconic movements through space: Long nominates as the work his patterns of walking through various sites in vast landscapes, or he fashions temporary linear arrangements of natural matter found in some remote location, which persist only in his photographic documentation.

By 1968, only two years after his arrival at St. Martin's, Long's work was being shown in Düsseldorf in the gallery of Konrad Fischer, the one-time collaborator with Gerhard Richter in the famous *Living with Pop* performance of 1963. In that piece, he and Richter had taken up Piero Manzoni's idea of the *Magic Base* and presented themselves on pedestals among the items of nominated sculpture. That notion later found its way back to Lon-

don in the performances enacted by two more of Caro's ex-students, Gilbert Proesch (b. 1943) and George Passmore (b. 1942). As the collective entity Gilbert and George (the name evokes a double act from the extinct English music hall), they enlisted themselves and every one of their visible activities into the service of a "living sculpture" (FIG. 105).

A prime intermediary in these exchanges was the Dutch artist Jan Dibbets (b. 1941), who was both a student at St. Martin's and part of Fischer's Düsseldorf circle. In the meantime, a group of young English artists from outside Caro's orbit were forging crucial contacts in New York. Impressed by Robert Morris and enlisting Joseph Kosuth as an ally, they adopted a collective identity under the rubric of the "Art & Language Press." Early members of the group included Terry Atkinson (b. 1939), Michael Baldwin (b. 1945), and Mel Ramsden (b. 1944). Despairing of a support system wedded to Modernist values of individual sensitivity and taste, they resolved to create the necessary intellectual framework in which their ambitions could be understood, even if this meant suspending the actual making of art for the duration. Their primary medium thus became a journal, *Art-Language*, which first appeared in May 1969 and presented itself in the sober format of a philosophical review.

Over the course of the 1960s, artists had increasingly preempted the normal division of labor whereby the verbal interpretation of their work was left to professional critics. Morris and Judd had already established a pattern in which the artist steps in to dictate critical terms, and both enjoyed significant success in redefining the reigning vocabulary of discussion. A general phenomenon of advanced artistic practice in the later 1960s is that of artists assuming more and more control over the circumstances in which their work was seen, to the extent that such efforts of control and the art could become difficult to distinguish from one another.

The old pattern, adhered to by the Abstract Expressionists' generation, was that the artist did his (occasionally her) creating inside the studio, in touch only with some inner muse and indifferent – at least for that crucial moment of inspiration – to the eventual fate of the product in the wider world. The 1960s, by contrast, had seen artists become increasingly professionalized, that is, defining themselves through shared standards of competence fostered by the exchange of services and information. This development gained strength from the fact that many young artists, in keeping with the rapid expansion of higher education, were coming through university departments or through art schools with high intellectual ambitions, their idea of a career corre-

spondingly became something to be fashioned in terms of credentials and opportune moves, much as their peers in other, established professions behaved. Facility with language and other forms of self-presentation passed from being mere advantages to assuming a place inside the creative product itself.

Richard Serra's (b. 1939) early career offers an example of the mobility and rapid assimilation of ideas encouraged within the new art world. A post-graduate degree from Yale University, where he studied from 1961 to 1964, led to a fellowship supporting further study in Paris and Florence, the latter bringing him into the orbit of Arte Povera (yet unnamed) at the moment of its emergence in 1966. He put on his first solo exhibition that year in Rome, which included *Animal Habitats*, a wood and wire wall structure inhabited by a hare (recalling Beuys and anticipating Kounellis). On his return to the United States in 1966, he shifted his concerns away from that rustic Italian repertoire to the more abstract, linguistic coordinates favored in New York circles. He wrote out and meditated on a long list of verbs that might conceivably generate works of sculpture; the number of infinitives runs to 108: "to roll, to crease, to fold, to store, to bend, ...to tear, to chip, to split, to cut, to sever, ...to open, to mix, to splash ..." and so on. New Yorkers witnessed a spectacular manifestation of the last verb at the very end of 1968. In a warehouse on the fringes of Harlem, Serra created *Splashing* by standing in the cavernous space and hurling molten lead at the corner of the wall and floor, his face masked like a soldier against the poisonous fumes. The results of repeating this operation yielded the cumulative sculpture *Casting* (FIG. 106), elemental imprints of the originating verbal imperative.

*Splashing* took place in the context of yet another effort by Castelli to gain a purchase on new movements. The warehouse was the dealer's storage space; its dimensions suited an extensive group showing of emerging sculpture, which Morris stepped in to curate. Morris later grouped the assembled work under the term "Anti Form" in another ambitious critical essay published in *Artforum*, still the central arena for argument in the New York scene: "Certain art," he observed with enthusiasm, "is now using as its beginning and as its means, stuff, substances in many states – from chunks, to particles, to slime, to whatever – and pre-thought images are neither necessary nor possible." In his capacity as impresario, Morris found himself standing by while Serra took over, in a more vivid guise, his own theatrical stance of the heroic worker. And Morris's new direction in sculpture, in abandoning the perpendicular rigidities of Minimalism for materials

106. RICHARD SERRA
*Casting*, 1969. Lead,
4"x 25' x 15' (10 cm
x 7.6 x 4.5 m). Destroyed.

like industrial felt, was tracing steps already taken by another Yale
fine-arts graduate included in the Castelli warehouse show, Eva
Hesse (1936-70).

Trained as a painter, Hesse had also taken advantage of immersion in a European context – in her case, a 1965 sojourn in West Germany – to find a liberating direction away from flat canvas toward objects in real space. In 1966, the year of her return to New York, she completed *Metronymic Irregularity I* (FIG. 107), the first in a series that recapitulates both her Yale training in geometric painting and the serial regularity of Minimalism, while compromising the premises of both. The skein of cotton-covered wires simulates the improvised tracks in a Jackson Pollock painting, but is traceable in its formal logic to the rigid grid of each gray panel; conversely, the legible origin and destination of each wire promises a clarity that is lost in the intricately lyrical pattern that connects the two rectangles and draws the background wall into the configuration of the piece.

107. EVA HESSE
*Metronymic Irregularity I*,
1966. Sculpmetal on wood,
with cotton-covered wire,
12 x 18 x 2" (30.5 x 45.7
x 5.1 cm). Wiesbaden
Museum, Germany.

The first of this series
served as a model for
two subsequent versions
comprising three and five
panels respectively. The
second was the largest,
measuring four by twenty
feet (1.2 x 5.9 m). When
it was first installed, the
stress exerted by the curved
wires was so great that the
panels burst off the wall.

108. EVA HESSE
*Accretion*, 1968. Fiberglass,
fifty tubes, each 4'10"
x 2½" (147.5 x 6.3 cm).
Kröller-Müller Museum,
Otterlo.

Hesse, too, kept up a parallel track of writing, trying out verbal equivalents to her visual experiments. Fragments of a verse-form statement, published in a 1969 exhibition catalogue, recall the innumerable self-admonitions that fill her copious personal diaries:

> I remember I wanted to get to non art, non connotive [*sic*],
> non anthropomorphic, non geometric, non, nothing,...
> question how and why in putting it together?
> can it be different each time? why not?
> how to achieve by not achieving? how to make by not
> making?
> it's all in that.

In *Accretion* (FIG. 108), completed in 1968, the naming of the piece announces her determination to shift sculpture from the passive to the active voice; the word forswears the customary suggestive function of titles in its being a plain report on a completed process. The configuration shares with Minimalist practice – Andre's in particular – reliance on replaceable units in serial formation; Hesse also deployed industrial materials – fiberglass and plastic resin – that lacked all fine-art connotations. But in choosing the unit of a leaning tube, inherently unstable and fashioned in a rough-and-ready way, she demonstrated that mechanical rigidities of form were superfluous to the work of drawing spatial context into the viewer's range of apperception. That success also confirmed her colleague Dan Graham's recognition that those Minimalist

rigidities were essentially mimetic, that is, witting or unwitting metaphors for the standardizations of mass production and marketing. Just as powerfully, Hesse offered a counter-argument to the conclusions that many Conceptualists had drawn from Minimalism. *Accretion*'s evident indeterminacy of angle and interval – these being altered every time the piece was installed – ensured that the resulting array precluded any literal description and therefore any substitution of language for vision, movement, or touch.

## *Anatomies*

The Castelli warehouse show, capping the rapid assumption of authority by young artists like Serra and Hesse, established that the ambitious practice of the moment divided itself between Conceptual art and experimental work in three dimensions; painting had been pushed to the margins. There was, further, a challenge to conventional prejudice in the fact that the new ascendancy of sculpture, traditionally understood as the most physical and therefore masculine of the visual arts, provided a greater scope for leadership by female artists. In 1969, Lynda Benglis (b. 1941) could even claim on behalf of sculpture the famous gestural color of Pollock and de Kooning, in *Bounce* (FIG. 109). Successive pours of dyed latex subside into a sheet under the force of gravity; but

109. LYNDA BENGLIS *Bounce*, 1969. Poured polyurethane pigment, 13'5½" x 15'6" (4.1 x 4.7 m). Williams College Museum of Art, Mass.

the resulting shape – despite its flamboyant pattern – belongs just as completely to the realm of sculpture as did Andre's floor arrangements of metal plates. Few sculptors of the period could claim so deftly to have subdued expressive illusionism and turned its devices against the "opticality" so prized by the Modernists.

The achievements of Hesse and Benglis are all the more striking in that they entailed challenging the male bar culture of Max's Kansas City. In this vein, the contribution of women dealers should not be neglected. Despite Castelli's backing of the warehouse exhibition, Paula Cooper (b. 1938) moved more quickly and astutely within this territory; hers was the first major gallery to establish itself in the SoHo district of downtown Manhattan, close to where most artists were living and working, and there she successfully sponsored, among others, both Andre and Benglis. Virginia Dwan, who had begun in Los Angeles in the early 1960s (where she provided Claes Oldenburg with a temporary home), had likewise become an important presence in New York by the end of the decade.

Any art based on splashing, leaning, pouring, and subsiding is going to place its greatest emphasis on the physical edges of the

110. Robert Smithson
*Eight Part Piece (Cayuga Salt Mine Project)*, 1969.
Rock, salt, mirrors, 8 units
24 x 24″ (60 x 60 cm) each,
overall 11″ x 30′ x 30″
(27.9 cm x 9.1 m x 76 cm).

gallery, on its function as a membrane separating the work from the outside world. It follows that the contribution of the dealer must become an enhanced component of the actual work on display. Without Dwan's sympathetic management and capacity for risk, Robert Smithson (1938-73), another stalwart at Max's Kansas City, would have encountered many more difficulties in the realization of his complex projects. In common with Judd and Morris, he was a prolific writer and contributor to the art press, and much of his artistic thinking likewise began in print. But his more allusive, elliptical prose – peppered with humor and savage satire of Modernist aestheticism – ranged further from strictly artistic concerns. His art correspondingly rejected the straightforwardly declarative mode of address adopted by his contemporaries, relying instead on devices of suggestion and absence.

To this end, from 1966, he transferred the largest part of his activity to remote locations far from the direct scrutiny of gallery visitors. In its juxtaposition of hard, rectilinear elements against pulverized natural materials like gravel, sand, or salt, the immediately visible part of a work like *Eight Part Piece* of 1969 (FIG. 110)

could be mistaken for the entirety of an Arte Povera sculpture. The viewer was given to know, however, that this formal configuration, though evocative in visual terms, was no more than a token (a "nonsite" in Smithson's parlance) for a series of interventions in an actual landscape (the "site"). The substances present in the gallery were products of the geology and terrain through which the artist had previously marked his own passage. In the case of the *Cayuga Salt Mine Project*, the site was a bewildering series of underground chambers and passages, utterly beyond both visualization and the conceptual ordering encoded in the Minimalist grid. The mirror was a constant in these itineraries, which took him (accompanied by Dwan) as far as the rain forest of Mexico's Yucatán peninsula. Inserted into an unbounded landscape, the thin, reflecting rectangles converted endlessness into delimited views – but only as the most fragile and temporary of interruptions.

Smithson's attitude to manufactured objects, to the engineered world, had little of the confidence in order and regularity implied by Minimalism: he surveyed the built environment for every sign of decay, incompletion, and failure. But he stood apart equally from belief in an unchanging order of nature. Arte Povera invoked a natural world outside of time, from which a purity of apperception could be released. For Smithson, by contrast, there was no terrain beyond history, that is, beyond the particular contingencies of human demands made upon it. The inherent instability of the "site-nonsite" relationship was meant to keep his art clear of two competing idolatries, the hubris of technological reason and the cult of eternal nature. It was no easy equilibrium to maintain: by 1970, the magnetism of vast landscapes in the American West had pulled the center of his work beyond the membrane of the gallery wall, and he assumed a leading part in the contemporary movement called "Land Art," whose exponents (Richard Long was one, also Michael Heizer (b. 1949), and Dennis Oppenheim (b. 1938)) sought to shake themselves entirely free of studios and galleries by imposing immense geometric markings, excavations, and earthen structures onto remote deserts, plains, and highland plateaux.

That striving toward the infinite, toward grand gestures against mountain ranges and ancient lake beds, had its direct counterpart in an opposite impulse toward the artist's solitary body. The key player here was Bruce Nauman (b. 1941), a young Midwesterner from Fort Wayne, Indiana, who had discovered art late in a rather aimless university career and pursued his studies to California in the mid-1960s. He later recalled that his defining

moment came in 1966 when he found himself spending most of his time alone in a storefront studio, equipped with a fresh post-graduate degree and no materials to speak of. He had set himself something of an experiment, consistent with West Coast meditational disciplines, to form a project from examination of the self and from a heightened perception of its everyday surroundings. Impressed by Ruscha's example, he also turned to simple verbal formulae capable of transforming some aspect of the environment into a ready-made work of art; but instead of *Twenty-six Gasoline Stations*, which selected the sprawling expanse of the Los Angeles basin, Nauman's nominated objects existed barely an arm's length from his body – and often at no distance whatsoever.

The power of a simple word definition was sufficient to conjure solid pieces of sculpture out of entities that were undeniably real but had no existence prior to the thought that produced them: *Platform Made Up of the Space Between Two Rectilinear Boxes on the Floor* was one such effort from 1966; *A Cast of the Space Under My Hotel Chair in Düsseldorf* (1966-68) was another. The 1963 retrospective of Duchamp's work at the Pasadena Museum had

111. Bruce Nauman
*Self-portrait as Fountain,* 1966. Photograph, 23½ x 23½" (60.2 x 60.2 cm). Leo Castelli Gallery, New York.

made it impossible for any West Coast artist to pretend that such maneuvers were free from an historical pedigree. Nauman offered his explicit acknowledgment to the inventor of the ready-made in one of a series of performance photographs, *Self-portrait as Fountain* (FIG. 111), which both transforms spitting into an absurd piece of architecture and equates the artist's own body with the notorious turned-up urinal to which Duchamp had given the title *Fountain* in 1917.

In his substantial works of sculpture, Nauman was generally content to use the easiest and cheapest of malleable materials (plaster, latex, fiberglass, cement), giving substance to his verbal requirements in one simple procedure and leaving matters of finish largely to chance. His devotion to homely materials and uningratiating appearances reached something of an extreme point, also in 1966, with a work carrying the unadorned descriptive title *Collection of Various Flexible Materials Separated by Layers of Grease with Holes the Size of My Waist and My Wrists* (FIG. 112). Against the kitchen-based ordinariness of its fabrication in foam rubber, sheet plastic, and aluminium foil, the piece achieves an unlikely aura and even a monumentality of presence: its iridescent surface gains unexpected scale from the slightness of the openings that measure the artist's body. *Self-portrait as Fountain* mocked the self-importance that attended the early 1960s performances of Klein, Beuys, and Morris; *Collection* likewise emphasizes the artist's exag-

gerated cult of self as a weak and pathetic recourse, however logical and necessary it might have become. In keeping with that recognition, Nauman's body makes its appearance in the gallery much as Smithson's rocks and sand occupy the latter's "non-sites": through samplings and traces, intentionally inadequate tokens for a presence elsewhere; the absent body may be weak but it dwarfs the capacities of art and artists, offering the readiest measure of their limits.

Begun in relative isolation, Nauman's example was considerably amplified when he was taken up and shown repeatedly in New York and Europe under the auspices of, yet again, Leo Castelli. The sum of his wilfully disparate work can be further likened to Smithson's in the way it marked a movement of practice across the permeable membrane of the gallery wall: Smithson opened a way outward; Nauman invited a reoccupation of the center of the gallery by the literal being of the artist. From the end of the 1960s onwards, a large cohort of "Body" artists – among them Marina Abramović (b. 1946), Vito Acconci (b. 1940), Chris Burden (b. 1946), and Rebecca Horn (b. 1944) – began working in centers from California to Central Europe; in place of the more theatrical scenarios seen previously, performance came to center on the isolated physical self subjected to acts and conditions that frequently commanded the viewer's attention by the sheer physical risk and distress they entailed.

112. BRUCE NAUMAN
*Collection of Various Flexible Materials Separated by Layers of Grease with Holes the Size of My Waist and My Wrists*, 1966. Aluminium foil, plastic sheet, foam rubber, felt, grease, 1¹/₂″ x 7′6″ x 18″ (4 cm x 2.3 m x 45.7 cm). Saatchi Collection, London.

## No Foreground

In the camps of both Land and Body artists, the gallery as container tended to drop out of consideration: both treated it as an obsolete irrelevance or an expedient stage and shop window for saleable "documentation." Certain European artists, on the other hand, drew opposite conclusions from similar premises. Painting and the very idea of an autonomous art object were no longer credible; both depended for their privileged status on the seemingly neutral context provided by the museum and the gallery; but for these artists the container remained so powerfully determining that to ignore it was an act of bad faith. An art that was truly in control of its essential resources was by necessity compelled – at least for the moment – to become one with the container.

A crucial figure in this tendency – later labelled as "institutional critique" – was Marcel Broodthaers (1924-76), an elusive and older figure who had devoted the main part of his life to avant-garde poetry and small-scale publishing in his native Belgium.

113. MARCEL BROODTHAERS
*Musée d'Art Moderne, Département des Aigles, Section XIXe Siècle*, 1968. Exhibition installed in artist's flat.

In 1962 Manzoni had helped draw Broodthaers out of obscurity by nominating him as a living work of art (Gilbert and George were latecomers to this device). The honoree, only a year later, had responded to an exhibition of George Segal's sculpture, effectively the *achrome* of the human figure, by making his first physical objects: a set of his own books encased in plaster. He went on to pursue over the course of the decade, with the most modest means, a persistent investigation of the museum as site and institution.

His open-ended project began life in his own apartment in Brussels as the *Musée d'Art Moderne, Département des Aigles* (*Museum of Modern Art, Department of Eagles*). That first incarnation, under the bureaucratic subheading *Section XIXe Siècle* (*19th-Century Section*), began in 1968 and lasted through the following year. It offered the essential artefacts of museum life: packing crates for paint-

ings, postcards of nineteenth-century works, signs for directing and controlling visitors (FIGS 113 and 114), and, of course, "dedicated management" – with the conspicuous exception of any actual works of art. As he coolly explained the omission, "I deny artistic value as an exhaustive value based on a 'different' language, when in fact, the definition of artistic activity occurs, first of all, in the field of distribution." If the Minimalists had established the artist as quasi-curator of his or her own work, Broodthaers acknowledged and seized on that role to the exclusion of any other function. Further "sections" proliferated under different classificatory headings in many other venues, most notably the 1972 *Section des Figures* (*Figures Section*), which borrowed scores of the most disparate objects from actual museums, given unity only by the shared eagle motif – and by the fact that one imaginary museum contained them all.

Broodthaers's fixation on images of eagles across all ages (in a "modern" art museum) functioned in the main as a parody of the thematic straitjackets that art historians and curators deploy in their work as guardians of high culture; at the same time, that emblem's long-standing symbolic association with the power of empires widened the implications of his museum's counterfeited authority. The French artist Daniel Buren (b. 1938), working from

114. MARCEL BROODTHAERS, *Musée d'Art Moderne, Département des Aigles, Section XIXe Siècle*, 1968. Vacuformed relief in painted plastic, 33 x 42" (84 x 120 cm).

The thin plastic is designed to give the impression of a solid relief, consistent with the fussy, official-looking typography, border, and directional indications. The small indicatators – to stairways (ESC. A, ESC. B), cloakroom (VESTIAIRE), information desk (RENSEIGNEMENTS) – suggest an extensive museum edifice. In a patriotic flourish, the Belgian painter Wiertz joins the great names of French Classicism and Realism: David, Ingres, and Courbet.

a similar ethical stance, also concluded that the seeming inevitability of the museum as the setting for art – and therefore the effective invisibility of the institution – blocked artists coming to a systematic understanding of their own practice. Buren, however, disputed the notion that the interests of museums or galleries could be contested by seeking substitutes for traditional media: for Richard Serra to dramatize the anti-illusionism and provisional character of his sculpture – in 1969 making the four lead slabs of *One-Ton Prop* cohere through nothing more than the pull of gravity (see FIG. 104, page 161) – was nonetheless to make monumental form out of those attributes. The same was true, in Buren's view, of painters like Ad Reinhardt and the early Frank Stella, whose repetitive neutrality of form became a dramatic signature when framed and hung on the gallery wall; even a work of Conceptual art – Kosuth's verbal *Investigations* being a conspicuous case – became a neutralized token of opposition as soon as it went on display.

Buren chose instead to begin again with abstract painting, to repeat the experiments of Reinhardt and Stella in eliminating any internal development or surprise, but to go one – and for him crucial – step further by removing any predetermined shape. His unchanging pattern was made from repeating, vertical stripes of white and an alternating color or tone, each 3$^1$/2 inches (8.7 cm) wide, destined for any existing surface, the limits of which would at the same time constitute the edges of the work. The renunciation of any horizontal lines blocked associations with floors and horizons, thus disallowing any perception of the work as a mural with the promise of depth. His goal was to isolate the objective fact of *visuality* unencumbered by the mystifications of figuration, even that residually present in the framing edge. And that achievement for him entailed supplanting the apparatus of presentation provided by the curator, the exhibition designer, and the architectural setting of the gallery or museum.

The paradox of Buren's efforts was that his commandeering of powers normally held by the managers of the art world entailed the artist's own contribution receding to background status, adhering as the thinnest possible tissue against the shell of its assigned spaces. Visuality distilled from the ideological baggage of fine art meant there would be nothing very much to see. The point was driven home in 1972 at *Documenta V* in Kassell, West Germany, when an exhibition preparator inadvertently hung Jasper Johns's *Flag* (see FIG. 2) against a wall of Buren's striped paper (FIG. 115), interrupting its uniformity with the forbidden horizontal complement. That fortuitous juxtaposition summed up the genealogy of the uniform stripe as a critical tool for painters,

a line of descent running from Johns through early Stella to Buren. Johns's strikingly ordinary choice of subject matter had been instrumental for artists who went on to use their conceptual sophistication in displacing the commonplace, in holding up to sceptical scrutiny all the symbols that mediate political consent. But Johns's moment had set in train a movement toward a heightened awareness of the deep, ineradicable implication of art in the machinery of that consent. This knowledge proved to be so overwhelming and the means of its diagnosis so absorbing that the mature dissenting art of the early 1970s began to lose confidence in addressing any subject beyond the most proximate institutions of artistic display and consumption.

By the early 1970s, the New Left had lost much of its drive, with its most militant leaders discouraged or harried into self-destructive terrorism; the hopes of May 1968 were rapidly dissipating in Europe; President Richard Nixon and Secretary of State Henry Kissinger proved capable of outlasting the American antiwar movement while intensifying the violence in Indochina. And any remaining hopes that artists could provide magical forms of political resistance rested on a mistaken understanding of the position occupied by artists in the most intense years of the Civil Rights and anti-war movements. The activists who propelled those campaigns were overtaken by a total commitment that left next to no time and energy for other pursuits: careers went into suspension; friends and lovers came increasingly from within a tight circle of political allies. As state repression of the New Left took hold, particularly in America and West Germany, the totality of that immersion became for some the extreme state of a fugitive, underground existence.

By those standards of commitment, any persuasive fusing between art and 1960s activism was unlikely from the start. The conceptual demands of advanced artistic practice had become so elevated that anything less than full-time application of one's resources was unlikely to make a mark. Before the rise of the New

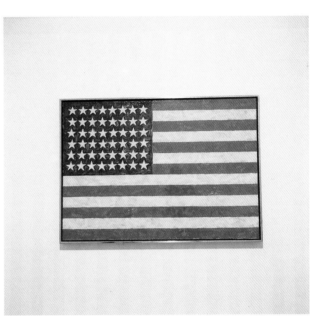

115. DANIEL BUREN
*Photo-Souvenir d'Exposition d'une Exposition* at *Documenta V*, 1972.
Collection of the artist.

Left, much of its sensibility – the content and style of the liberation it imagined – was thoroughly rehearsed within avant-garde circles. But if art was the laboratory of a future politics, it could never be the productive engine. By the mid 1960s, certainly, a stark choice existed between the demands of "the Movement" and the demands of a career in art, however radically conceived.

The beginning of the 1970s, however, witnessed a reversal of the dynamic that had existed a decade before. The social and ethical experimentalism that had gone on within the culture of the Left now set the agenda for advanced art. Nowhere was this more true than in the forcing of feminist issues into inescapable prominence; abstract ideals of liberation had all too often exposed the ingrained chauvinism of the largely male leadership, and a large number of women activists grew determined to redress the balance in the future. In its necessary preoccupation with symbols, perceptions, and representations, this was another kind of politics, and the art world came to serve as a natural staging area for the initial, consciousness-raising phase of the women's movement.

For artists generally, there emerged another avenue whereby their practice might be integrated with a politicized working environment: it lay in the ground and floorboards under their feet, in their daily efforts to secure the physical space and means to function. The recession of the early 1970s, with its succession of oil-price shocks (as Arab producers recouped their losses on the war-inflated dollar), forced art dealers to pull back from the support they had given to new media and unsalable forms of art. Recession, however, lowered property values and allowed artists to strike back with a new wave of cooperative, not-for-profit galleries. Fringe urban districts like-

228 E 3 St.
Block 385  Lot 19
24 x 105'  5 story walk-up old law tenement

Owned by Harpmel Realty Inc.  608 E 11 St.  NYC
Contracts signed by Harry J. Shapolsky, President('63)
                    Martin Shapolsky, President('64)

Acquired from John The Baptist Foundation
c/o The Bank of New York, 48 Wall St. NYC
for $237 000.- (also 5 other properties) , 8-21-1963

$150 000.- mortgage (also on 5 other properties) at 6%
interest as of 8-19-1963 due 8-19-1968
held by The Ministers and Missionaries Benefit Board of
The American Baptist Convention, 475 Riverside Dr.  NYC

Assessed land value $8 000.-  total $28 000.-(1971)

116. HANS HAACKE
*Shapolsky et al. Manhattan Real Estate Holdings, a Real-Time System as of May 1, 1971* (detail), 1971.

The work was composed of two maps, one of the Lower East Side and one of Harlem, indicating properties described on 142 typewritten data sheets, attached to photographs and giving each property's address, block and lot number, lot size, building code, the corporation's address and its officers, the date of acquisition, prior owner, mortgage, and assessed tax value. Charts showed how insider exchanges disguised their ownership. *Shapolsky et al* operated entirely within the established systemic and serial logic that governed the advanced art of the moment – chiefly Minimalist sculpture. But by introducing only one allowable shift in the matter disposed in the system – in this case the interlocking, clandestine ownership network of a fabulously lucrative group of slum properties – Haacke generated an economic X-ray of both the geography and class system of New York City. Despite his rigorous exclusion of commentary or polemic, Haacke's work generated a notoriously explosive response when the director and board of the Guggenheim Museum banned its exhibition.

wise provided new studio space and became the everyday communities for large numbers of artists with their partners and families. The building of Minimalist boxes or warehouse installations gave way to immersion in the city's economic and social fabric – preeminently in New York's SoHo – and confrontation with the powers that normally governed it. Though gentrification would follow, casting a moral shadow over this enterprise, the worldly experience that came with the first building of communities gave artists a vital cognitive grip on the larger environment.

It is a common misconception that Conceptual Art can be simply understood as some final abstraction of the work of art, the arrival of the "least object," which utterly leaves behind any capacity for describing the world. Dan Graham's *Homes for America* of 1966 (see FIG. 100) deftly diagnosed shifts in the common life of society that had undercut Modernist affirmations of self-possession and individuality, rendering them archaic and unrealistic. The wide realms of political and economic life remained beyond the reach of advanced art, but the slow processes of degradation in urban life turned out to be well within its grasp. In the new decade, the German Hans Haacke (b. 1936; FIG. 116), the American Martha Rosler (b. 1943), and Gordon Matta-Clark (1948–78), son of the Chilean-born Surrealist painter Roberto Matta, were among those whose work was fueled by an activist's awareness of urban decay and the hidden networks of power that encourage the despoiling of working neighborhoods in the postindustrial city. It was local when compared to wars fought half a world away, specific when compared to the transnational "Society of the Spectacle" so anathemized by the Situationists. But it offered concreteness and a microcosm of larger structures of inequality and deprivation.

Visual means fostered by Minimalism and Conceptualism – in avoiding the picturesque clichés of urban decay – proved to be the keys to unexpectedly vivid, demystifying modes of reference to the world. A second era of dissent in the visual arts lay in store.

# Afterword

By all the evidence, no one will ever write a concluding word on the 1960s. The printing of *The Rise of the Sixties* appears in the aftermath of an American presidential campaign that turned on arguments over each candidate's conduct during the conflicts of that decade. This retroactive fighting over commitments and actions some thirty years in the past threatened to overshadow the actual lives and treasure lost in the present American occupation of Iraq. That human tragedy and policy quagmire has engendered as thoroughgoing an alienation of the United States from the rest of the world as had the Vietnam incursion itself. And the themes of cultural conflict that run so strongly through this book may therefore find some renewed purchase in this atmosphere of heightened political tension and recriminatory rhetoric. An activist Rip Van Winkle awakened from a 1969 slumber might find the style and terms of debate entirely familiar—and could join the fray without missing a beat.

This circumstance sets in high relief the ready way in which this era can be defined almost entirely in agonistic terms (from the Greek *agōnia* for competitive struggle). More artists than could be included in the first edition of this book took its conflicts as the primary theme and motivation for their art. One who more than deserves a place in this account is Leon Golub (1922–2004), the Chicago-born painter who died shortly before this afterword was composed. From his first works addressing the atrocities of the Vietnam war (which converge in time with the young John Kerry's famously eloquent congressional testimony on the

same subject), Golub deployed, against the grain of his generation's advanced art, large-scale renderings of human figures in various states of torment or savagery.

This project came to a peak of effectiveness and power in the 1980s when his *Mercenaries* series reduced the Reagan-era repression in Central America to stark confrontations between torturer/interrogators and their victims. Hung unstretched with the temporary feeling of hit-and-run posters, Golub's canvases share with the leading abstract painters a flattened color vocabulary and a drama in the concrete textures of worked pigment; but his ragged silhouettes and flayed brushwork gave form like no other to a pattern of depravity that remained largely hidden behind the covert apparatus of "security" until the dissemination in 2004 of the sadistic photographs from the Abu Ghraib prison in Iraq.

Mention of those images—their digital encoding slipping the tight control of state information management—might suggest that the presumed authenticity of the photographic record has superseded Golub's stubbornly traditional means of representation, no great distance from those available to Goya in his *Disasters of War*. But much that determines contemporary existence happens out of sight, and Golub's *Mercenaries* have gained immensely in pertinence for having anticipated the horrific corruption that surfaced at Abu Ghraib, stripping away in advance the tissue of official excuses and rationalizations with which such scandals are regularly made again to disappear. His relentless concentration and commitment over the course of a long career brings home how much the tensions, wars, and low-intensity conflicts of the present represent a continuity with the those of the 1960s—not some uncanny return to the past.

In celebrating the skill, prescience, and moral compass of a Golub, however, there is a danger that the era in which his project was formed be recalled exclusively for its agonistic character. As no society can thrive on perpetual turmoil, seeing a return of the 'sixties in every exacerbation of political conflict can serve the Right's tireless campaign to demonize the period as nothing more than the regrettable release of

self-indulgent and destructive appetites. In this new mythology, responsibility for official violence—orders of magnitude more powerful, widespread, and careless—is shifted onto those whose protests secured basic rights for their fellow citizens and shortened senseless warfare abroad.

What must be avoided at all costs, if historical memory is to be preserved and deepened, is an ideological separation between critical action and critical thought. Activism and emotion were, of course, crucial parts of the equation. Even in Europe, with its long traditions of social critique and popular political resistance, "the events" of 1968 aroused a new energy and complexity of intellectual imagination, which filtered into aesthetic endeavors far from the public battlegrounds between authority and student/labor movements of resistance. In the United States, emerging from the rigid orthodoxies of the Cold War and lingering McCarthyite ban on virtually every form of dissent, the rapid spread of critical ideas from the crucible of the civil rights protests to the contestation against the war in Southeast Asia worked like a monsoon falling on a parched landscape. The unfolding of Conceptualism in art—in the sense of a stripping down of one's practice to expose the premises and logical consequences entailed in practicing a consoling art form inside a divided, self-doubting social order—surely owed its drive to the political awakening beyond the confines of the art world.

Nor should one underestimate the contribution of artists' gestures in providing symbolic markers for the wider movements of dissent and contestation. This new printing marks the fifty-year anniversary of Jasper Johns's *Flag* of 1954–1955. Magnified by the newly internationalized apparatus of fine-art dissemination, this outwardly self-effacing exercise inserted a seed of ironic distance right at the heart of American Cold-War hegemony. The flourishing of appropriated national symbols—preeminently the American stars and stripes—on posters, clothing, badges, record sleeves, and all the paraphernalia of the 1960s counter-culture owed much of its currency to Johns's

original intervention deep within the interior of avant-garde preoccupations.

As traced in the narrative of this book, the grid-like composition of *Flag*, its refusal to distinguish its physical format from its internal composition, its delicately poised double-nature as simultaneously representation and the thing represented, all fed the determination of 1960s artists to locate their art as closely as possible to the boundary between art's traditional domain of imaginative perception and the base materiality of one's means of signification.

This determination most often generated an art that, in its outwardly austere abstraction, can seem a world away from the heart-on-the-sleeve outrage over injustice and repression to which Golub gave eloquent expression. But even the most determined social critic cannot live permanently in the latter state and preserve his or her mental resources. That, at least, is the lesson of advanced art in the 1960s taken as a whole, brought home by the establishment in 2003 of a place of pilgrimage for anyone seeking to absorb the clarifying logic and order present in some of the most serious painting and sculpture of the period. This venue is Dia:Beacon, an exhibiting space carved—following an exhibiting practice pioneered by Arte Povera—out of a vast, abandoned printing factory on the banks of the Hudson river about an hour's journey north of New York City.

The existence of such a facility points to a theme often sounded in this book, that is, the crucial role played by dealers and patrons as actors in art history, particularly as the network of exhibition, publicity, and commerce in art objects expands in the period after the Second World War. Thus a Leo Castelli or a Virginia Dwan has as great a part to play in the preceding narrative as most of the artists who figure in it. Much the same can be said of the processes by which the art of that period is being perpetuated, both through the understanding of its later audiences and through the new works of art that follow in its lineage.

That task presents extra difficulties when a good deal of the art in question was ephemeral, site-dependent, or

extraordinarily large in physical extension—thus not easily served, if at all, by conventional forms of museum collecting and display. That realization prompted Philippa de Menil, from the distinguished Franco-American family of art patrons (also socialist in outlook despite their oil-industry wealth), with Heiner Friedrich, a German dealer/gallerist, to establish the Dia Art Foundation in 1974. Their purpose was both to collect works that the museum world was not yet prepared to assimilate and to assure a permanent life for other works too unconventional or inseparable from a specific location otherwise to survive. Some Dia interventions entailed securing Manhattan spaces in perpetuity for installation pieces; others put vastly scaled land works into a form of public trust.

One example of the latter is the *Lightning Field*, a vast sculpture by Walter de Maria (b. 1935) in the remote semi-desert of southern New Mexico. Covering a rectangle one mile (1.6 km) by a third of a mile (0.5 km) in area with 400 vertical stainless steel poles spaced a uniform 220 feet (61 m) apart, de Maria took the minimalist grid to an exponentially wider field of operation. Actual lightning events being relatively rare and unpredictable, the poles, with their solid tapered tips, infrequently call down the energy of the heavens but constantly serve, by their variations in height, to define an even horizontal plane across the vagaries of a natural terrain.

Accessible only to small groups booked in advance, the quasi-Baroque grandeur of the *Lightning Field* assumes graspable human scale in the installations at Dia:Beacon, which include a series of excavations by Michael Heizer, here clad in steel, along with a suitably expansive floor piece by de Maria, both in close proximity to the artist who has most rigorously pursued the precise mapping and permutation of geometric coordinates within his art: Sol LeWitt (b. 1928). The uniformly white surfaces and right angles of the entire Dia facility, down to the ranks of square-mullioned windows that flood the spaces with natural light, appear as a kind of homage to the white, openwork geometries of LeWitt's sculpture, in which the viewer's cognitive understanding of their regularities

always sits uneasily with the complex and changing perceptual field that they present to the moving eye.

A significant number of the artists who figure prominently in the preceding pages—Robert Ryman, Agnes Martin, Andy Warhol (at his largest scale and highest degree of abstraction), Joseph Beuys, Donald Judd, Bruce Nauman, Richard Serra, and Robert Smithson—also constitute a major part of the Dia:Beacon collection. Some of these works date from the later 1950s and 1960s; others descend virtually to the present, but always in a consistent mode that asserts a continuing vitality for the new rules of art forged in that original, critical climate: that no expressive gesture could stand if it did not at the same time articulate with equivalent vividness both the physical determinants and the signifying conventions that made it possible. The corollary of this premise is that every physical attribute of the work— every artistic decision regarding material, scale, color, fabrication, and position—must be equally meaningful and transparently available to the viewer's cognitive response. The rigor entailed in that burden of responsibility constituted the ethics of this artistic community.

The results of such imperatives in action testify to its potential for rich and unpredictable variety, from the massiveness of Serra's fabrications in Cor-Ten steel to the weightless string-and-pin configurations of Fred Sandback (1943–2003), gallery interventions that manage to slice through space with decisive severity. But there is just as strong a common feeling of sensory calm and the cognitive clarity that art practice can provide amid the turbulence of modern experience. This too represents the ferment of the 1960s, and the consistency and insight with which the Dia:Beacon project has been carried out ensures that it will live outside the retrospective pages of books like this one.

The Dia foundation came into being just one year after the death in 1973 of Robert Smithson in a flying accident as he was viewing one of his large land sculptures from the air. His sudden and arbitrary removal from this artistic community left a palpable void that made all work pursued outside

the confines of museum and gallery seem suddenly threatened and fragile. So began a heightened consciousness of history and an almost religious vocation to gather and protect aesthetic relics against the erosion of time.

It was fitting, therefore, that Dia in 1999 became custodian of the work with which Smithson's name is most identified, its fame now extending well beyond the art world into the global general culture: his 1969 *Spiral Jetty* on the northern shores of Utah's Great Salt Lake. Extending some 1500 feet (457 m) from the rock-strewn hillside into sluggish water tinted red by tiny shrimp able to survive the salinity, this inward-turning causeway has changed drastically over the three decades of its existence. Disappearing beneath the surface for years at a time when water levels rose, it has now reemerged so encrusted with layers of crystalline salt that its iconic shape has lost its crisp edge, while its black basalt boulders, shifted from the surrounding slopes, now barely register from any distance.

Just what would constitute a mission to "preserve" Smithson's *Jetty* throws into relief the shortsightedness of any ultimate distinction between the activist conception of 1960s art stressing the flux of *agōnia* and the calmly stable coordinates exemplified by the abstract works gathered at Dia:Beacon. The *Jetty* incorporates a grand, inherently politicized antagonism to the marketplace as arbiter of artistic fortunes, while it opens itself to a whole ecology of continual change. At the same time, for all of its bulk, it possesses every bit of the clarity and refined geometry displayed by the gallery-bound constructions of the Minimalists. But it transcends both of these options by positing the spiral-form, in all of its pervasive symbolic presence in human affairs, as the very pattern of transformation itself—in personalities, in cultures, in whole social orders.

Nor did Smithson's vision rest with the merely human. Virtually the only artist to respond in depth to the lessons of science, he saw in the Jetty a fragile, graspable mid-point along a continuum that reached from the stepped molecular rotation within the lake's salt crystals to the whirl of remote

galaxies propelled by the birth and death of stars. In such a register, the human-scale that had governed artistic practice for millennia seems an afterthought, the capacity for vision built into the human nervous system a feeble constraint on the possible extensions of art. This dialogue between the seen and unseen, with the consequent elevation of art to a persuasive form of knowledge, became a casualty of Smithson's untimely death. But the record remains a latent point of departure towards the art beyond art that lies, in potentia, between the active and contemplative poles of 1960s practice.

| | Politics | Scientific and sports events |
|---|---|---|
| **1954** | • Algerian war against French rule begins<br>• US tests hydrogen bomb at Bikini Atoll, Pacific Ocean<br>• Geneva agreement divides Vietnam into North and South<br>• US Supreme Court declares school segregation unlawful<br>• UK ends post-war rationing | • Death of atomic physicist Enrico Fermi (directed first controlled nuclear reaction, 1942)<br>• USA launches *USS Nautilus*, first atomic-powered submarine<br>• Roger Bannister runs first 4-minute mile |
| **1955** | • Winston Churchill resigns as Prime Minister, succeeded by Anthony Eden (UK)<br>• Warsaw Pact established<br>• Montgomery Bus Boycott incident begins, Alabama (US)<br>• French forces leave Vietnam | • First Atoms for Peace conference organized in Ge<br>• Joe DiMaggio elected to Baseball Hall of Fame (U<br>• Albert Einstein dies<br>• Sony markets first transistor radio (Japan)<br>• Mass immunization with Salk polio vaccine begun (USA) |
| **1956** | • Nasser, Prime Minister of Egypt, seizes Suez Canal<br>• Arab-Israeli War<br>• Hungarian uprising violently suppressed by Soviet forces<br>• Soviet Premier Nikita Khrushchev denounces Stalin's crimes and personality cult at All-Union party Congress | • Anti-neutron discovered at University of California<br>• Olympic Games held in Melbourne (Australia) |
| **1957** | • Harold Macmillan becomes Prime Minister (UK)<br>• DEW line established (USA Canada)<br>• 'Papa Doc' Duvalier elected president of Haiti<br>• Clashes over school desegregation in Little Rock, Arkansas (USA)<br>• Gaza Strip comes under UN peacekeeping protection<br>• Treaty of Rome establishes European Economic Community | • Jim Brown named National Football League's Rookie of the Year (USA)<br>• USSR launches Sputnik 1<br>• UK tests its first hydrogen bomb<br>• Interferon discovered<br>• International Geophysical Year (IGY)<br>• Jodrell Bank space telescope inaugurated (UK) |
| **1958** | • Campaign for Nuclear Disarmament founded, stages Aldermaston march (UK)<br>• European Economic Community (EEC) established<br>• Charles de Gaulle becomes President of France<br>• Mao Zedong announces Great Leap Forward (China)<br>• Colonial leaders stage coup in Algiers | • The Edsel introduced by Ford Motor Company (U<br>• *Explorer 1* launched from Cape Canaveral (USA)<br>• Manager and 7 members of Manchester United football team killed in plane crash |
| **1959** | • Resurgence of Basque separatist movement in Spain<br>• Revolution in Cuba establishes Fidel Castro as Premier<br>• Televised 'Kitchen Debate' between Soviet Premier Khrushchev and US Vice-President Nixon | • Albert Sabin develops oral polio vaccine<br>• First Hovercraft crosses English Channel<br>• Louis and Mary Leakey discover controversial primate fossils in Olduvai Gorge, Tanzania<br>• IBM puts first fully transistorized computer on the market (USA)<br>• Soviet spacecraft photographs far side of the moon |
| **1960** | • Caryl Chessman executed (USA)<br>• Katanga Revolt begins (Belgian Congo)<br>• Organization of Petroleum Exporting Countries (OPEC) formed<br>• Sharpeville Massacre (South Africa) | • First laser constructed, California<br>• Olympic Games held in Rome (Italy)<br>• Cassius Clay wins Olympic gold medal, heavy-weight boxing |
| **1961** | • Peace Corps established (USA)<br>• Berlin Wall erected (Germany)<br>• Amnesty International founded (UK)<br>• John Fitzgerald Kennedy becomes president (USA)<br>• Bay of Pigs Invasion (USA-Cuba)<br>• Commission of the Status of Women established (USA)<br>• Freedom Rides begin in America South | • Yuri Gagarin is first man in space (USSR)<br>• Roger Maris breaks Babe Ruth's season record for baseball home runs (USA)<br>• The contraceptive pill becomes available<br>• Astronaut Alan Shepard becomes first American in space |

| Visual arts | Other cultural events |
|---|---|
| • Six Gallery opens in San Francisco (USA)<br>• Jess (Burgess Collins) begins *Tricky Cad*, San Francisco<br>• Robert Rauschenberg begins 'Combine 'series (USA)<br>• Henri Matisse dies (France) | • Alison and Peter Smithson, Hunstanton Secondary School (UK)<br>• Kingsley Amis: *Lucky Jim*<br>• Newport Jazz Festival established (USA)<br>• Ray Charles records 'I Got a Woman'<br>• *On the Waterfront* with Marlon Brando, dir. Elia Kazan (USA) |
| • Jasper Johns paints *Flag*<br>• *Documenta* established in Kassel (West Germany)<br>• Independent Group members: *Man, Machine and Motion* exhibition, ICA, London<br>• Peter Blake begins *On the Balcony* (UK)<br>• Jess (Burgess Collins) composes *The Mouse's Tale*<br>• Ray Johnson composes 'Elvis' collages | • James Dean killed in car crash (USA)<br>• *Rebel without a Cause* with James Dean, dir. Nicholas Ray<br>• First McDonald's hamburger outlet opens, Chicago<br>• Chuck Berry records 'Maybelline' (USA)<br>• Tennessee Williams: *Cat on a Hot Tin Roof*<br>• *The Diary of Anne Frank* published<br>• Bruce Goff, Bavinger House, Norman, Oklahoma |
| • Jackson Pollock killed in car crash (USA)<br>• Group show *This Is Tomorrow* held at the Whitechapel Gallery, London<br>• Tate Gallery exhibits Abstract Expressionists, London<br>• Jean Dubuffet works on his 'Tableaux' series (France)<br>• Richard Hamilton composes collage *Just what is it that makes today's homes so different, so appealing?* (UK) | • Allen Ginsberg's *Howl* published (USA)<br>• Johnny Cash records 'I Walk the Line' (USA)<br>• John Osborne: *Look Back in Anger*<br>• Elvis Presley records 'Heartbreak Hotel' (USA)<br>• Mies van der Rohe and Philip Johnson, Seagram Building, New York<br>• John Ashbery: *Some Trees* |
| • Asger Jorn and Pinot-Gallizio's Alba laboratory (Italy)<br>• Helen Frankenthaler paints *Eden*<br>• Wallace Berman arrested on obscenity charges at his first exhibition at newly opened Ferus Gallery<br>• Group Zero founded by Otto Piene, Heinz Mack, and Günther Uecker (West Germany)<br>• Cy Twombly moves to Rome | • Jack Kerouac's *On the Road* published (USA)<br>• *The Seventh Seal* directed by Ingmar Bergman<br>• Jerry Lee Lewis records 'Great Balls of Fire'<br>• *The Searchers* directed by John Ford<br>• Roland Barthes: *Mythologies*<br>• *West Side Story* musical opens in New York |
| • Yves Klein exhibits monochrome paintings (France)<br>• Jasper John's first solo exhibition, Leo Castelli Gallery, New York<br>• Jay DeFeo begins work on *The Rose*, San Francisco<br>• Mark Rothko paints murals for the Seagram Building, New York | • John Cage makes a concert tour of Europe<br>• Samuel Beckett: *End Game*<br>• Claude Levi-Strauss: *Structural Anthropology*<br>• Vladimir Nabokov: *Lolita*<br>• Marcel Breuer, P.L. Nerri and Bernard Zehrfuss, UNESCO Headquarters, Paris |
| • Allan Kaprow stages *18 Happenings in 6 Parts* in New York<br>• *Place* exhibition, ICA, London<br>• Retrospective of Barnett Newman's work, organized by Clement Greenberg, New York<br>• Frank Lloyd Wright's Guggenheim Museum completed, New York | • William Burroughs: *The Naked Lunch*<br>• *La Dolce Vita* directed by Federico Fellini<br>• Lorraine Hansberry: *A Raisin in the Sun*<br>• *Hiroshima Mon Amour* directed by Alain Resnais<br>• *Un Bout de Souffle* (*Breathless*), directed by Jean-Luc Godard<br>• Buddy Holly, Richie Valens, and the "Big Bopper" killed in air crash (USA) |
| • Claes Oldenburg Happening, *Snapshots from the City*<br>• Performance of Yves Klein's *Anthropométries*, Paris<br>• Arman fills Galérie Iris Clert, Paris, with 30 tons of rubbish<br>• Jean Tinguely's *Hommage à New York* self-destructs in sculpture garden of Museum of Modern Art, New York<br>• Ileana Sonnabend Gallery opens, Paris<br>• Richard Bellamy opens Green Gallery, New York | • Brasília founded as new capital of Brazil with state buildings by Oscar Niemayer<br>• *Psycho* directed by Alfred Hitchcock<br>• D.H. Lawrence's *Lady Chatterley's Lover* (1928) cleared of obscenity charge and published in complete form (UK)<br>• *Saturday Night and Sunday Morning* directed by Karel Reisz<br>• Chubby Checker records 'The Twist' (USA) |
| • Gerhardt Richter emigrates from East to West Germany<br>• Piero Manzoni constructs *Base Magica* (Italy)<br>• Claes Oldenburg, *The Store*, New York<br>• Morris Louis begins his 'Unfurled' series (USA)<br>• Fluxus formed<br>• Henry Flynt coins term 'Concept Art'<br>• Yves Klein exhibitions, New York and Los Angeles | • Lenny Bruce imprisoned for obscenity (USA)<br>• Joseph Heller: *Catch 22*<br>• Michel Foucault: *L'Histoire de la Folie*<br>• Lewis Mumford: *The City in History*<br>• Günter Grass: *The Tin Drum*<br>• Yevgeny Yevtuschenko: *Babi Yar*<br>• *Viridiana* directed by Luis Buñuel |

| | Politics | Scientific and sports events |
|---|---|---|
| **1962** | • Cuban Missile Crisis (USA-USSR)<br>• Adolph Eichmann executed (Israel)<br>• Michael Harrington's *The Other America* documents wide-spread poverty<br>• Rachel Carson's *Silent Spring* denounces pesticide pollution<br>• Riots follow racial integration, University of Mississippi | • Thalidomide identified as cause of birth defects<br>• Astronaut John Glenn circles the earth (USA)<br>• Jack Nicklaus wins US Open golf championship<br>• Linus Pauling awarded Nobel Peace Prize<br>• Brazil wins World Cup<br>• Telestar satellite put into orbit (USA) |
| **1963** | • President John F. Kennedy visits West Berlin<br>• President John F. Kennedy assassinated in Dallas, Texas<br>• Nelson Mandela imprisoned for life (South Africa)<br>• Civil rights march on Washington DC<br>• Nuclear Test Ban Treaty signed (USA-UK-USSR)<br>• The Profumo affair political scandal (UK)<br>• Great Britain refused entry into European Common Market | • International Red Cross, 100th anniversary<br>• Color version of Polaroid Land Camera introduced<br>• Margaret Court Smith wins women's tennis singles at Wimbledon, London<br>• Valentina Tereshkova becomes first woman in space (USSR) |
| **1964** | • Palestine Liberation Organization (PLO) formed<br>• Greek-Turkish Cypriot War<br>• Nikita Khrushchev ousted as leader of USSR<br>• Harold Wilson becomes Prime Minister (UK)<br>• Ian Smith becomes Prime Minister of Rhodesia<br>• US Congress passes Tonkin Gulf Resolution authorizing intervention (Vietnam) | • Cassius Clay wins boxing heavyweight title, changes name to Muhammed Ali and refuses military conscription for Vietnam<br>• Olympic games held in Tokyo<br>• China explodes atom bomb |
| **1965** | • Racial riots in Watts district of Los Angeles<br>• Malcolm X assassinated, New York<br>• President Lyndon Johnson steps up bombing raids in Vietnam<br>• Military coup in Indonesia, mass murder of Leftists and Chinese<br>• White government of Rhodesia declares independence | • Medicare health plan established (USA)<br>• Albert Schweitzer dies<br>• Noam Chomsky, *Aspects of the Theory of Syntax* |
| **1966** | • Black Panthers organization formed (USA)<br>• Freedom March, Mississippi (USA)<br>• Cultural Revolution begins (China)<br>• Ronald Reagan elected Governor of California<br>• Strasbourg students and Situationists International publish *On Student Poverty*<br>• National Organization of Women founded (USA) | • Billie Jean King wins women's singles championship at Wimbledon<br>• Bobby Charlton receives European Player of the Year award<br>• England wins football World Cup over Germany |
| **1967** | • Military coup in Greece installs dictatorship<br>• Che Guevera killed (Bolivia)<br>• Six-Day War (Israel and Egypt)<br>• Thurgood Marshall appointed first black Justice of the Supreme Court (USA)<br>• Parliament decriminalizes abortion and homosexuality (UK) | • First heart transplant performed by Dr. Christiaan Barnard, Cape Town (South Africa)<br>• Physicist Robert Oppenheimer (inventor of the atomic bomb) dies |
| **1968** | • Student occupations, riots, general strike, France<br>• Assassination of Martin Luther King Jr. in Memphis (USA)<br>• USSR invades Czechoslovakia<br>• Assassination of Robert F. Kennedy in Los Angeles<br>• My Lai massacre (Vietnam)<br>• Tet Offensive, Vietnam<br>• Trades Union Congress (TUC) founded (UK) | • American athletes Tommie Smith and John Carlos give Black Power salute at Olympic Games, Mexico City<br>• BMW produces its 2002 sedan (West Germany)<br>• Alec Rose completes solo sail around the world<br>• Rod Laver wins first Wimbledon tennis title open to professionals |
| **1969** | • Civil conflict in Northern Ireland, direct rule from London<br>• Weathermen "Days of Rage" in Chicago<br>• Vietnam moratorium protests (USA)<br>• Riots after police raid on gay Stonewall Inn, New York<br>• Greenpeace founded (Canada)<br>• President Ho Chi Minh dies (Vietnam)<br>• Richard Nixon becomes President of the United States | • Apollo 11 Commander Neil Armstrong is first man to walk on the moon<br>• First Concorde flight<br>• Term 'black hole' coined<br>• Rod Laver wins tennis's Grand Slam<br>• Eddy Merckx wins Tour de France bicycle race<br>• Boris Spassky wins World Chess Championship |

| Visual arts | Other cultural events |
|---|---|
| • Warhol's first major exhibition, Ferus Gallery, Los Angeles<br>• Philip Johnson designs new wing for MOMA, New York<br>• Fluxus Internationale exhibition, Wiesbaden (W. Germany)<br>• Piero Manzoni names Marcel Broodthaers a living work of art (Belgium)<br>• Death of Yves Klein | • Marilyn Monroe commits suicide (USA)<br>• Edward Albee: *Who's Afraid of Virginia Woolf?*<br>• Anthony Burgess: *A Clockwork Orange*<br>• Bob Dylan records 'Blowin' in the Wind' (USA)<br>• Ken Keesey: *One Flew Over the Cuckoo's Nest*<br>• *Dr. No*, first James Bond film |
| • Death of Piero Manzoni (Italy)<br>• Andy Warhol produces 'Race Riot' series (USA)<br>• *Leben mit Pop* exhibition, Düsseldorf (W. Germany)<br>• Joseph Beuys performs at Fluxus, (W. Germany)<br>• Dan Flavin produces first fluorescent light sculpture<br>• Marcel Duchamp retrospective, Pasadena Museum of Art (USA) | • Hans Scharoun, Philharmonic Concert Hall, Berlin (West Germany)<br>• 'Doctor Who' first appears on British television<br>• Betty Friedan: *The Feminine Mystique*<br>• Suicide of Sylvia Plath (UK)<br>• *The Birds* directed by Alfred Hitchcock<br>• Thomas Pynchon: *V* |
| • *Amerikansk pop-kunst* exhibition tours Europe<br>• Robert Rauschenburg wins Grand Prize for Painting at the Venice Biennale<br>• Edward Kienholz's *Backseat Dodge '38* causes political outrage in Los Angeles<br>• Warhol paints Kennedy assassination series<br>• Carolee Schneeman performs *Meat Joy* | • Height of Beatlemania in UK and USA<br>• Peter Brook directs Peter Weiss's *Marat/Sade*, London<br>• Susan Sontag writes 'Notes on Camp' for *Partisan Review*<br>• Joe Orton: *Entertaining Mr Sloane*<br>• *The Gospel According to St Matthew*, dir. Pier Paolo Pasolini<br>• Mary Quant introduces the mini-skirt, London<br>• Herbert Marcuse: *One-Dimensional Man* |
| • *Three American Painters* exhibition organized by Michael Fried held at Fogg Art Museum, Harvard University<br>• Robert Morris and Carolee Schneeman: *Site*, New York<br>• James Rosenquist paints *F-111* (USA)<br>• *New Generation* exhibition, Whitechapel Gallery, London<br>• Donald Judd publishes article 'Specific Objects' (USA) | • Helen Gurley Brown becomes Editor-in-Chief of *Cosmopolitan* magazine, New York<br>• *The Pawnbroker* directed by Sidney Lumet<br>• National Endowment for the Arts (NEA) founded (USA)<br>• Bob Dylan records 'Like a Rolling Stone' (USA)<br>• James Brown records 'Papa's Got a Brand New Bag' (USA) |
| • Barnett Newman completes *Stations of the Cross* (USA)<br>• Sigmar Polke's first solo exhibition (West Germany)<br>• Carl Andre's *Equivalent VIII* shown in Tate Gallery, London<br>• Dan Graham's *Homes for America* published<br>• Eva Hesse constructs first *Metronymic Irregularity* (USA)<br>• Mark Rothko completes series of paintings for chapel in Houston, Texas | • *Blow-Up* directed by Michelangelo Antonioni<br>• Truman Capote: *In Cold Blood*<br>• Angela Carter: *Shadow Dance*<br>• Timothy Leary founds League for Spiritual Discovery (USA)<br>• Masters and Johnson: *Human Sexual Response*<br>• Robert Venturi: *Complexity and Contradiction in Architecture* |
| • Critic Germano Celant coins term *Arte Povera* (Italy)<br>• Peter Blake designs cover for Beatles' album 'Sergeant Pepper's Lonely Hearts Club Band' (UK)<br>• Joseph Kosuth's 'Investigation' series (USA)<br>• Sol Lewitt writes 'Paragraphs on Conceptual Art' (USA) | • Monterey Pop Festival, California (USA)<br>• Marshall McLuhan: *The Medium is the Message*<br>• Jimi Hendrix records 'Are You Experienced?' (UK)<br>• Aretha Franklin records 'Respect' (USA)<br>• *Velvet Underground and Nico* album released (USA)<br>• *Belle de Jour* directed by Luis Buñuel (France) |
| • Death of Marcel Duchamp<br>• Walter de Maria fills Galerie Heiner Friedrich, Munich with moist earth<br>• Christo wraps Kunsthalle, Berne (Switzerland)<br>• Marcel Broodthaers, *Musée d'Art Moderne, Dept des Aigles* opens in Brussels (Belgium)<br>• Richard Hamilton designs cover for Beatles' *White Album* | • *2001: A Space Odyssey* directed by Stanley Kubrick<br>• *If...* directed by Lindsay Anderson (UK)<br>• *Ma Nuit Chez Maud* directed by Eric Rohmer<br>• Tom Wolfe: *The Electric Kool-Aid Acid Test*<br>• James Stirling's History Faculty Library, Cambridge (UK)<br>• *Performance* directed by Nicolas Roeg and Donald Cammell<br>• Sly and the Family Stone record *Everyday People* (USA) |
| • Joseph Beuys exhibits *The Pack* (West Germany)<br>• Art Workers coalition (AWC) formed in New York<br>• Robert Smithson begins *Spiral Jetty* at Great Salt Lake, Utah (USA)<br>• 'When Attitude Becomes Form' exhibition (Switzerland and UK)<br>• First issue of *Art-Language* published, London | • Margaret Atwood: *The Edible Woman*<br>• *The Wild Bunch* directed by Sam Peckinpah (USA)<br>• Actress Sharon Tate and others murdered by Charles Manson and his followers<br>• BBC begins broadcast of 'Monty Python's Flying Circus' (UK)<br>• Woodstock Festival held in upstate New York<br>• Skidmore, Owings, and Merrill, John Hancock Center, Chicago |

# Bibliography

## HISTORY, POLITICS, AND MEDIA

BRANCH, TAYLOR, *Parting the Waters: America in the King Years 1954-1963* (New York: Simon and Schuster, 1988)

FARBER, DAVID (ed.), *The Sixties: From Memory to History* (Chapel Hill, N.C.: University of North Carolina Press, 1995)

FISERA, VLADIMIR (ed.), *May 1968: A Documentary Anthology* (London: Alison and Busby, 1978)

KNABB, KEN (ed.), *Situationist International Anthology* (Berkeley: Bureau of Official Secrets, n.d.)

KOPKIND, ANDREW, *The Thirty Years' War: Dispatches and Diversions of a Radical Journalist 1965-1994* (London and New York: Verso, 1995)

MILLER, JAMES, *Democracy Is in the Streets, From Port Huron to the Seige of Chicago* (New York: Touchstone, 1987)

SYRES, SOHNIA et al (eds), *The 60s without Apology* (Minneapolis: University of Minnesota Press, 1984)

SINGER, DANIEL, *Prelude to Revolution: France in May 1968* (New York: Hill and Wang, 1970)

WELLS, TOM, *The War Within: America's Battle over Vietnam* (Berkeley and Los Angeles: University of California Press, 1995)

## ANTHOLOGIES OF ARTISTS' STATEMENTS, DOCUMENTS, AND CRITICAL ESSAYS

ARMSTRONG, RICHARD, and RICHARD MARSHAL(eds), *The New Sculpture 1965-75: Between Geometry and Gesture* (New York: Whitney Museum of American Art, 1990)

ATELIER POPULAIRE, *Posters from the Revolution: Paris, May 1968* (London: Dobson, 1969)

BATTCOCK, GREGORY (ed.), *Minimal Art (*introduction by Anne M. Wagner; Berkeley and Los Angeles: University of California Press, 1995)

——, *The New Art* (revised edition; New York: Dutton, 1973)

BUREN, DANIEL, *Five Texts* (Oxford: Museum of Modern Art, 1973)

CELANT, GERMANO (ed.), *Roma-New York: 1948-1964* (New York: Rayburn Foundation, 1993)

CLEARWATER, BONNIE (ed.), *West Coast Duchamp* (Miami Beach: Grassfield Press, 1991)

FRANK, ROBERT, *The Americans* (introduction by Jack Kerouac; reprint, Manchester: Cornerhouse Publications, c. 1958)

GRAHAM, DAN, *Rock My Religion* (Cambridge, Mass., and London: MIT Press, 1993)

GUILBAUT, SERGE (ed.), *Reconstructing Modernism: Art in New York, Paris, and Montreal 1945-1964* (Cambridge, Mass., and London: MIT Press, 1990)

HARRISON, CHARLES, and PAUL WOOD (eds), *Art in Theory 1900-1990* (Oxford: Blackwell, 1993)

HENDRICKS JOHN (ed.), *Fluxus Codex* (New York: Harry N. Abrams, 1988)

JUDD, DON, *Complete Writings 1959-1975* (Halifax: Press of the Nova Scotia College of Art and Design, 1977)

KAPROW, ALLAN, *Assemblages, Environments, and Happenings* (New York: Harry N. Abrams, 1966)

——, *Essays on the Blurring of Art and Life* (Berkeley and Los Angeles: University of California Press, 1993)

KIRBY, MICHAEL, (ed.), *Happenings* (New York: Dutton, 1965)

KOSTELANTZ, RICHARD, *The Theatre of Mixed Means: an introduction to happenings, kinetic environments and other mixed-means performances* (London: Pitman, 1970)

KOSUTH, JOSEPH, *Art After Philosophy and After: Collected Writings 1966-1990* (Cambridge, Mass., and London: MIT Press, 1993)

LIPPARD, LUCY, *Six Years in the Dematerialization of the Art Object* (New York: Praeger, 1973)

MEYER, URSULA, *Conceptual Art* (New York: Dutton, 1972)

MORRIS, ROBERT, *Continuous Project Altered Daily: The Writings of Robert Morris* (Cambridge, Mass., and London: MIT Press, 1994)

RAINER, YVONNE, *Work 1961-73* (Halifax: Press of the Nova Scotia College of Art and Design, 1974)

REINHARDT, AD, *Art as Art: The Selected Writings of Ad Reinhardt* (ed. Barbara Rose; New York: Viking, 1975)

RICHTER, GERHARD, *The Daily Practice of Painting: Writings 1960-1993* (ed. Hans-Ulrich Obrist; London: Thames and Hudson, 1995)

ROBBINS, DAVID, *The Independent Group: Postwar Britain and the Aesthetics of Plenty* (Cambridge, Mass., and London: MIT Press, 1990)

SANDFORD, MARIELLEN R. (ed.), *Happenings and Other Acts* (London and New York: Routledge, 1995)

SCHNEEMAN, CAROLEE, *More than Meat Joy: Complete Performance Works and Selected Writings* (ed. Bruce McPherson; New Paltz, N.Y.: Documentext, 1979)

SERRA, RICHARD, *Writings, Interviews* (Chicago and London: University of Chicago Press, 1994)

SMITH, PATRICK S. (ed.), *Warhol: Conversations about the Artist* (Ann Arbor: UMI Research Press, 1988)

SMITHSON, ROBERT, *The Writings of Robert Smithson*, (ed. Nancy Holt; New York: New York University Press, 1979)

SUSSMAN, ELIZABETH (ed.), *On the Passage of a Few People through a Rather Brief Moment in Time: The Situationist International 1957-1972* (Cambridge, Mass., and London: MIT Press, 1989)

THISTLEWOOD, DAVID (ed.), *Joseph Beuys: Diverging Critiques* (Liverpool: Tate Gallery, 1995)

## EXHIBITION CATALOGUES

*1965-1975: Reconsidering the Object of Art* (Los Angeles: Museum of Contemporary Art, 1995)

*L'Art conceptuel: une perspective* (Musée d'Art Moderne de la Ville de Paris, 1989; texts in English and French)

*The Art of Assemblage* (New York: Museum of Modern Art, 1961)

*Billy Al Bengston: Paintings of Three Decades* (Houston: Contemporary Arts Museum, 1988)

*Joseph Beuys: The Revolution Is Us* (Liverpool: Tate Gallery, 1993)

*In the Spirit of Fluxus* (Minneapolis: Walker Art Center, 1993)

*Forty Years of California Assemblage* (Los Angeles: Wight Art Gallery UCLA, 1989)

*Robert Frank: Moving Out* (Washington, D.C.: National Gallery of Art, 1994)

*Helen Frankenthaler* (New York: Museum of Modern Art, 1989)

*German Art in the Twentieth Century* (London: Royal Academy of Arts, 1985)

*Eva Hesse* (New Haven: Yale University Art Gallery, 1992)

*I Don't Want No Retrospective: The Works of Edward Ruscha* (San Francisco: Museum of Modern Art, 1982)

*Italian Art in the Twentieth Century* (London: Royal Academy of Arts, 1989)

*Jess: A Grand Collage 1951-1993* (Buffalo: Albright Knox Gallery, 1994)

*Yves Klein* (Houston: Rice University Institute for the Arts, 1982)

*Agnes Martin* (New York: Whitney Museum of American Art, 1992)

*Robert Morris* (New York: Guggenheim Museum of Art, 1994)

*New York Painting and Sculpture: 1940-1970* (New York: Metropolitan Museum of Art, 1970)

*Sigmar Polke* (San Francisco: Museum of Modern Art, 1990)

*Pop Art* (London: Royal Academy of Arts, 1991)

*Robert Rauschenberg* (Washington, D.C.: National Collection of Fine Art, 1977)

*Gerhard Richter* (London: Tate Gallery, 1991)

*Robert Ryman* (London: Tate Gallery, 1993)

*Richard Serra* (New York: Museum of Modern Art, 1986)

*Andy Warhol* (New York: Museum of Modern Art, 1989)

*When Attitudes Become Form: works, concepts, processes, situations, information* (London: Institute of Contemporary Art, 1969)

## HISTORICAL AND CRITICAL STUDIES

ALLOWAY, LAWRENCE, *Topics in American Art since 1945* (New York: Norton, 1945)

BANES, SALLY, *Greenwich Village 1963: Avant-Garde Performance and the Effervescent Body* (Durham, N.C.: Duke University Press, 1993)

BRUGGEN, COOSJE VAN, *Bruce Nauman* (New York: Rizzoli, 1988)

BUCHLOH, BENJAMIN H.D. (ed.), *Broodthaers: Writings, Interviews, Photographs* (Cambridge, Mass., and London: MIT Press, 1988)

———, "Formalism and Historicity: American and European Art since 1945," in *Europe in the Seventies: Aspects of Recent Art* (Chicago: Art Institute of Chicago, 1977)

BURNHAM, SOPHY, *The Art Crowd* (New York: David McKay, 1973)

CROW, THOMAS, *Modern Art in the Common Culture* (New Haven and London: Yale University Press, 1996)

DAVIDSON, MICHAEL, *The San Francisco Renaissance: Poetics and Community at Mid-Century* (Cambridge: Cambridge University Press, 1989)

FRIED, MICHAEL, *Three American Painters* (Cambridge, Mass.,: Fogg Museum of Art, 1965)

———, *Morris Louis* (New York: Harry N. Abrams, 1971)

GREENBERG, CLEMENT, *Collected Essays and Criticism* (4 vols, ed. John O'Brian; Chicago and London: University of Chicago Press, 1986-89)

HARRISON, CHARLES, *Essays on Art and Language* (Oxford: Blackwell, 1991)

HAYWOOD, ROBERT, "Heretical Alliances: Claes Oldenburg and the Judson Memorial Church in the 1960s," *Art History*, XVIII (June 1995), pp:185-212

HESS, THOMAS, *Barnett Newman* (New York: Museum of Modern Art, 1971)

KATZ, ROBERT, *Naked by the Window: The Fatal Marriage of Carl Andre and Ana Mendieta* (New York: Atlantic Monthly Press, 1990)

KOCH, STEPHEN, *Stargazer: Andy Warhol's World and His Films* (New York: Praeger, 1973)

KRAUSS, ROSALIND, *Passages in Modern Sculpture* (New York: Viking, 1977)

KURTZ, BRUCE, "Last Call at Max's," *Artforum*, XIX (April 1981), pp: 26-29

LIPPARD, LUCY, *Eva Hesse* (New York: Da Capo, 1992)

———, *Ad Reinhardt* (New York: Harry N. Abrams, 1981)

MELLOR, DAVID, *The Sixties Art Scene in London* (London: Phaidon, 1993)

ORTON, FRED, *Figuring Jasper Johns* (London: Reaktion, 1994)

PINCUS, ROBERT, *On a Scale to Compete with the World: The Art of Edward and Nancy Reddin Kienholz* (Berkeley and Los Angeles: University of California Press, 1990)

PINCUS-WITTEN, ROBERT, *Postminimalism to Maximalism: American Art 1966-1986* (Ann Arbor: UMI Research Press, 1987)

ROSE, BARBARA, *Claes Oldenburg* (New York: Museum of Modern Art, 1970)

RUBIN, WILLIAM S., *Frank Stella* (New York: Museum of Modern Art, 1970)

SOLNIT, REBECCA, *Secret Exhibition: Six California Artists of the Cold War Era* (San Francisco: City Lights, 1990)

STEINBERG, LEO, *Other Criteria: Confrontation with Twentieth-Century Art* (Oxford: Oxford University Press, 1972. Includes "Contemporary Art and the Plight of its Public," cited on p.7)

WALL, JEFF, *Dan Graham's Kammerspiel* (Toronto: Art Metropole, 1991)

WELLS, JENNIFER, "The Sixties: Pop Goes the Market," *Definitive Statements: American Art 1964-66* (Providence, R.I.: Brown University, List Art Center, 1986)

# Picture Credits

Collections are given in the captions alongside the figures. Sources for illustrations not supplied by museums or collections, additional information, and copyright credits are given below. Numbers to the left refer to figure numbers unless otherwise indicated.

Title page: as 79
1   Courtesy Pierre Alechinsky, Bougival; photo: André Morain
2   The Museum of Modern Art, New York. Gift of Philip Johnson in honor of Alfred H. Barr, Jr. Photo © The Museum of Modern Art, New York. © Jasper Johns/DACS, London/VAGA, New York 1996
3   Courtesy estate of Hans Namuth, New York
4 below   Courtesy Harry N. Abrams Inc, New York
5   Range/Bettmann/UPI
6   Marc Riboud/Magnum, London
page 15:   detail of figure 17
8   Courtesy Leo Castelli Gallery, New York. © Robert Rauschenberg/DACS, London/London/VAGA, New York 1996
9   Courtesy Sonnabend Gallery, New York
10   The Carnegie Museum of Art, Pittsburg. Gift of G. David Thompson, 55.24.4. © Willem de Kooning/ARS, NY, and DACS, London 1996
11   Courtesy Leo Castelli Gallery, New York. © Jasper Johns/DACS, London/VAGA, New York 1996
12   © Robert Frank, courtesy Pace/MacGill Gallery, New York
13   © Robert Frank, courtesy Pace/MacGill Gallery, New York
14   San Francisco Museum of Modern Art, gift of Frederic P. Snowden 76.102; photo Ben Blackwell
16   Photo by David Wakely, San Francisco
18   Courtesy the Estate of Jay DeFeo; photo Ben Blackwell.
19   Photo by George Hixson
20   The Museum of Modern Art, New York. Gift of Philip Johnson. Photo © The Museum of Modern Art, New York.
21   Range/Bettmann/UPI
22   Courtesy Claes Oldenburg, New York
23   The Chrysler Museum, Norfolk, Virginia. Gift of Walter P. Chrysler, Jr., 71.685. Photo by Scott Wolff
24   Courtesy Claes Oldenburg, New York
page 39:   detail of figure 31
26   The Art Institute of Chicago, Harriott A. Fox Fund, 1956.1201
28   Collection Centre Georges Pompidou, Paris, photo J.C. Planchet

29   Courtesy Anthony d'Offay Gallery, London. © Richard Hamilton 1996. All rights reserved DACS
30   Courtesy Richard Hamilton, London
32   Musée National d'Art Moderne, Centre Georges Pompidou, Paris 1989
33   Range/Bettmann/UPI
35   © DACS 1996
38   Courtesy Robyn Denny, London
39   Courtesy the Barbican Art Gallery, London and Robyn Denny
41   Musée National d'Art Moderne, Centre Georges Pompidou, Paris
42   Grey Art Gallery & Study Center, New York University Art Collection, New York, gift of the artist, 1963.2. Photo James Prince
43   The Saint Louis Art Museum, Missouri. Purchase. Funds given by the Shoenberg Foundation Inc.
44   © 1996 The Museum of Modern Art, New York
45   Whitney Museum of American Art, New York, gift of Mr. and Mrs. Eugene M. Schwartz and purchase, with funds from the John I. H. Baur Purchase Fund; with Charles and Anita Blatt Fund: Peter M. Brant: B. H. Friedman; the Gilman Foundation; Frances and Sydney Lewis; the Albert A. List Fund; Philip Morris Incorporated; Sandra Payson; Mr. and Mrs. Albrecht Saalfield; Mrs. Percy Uris; Warner Communications Inc. and the National Endowment for the Arts. Photo Gamma One Conversions, New York
page 69:   detail of figure 69; photo Douglas Parker
48   Photograph by Robert E. Mates & Paul Katz © the Solomon R. Guggenheim Foundation, New York
49   © Charles Brittin, Santa Monica
50   Museum Moderner Kunst Stiftung Ludwig, Vienna (formerly Hahn Collection)
51   Los Angeles County Museum of Art. Purchased with funds provided by the Art Museum Council
52   Courtesy Betye Saar, Los Angeles; photo by Steve Peck
53   Courtesy Dennis Hopper ©, Venice California
55   Courtesy Dennis Hopper ©, Venice California
56   Hood Museum of Art, Dartmouth College, Hanover, New Hampshire. Gift of James J. Meeker, Class of 1958, in memory of Lee English
57   The Museum of Modern Art, New York, The Sidney Harriet Janis Collection. © ADAGP, Paris, DACS, London 1996
58   Courtesy Edward Ruscha, California
59   © Seymour Rosen-Los Angeles-1991.

© ARS, NY, and DACS, London 1996
60   © ARS, NY, and DACS, London 1996
61   Courtesy Sonnabend Gallery, New York. © ARS, NY, and DACS, London 1996
62   Courtesy The Andy Warhol Foundation, New York. © ARS, NY, and DACS, London 1996
63   © Roy Lichtenstein/DACS 1996
64   The Museum of Fine Arts, Houston, Gift of D. and J. de Menil
65   Courtesy Stefan T. Edlis; photo by Geoffrey Clements, New York
66   Albright-Knox Art Gallery, Buffalo, New York. Gift of Seymour H. Knox, 1964. © George Segal/DACS, London/VAGA, New York 1996
67   Courtesy the Sonnabend Gallery, New York. © ADAGP, Paris and DACS, London 1996
68   Courtesy Gerhard Richter, Cologne
69   Photo Douglas Parker
73   Courtesy the artist. © Kenneth Noland/DACS, London/VAGA, New York 1996
page 105:   detail of figure 75, courtesy Anthony Caro; photo John Riddy
74   Courtesy Anthony Caro, London
75   Courtesy Anthony Caro, London; photo John Riddy
76   Courtesy Bridget Riley, London; photo John Webb
77   Hulton Deutsch Collection Limited, London
78   Purchase, funds provided by Mrs John D. Rockefeller 3rd (Blanchette Hooker, class of 1931) 1971.36
80   © William Turnbull 1996. All rights reserved DACS
82   © ADAGP, Paris, and DACS, London 1996. Courtesy Sidney Janis Gallery, New York, photo Allan Finkelman
83   © ADAGP, Paris, and DACS, London 1996. Photo Harry Shunk, New York
84   Courtesy Simone Forti, Vermont
86   Courtesy Carolee Schneemann, New York State; photo by Al Giese
87   Deutsche Presse-Agentur, Frankfurt
88   © 1996 Lenono Photo Archive
89   Courtesy Sonnabend Gallery, New York
page 135:   detail of figure 97
90   © DACS 1996
91   Courtesy Galleria Blu, Milan
92   © ARS, NY, and DACS, London 1996
93   As 92
94   © Estate of Donald Judd/DACS, London/VAGA, New York 1996
95   © ARS, NY, and DACS, London 1996
96   © Carl Andre/DACS, London/VAGA, New York 1996
99   Rheinisches Bildarchiv, Cologne

# Index